From Block to Big Screen

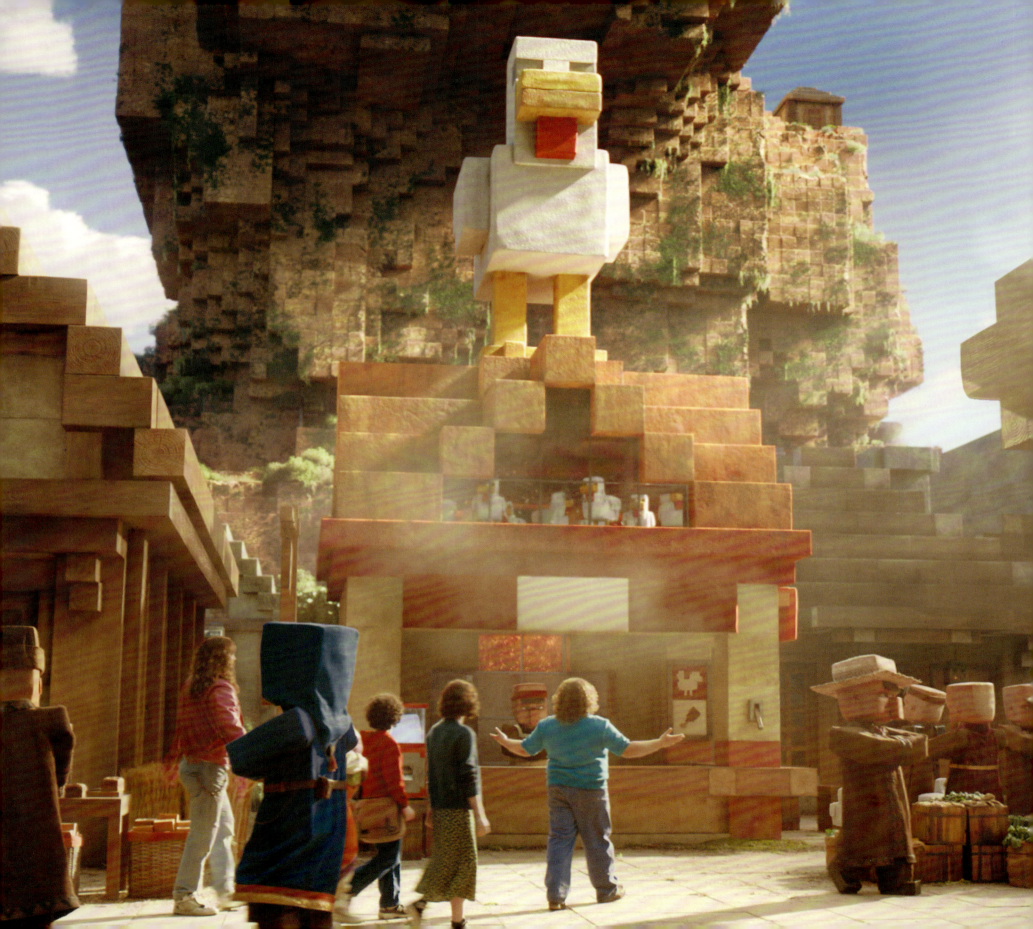

A MOVIE

From Block to Big Screen

WRITTEN BY ANDREW FARAGO

FOREWORD BY JENS BERGENSTEN

INSIGHT EDITIONS

SAN RAFAEL · LOS ANGELES · LONDON

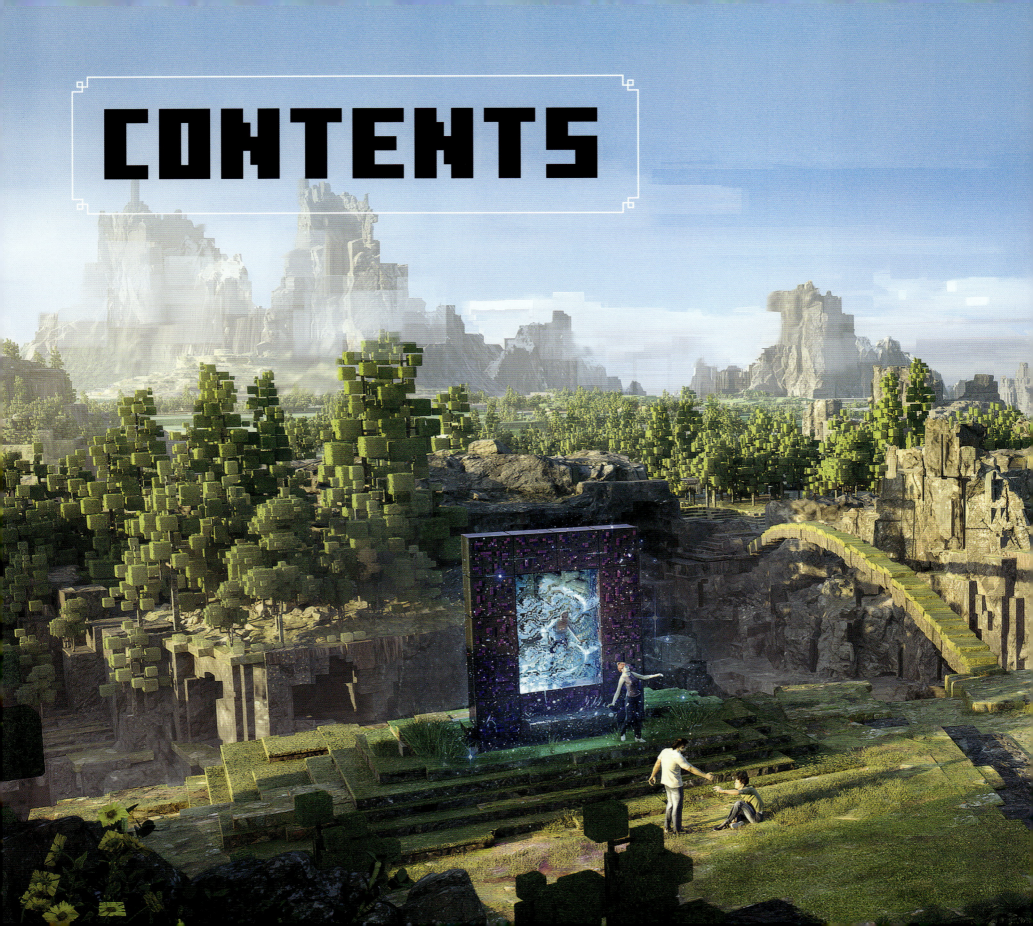

CONTENTS

6	Foreword
10	One Block at a Time
12	Chapter 1: Limitless Possibilities
60	Chapter 2: Building Blocks
134	Chapter 3: Mob Mentality
168	Chapter 4: Putting It All Together
188	Endgame

FOREWORD

I love video games and the magical and fantastic worlds that they provide. As a game designer it has thus been a great privilege to lead the creative work on the *Minecraft* franchise for over a decade. However—despite thousands of hours thinking about the game—I still find it challenging to explain what *Minecraft* truly is. Sure, it's about being creative in a world which is made from blocks, but there is also so much more.

Adventure, exploration, tinkering, collecting, dreaming, storytelling . . . the list goes on.

Minecraft also means different things to different people. Some people see it as a way to express themselves. Some see it as a way to compete or hang out with others, or maybe to develop their own features and learn new skills. *Minecraft* is amazing in its versatility. The thing *Minecraft* players have in common is that *Minecraft* is important to them and an important part of their lives. *Minecraft* has most definitely been very important in mine!

So, we all at Mojang work very hard to make sure we are good stewards of the game and prove to the community that *Minecraft* is in good hands. In *Minecraft* every world shares the same foundations. You will find the same environments, creatures, mechanics, and potential encounters. Players then bring their own flair and perspectives and create something completely new and unique—a player's story. Creating such stories is what players have been doing since the beginning. During the process of developing *A Minecraft Movie*, we spent a tremendous amount of effort on how we wanted this story to show up.

With Jared's direction and a wonderfully talented team—who shared our community's love for the game—we were able to capture these collectively shared experiences while still creating something never seen before. Together we are very excited to share with you a unique and entertaining *Minecraft* story!

Jens Bergensten
Chief Creative Officer, Mojang Studios

OPPOSITE (Concept art)
The Nether holds many secrets . . . including a vast piglin army.

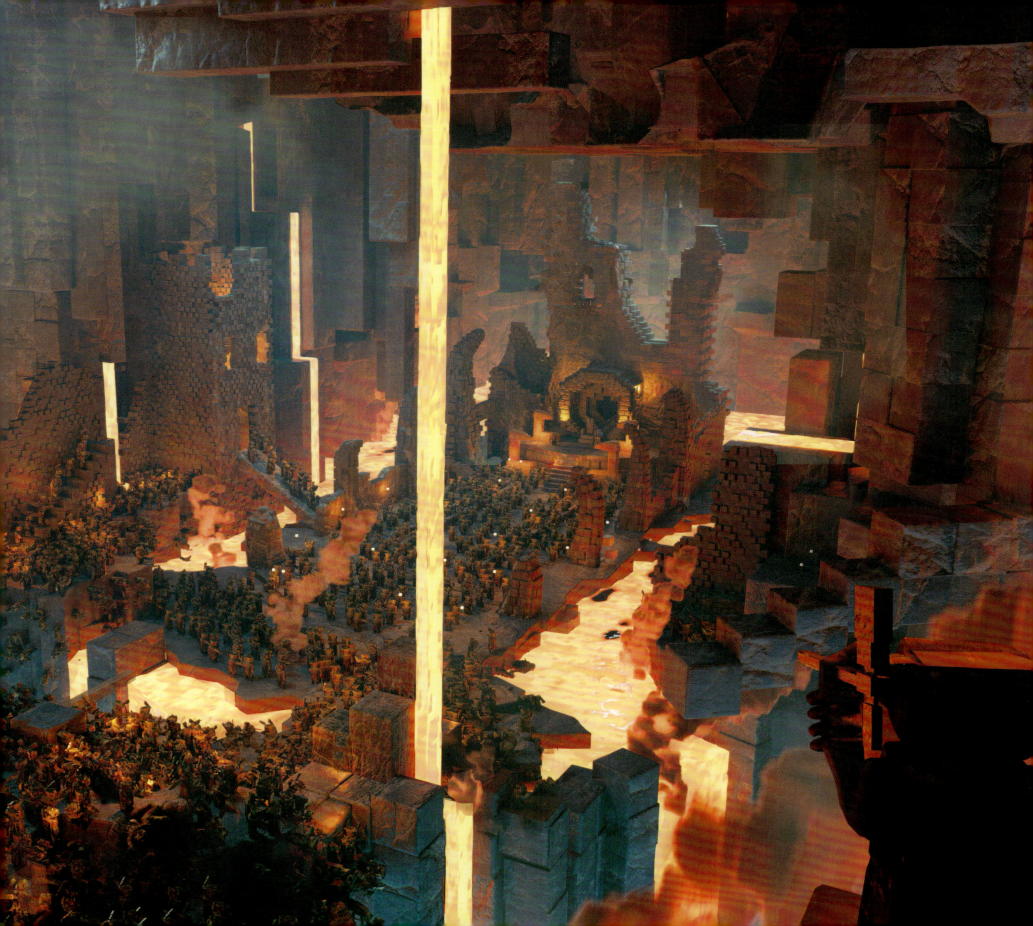

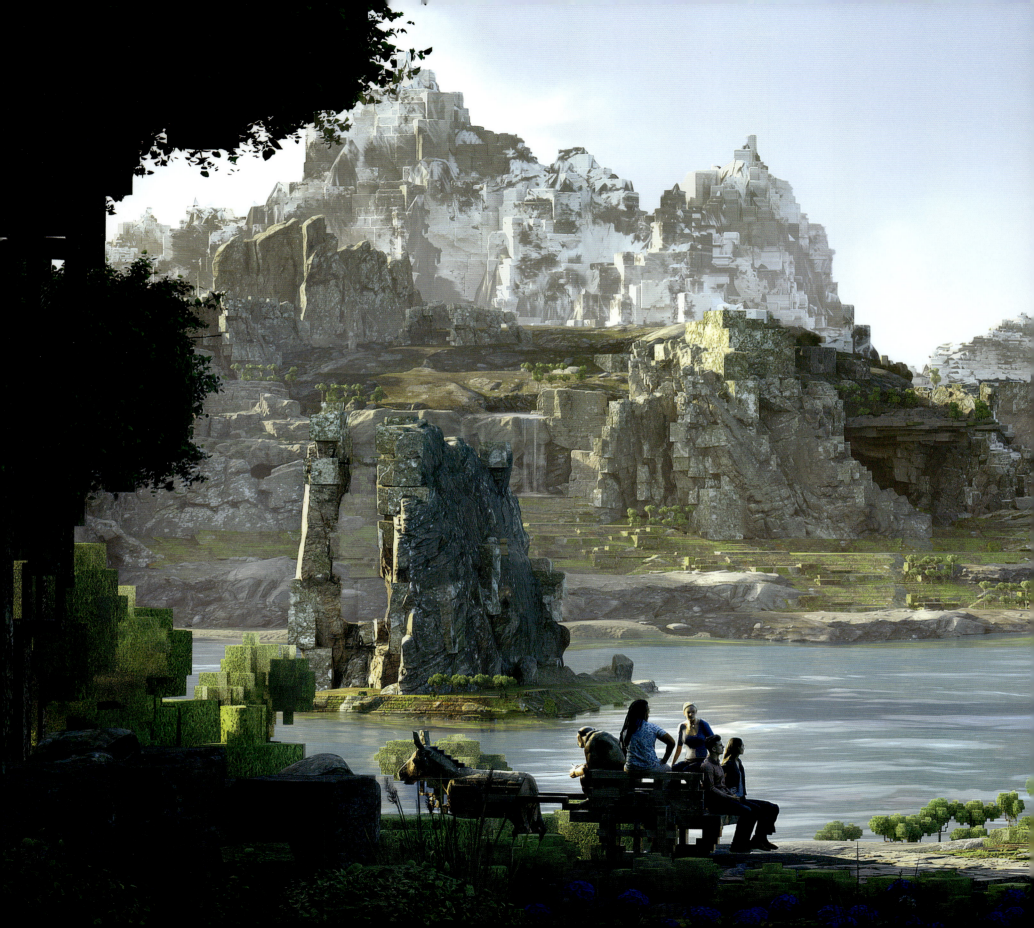

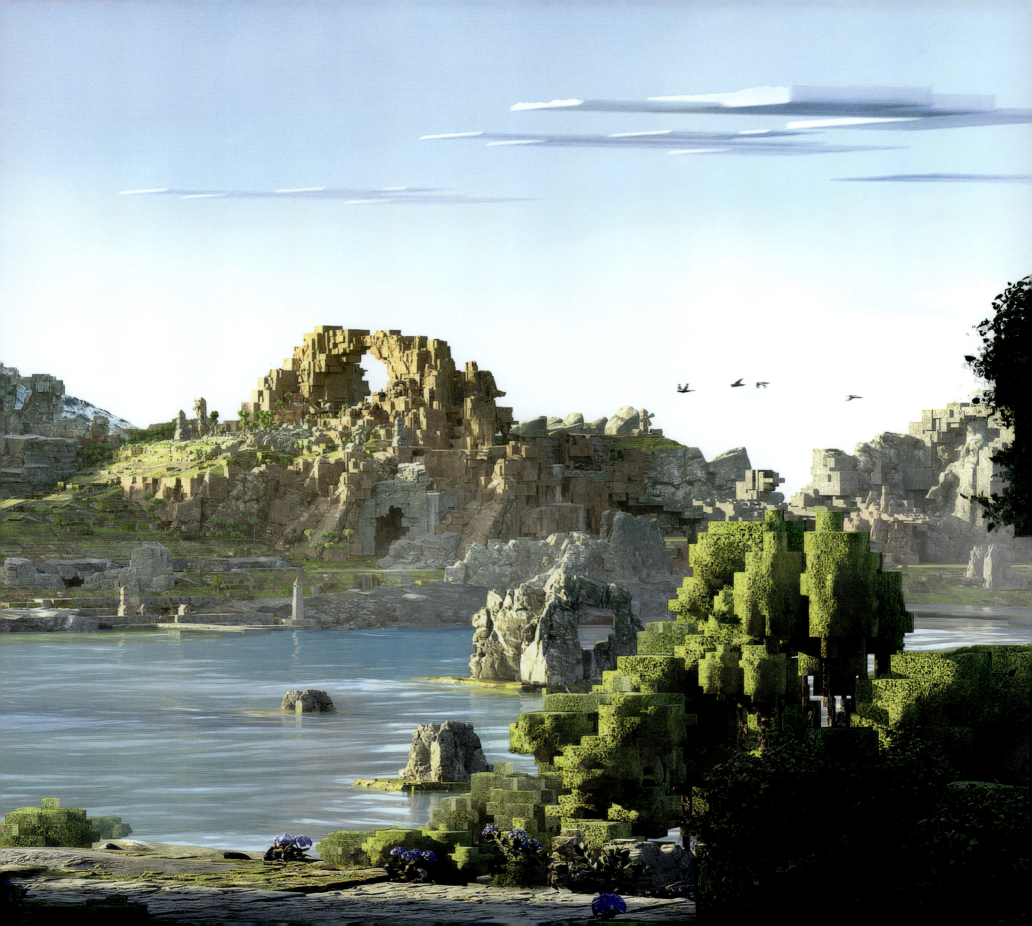

ONE BLOCK AT A TIME

From the beginning, "one block at a time" has been the guiding principle behind *Minecraft*, the world's highest-selling game.

Whether players experience *Minecraft* in Creative mode, building a new world from the ground up, or facing the challenges of Survival mode—Mojang has never strayed from the core concept of a world built of blocks, mobs, and community.

The world of *Minecraft* is one of infinite possibilities—but that's not to say it's a world without rules.

"Nothing comes from nowhere, and everything has an origin," says *Minecraft* senior creative director of entertainment, Torfi Frans Ólafsson. "And everything has an associated cost. When you see something complicated and large, you know a tremendous amount of effort went into it, and that's very gratifying."

Jens Bergensten, chief creative officer of *Minecraft*, joined Mojang in 2010, and he and his team ensure that the popular game has followed that philosophy, a core that has held throughout every iteration, from the very beginning through the most recent update. "One of the most important things is that we have a 'one block at a time' principle. That you interact with one block at a time—remove

one block, add one block. No copy-paste functionality or templates, anything like that," Bergensten says.

"And I'd say there are three reasons for that. One is to keep the core game loop intact. The journey is the destination, in a sense, because once you've built your castle, the game's over. It's what took you there that was interesting.

"The second thing is that if you build one block at a time instead of using templates, it allows you to become creative, almost by accident. It makes every building unique. You might accidentally place one block too many, and then you've got a new shape. There was some effort behind it; you accomplished something when you made a new building or contraption or something.

"But the third reason comes when you are playing multiplayer. It's important that you understand what a player is trying to achieve by just observing. If players drop things with commands or copy and paste, you lose that part of the game. But when you see someone building a world block by block, not only can you see what they intend to do, but you can also help out. And then you have two players building something much faster than one. So that collaborative feeling as well is what we want."

That collaborative feeling was essential to the production of *A Minecraft Movie*, a film that, much like the game that inspired it, is the result of teamwork. Hours of work. Hours of play. And assembling a team of adventurers that strikes the perfect balance between order and chaos.

"*Minecraft* is one of those games that's best played with friends, or with other people, and that's a huge reason for its growth, and why it became what it is," says Torfi Frans Ólafsson.

"Then we have our own internal interpretation," Ólafsson continues. "Everybody can build regardless of whether they're artists or not. You can take some large blocks, anyone can, and you can build something that looks like a dog. But when you give people smaller blocks, they're going to start struggling and doubting themselves. The lower fidelity gives everyone permission to be creative, and that's part of the magic of *Minecraft*."

Bringing that magic to the screen was no simple task, however.

Minecraft has no set goal, and the game's main characters, Steve and Alex, have no real personalities or identities. The infinite landscapes and limitless storytelling opportunities present unlimited gameplay options, with worlds to explore and challenges to brave. The building blocks of *Minecraft* can reshape the entire landscape of the Overworld and the Nether, and the creatures that you encounter along the way can be friends or foes depending on your style of gameplay.

"Nothing comes from nowhere, and everything has an origin."

The world of *Minecraft* allows for epic quests and quiet meditations, solo quests or multiplayer adventures, from the ridiculous to the sublime—so how do you bring such a complex game, one that is all things to all players, to the big screen?

Legendary Pictures producer Cale Boyter sums up that journey perfectly.

"It was a long road, my friend. A long and winding road."

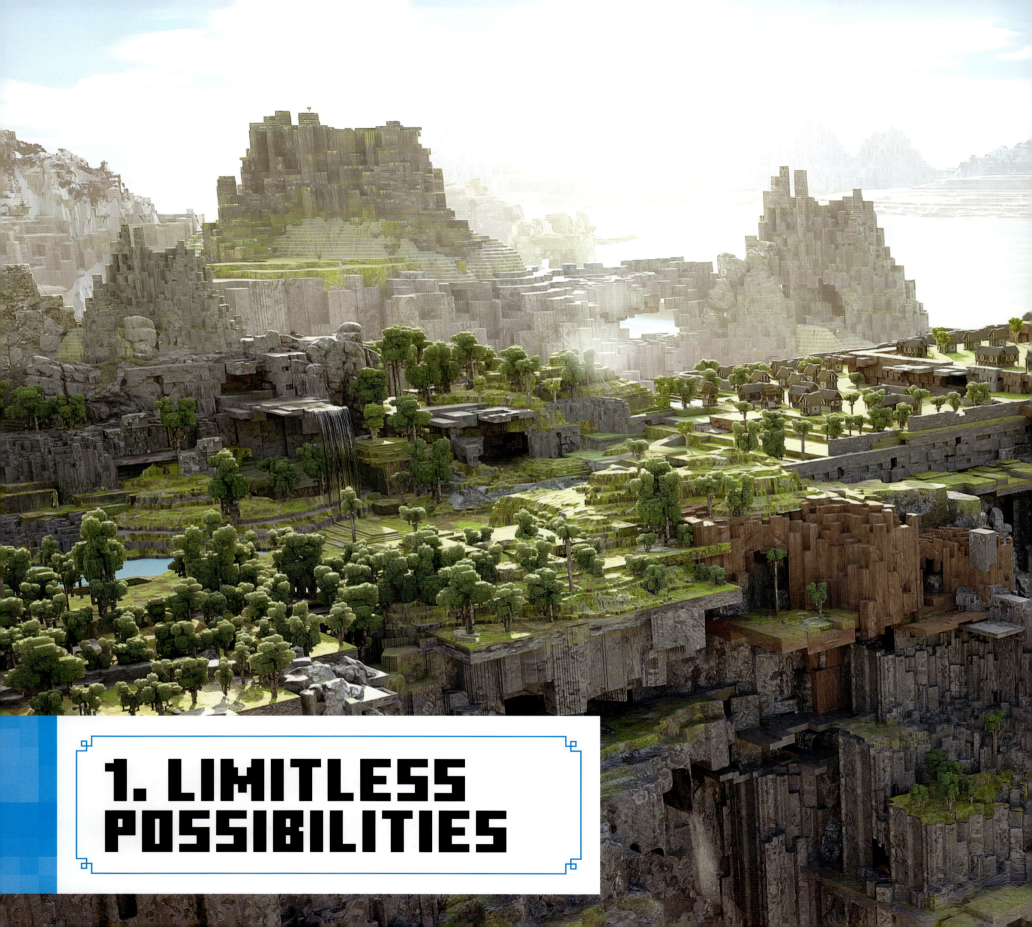

1. LIMITLESS POSSIBILITIES

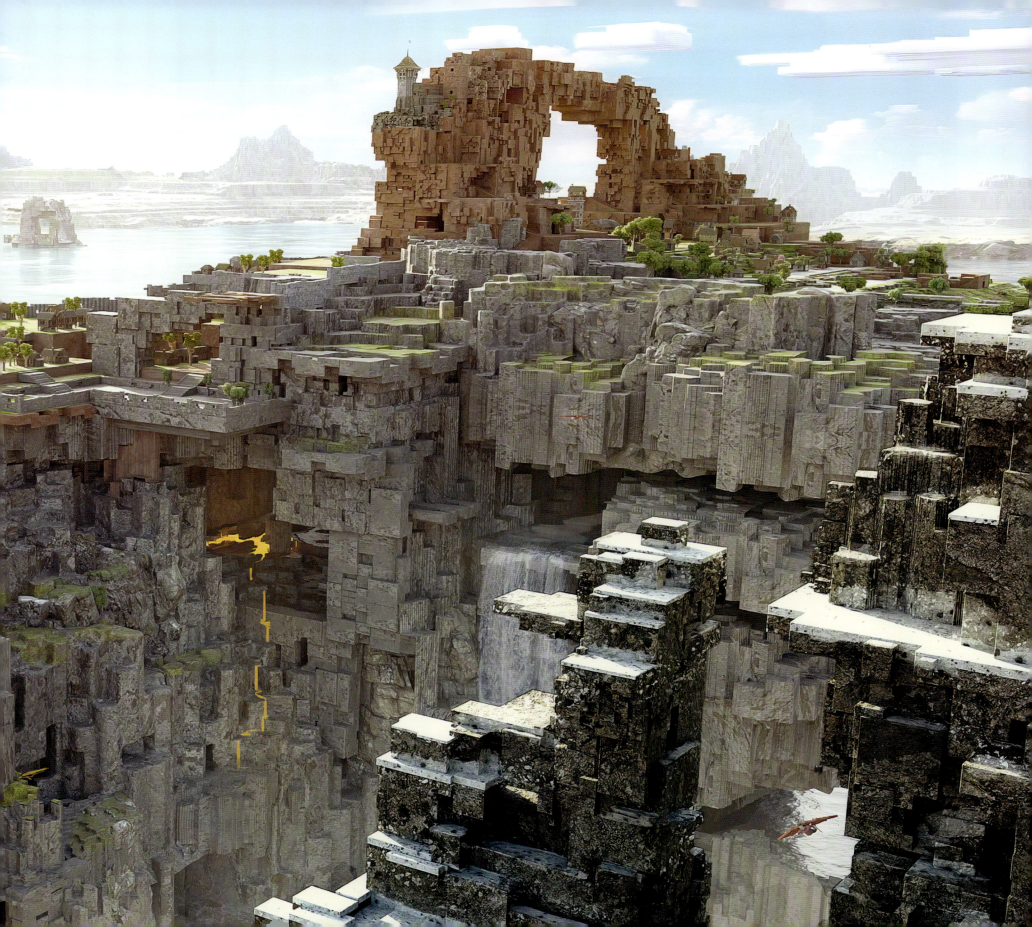

Components

After two years of development and beta testing, *Minecraft* debuted in November 2011, and thanks to its innovative and intuitive gameplay, Mojang's sandbox game quickly became a global phenomenon.

By the start of 2014, *Minecraft* was well on its way to becoming the most popular video game of all time, and none of the millions of *Minecraft* fans around the globe were surprised when Mojang announced that a major motion picture based on the hit game was in development and that the *Minecraft* movie would soon be making its way to theaters worldwide. The announcement was just a bit premature, Vu Bui, Mojang media director and a producer on the movie, notes, as Mojang and Warner Bros. were still in the midst of their earliest discussions about just what a *Minecraft* movie could and should be. "We were incredibly confident that Warner Bros. was the right studio for us," he says. "Meeting with Warner Bros., and trusting them and seeing the potential for them to bring it to life in the way that we wanted to see on the big screen.

"The other studios weren't willing to invest the way that Warner Bros. did. The first time they came to Stockholm to meet with us, they'd already spent a lot of time learning and understanding *Minecraft* as

ABOVE (Concept art)
The power of the Earth Crystal creates a portal between the two realms.

OPPOSITE (Concept art)
The Redstone Mine provides a valuable resource for builders.

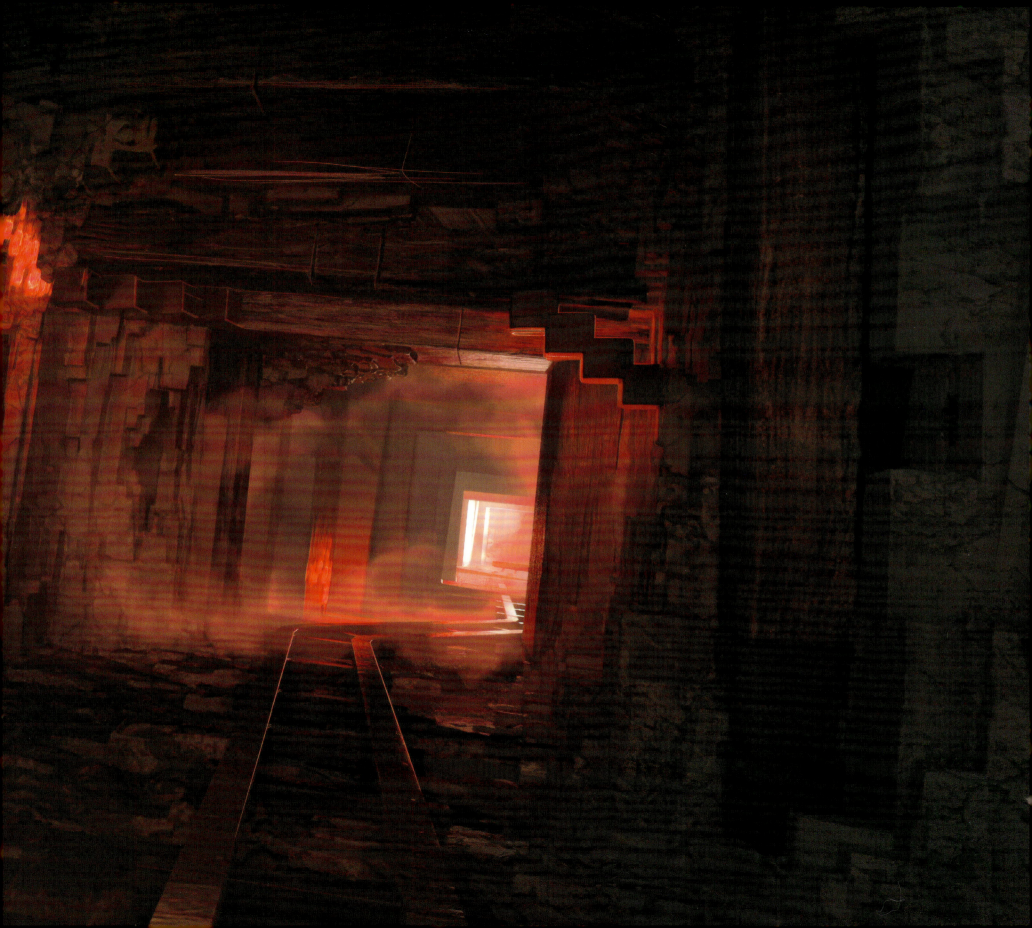

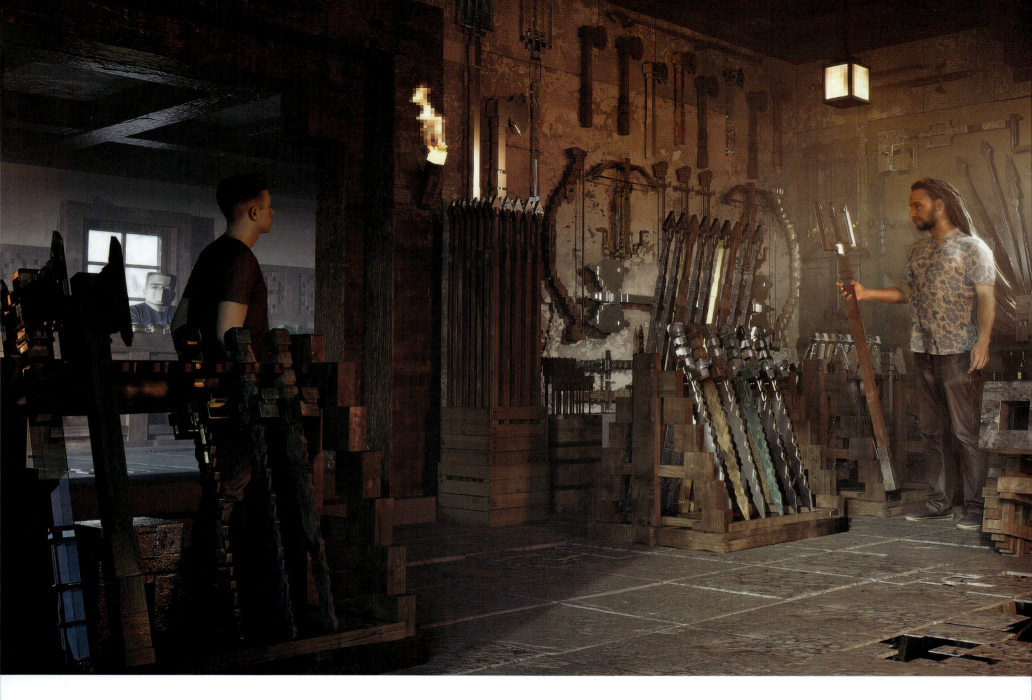

opposed to just telling us the market potential of a movie or how many more games we could sell with a successful movie. Warner Bros. focused on the storytelling aspect of it, how each player tells their own story, and how we could use that to our advantage. It became a canvas that we could use to paint a story that could only be told in the *Minecraft* world. Some of the other studios suggested that they could take any existing script or idea they already had and just put it into *Minecraft*. But the Warner Bros. executives we worked with knew that to do this right, we had to build something, to tell a story that could only happen in *Minecraft*. Not in Middle-earth, not at Hogwarts, not anywhere else."

Speculation about the film began immediately, as fans discussed potential directors, stars, and storylines. Mojang and its new parent company, Microsoft, expanded *Minecraft*'s world with updates to the classic game, supplemental editions and spinoffs, original books, comics, and spin-off games including action-RPG *Minecraft Dungeons* and the interactive adventure *Minecraft: Story Mode,* all of which added to the

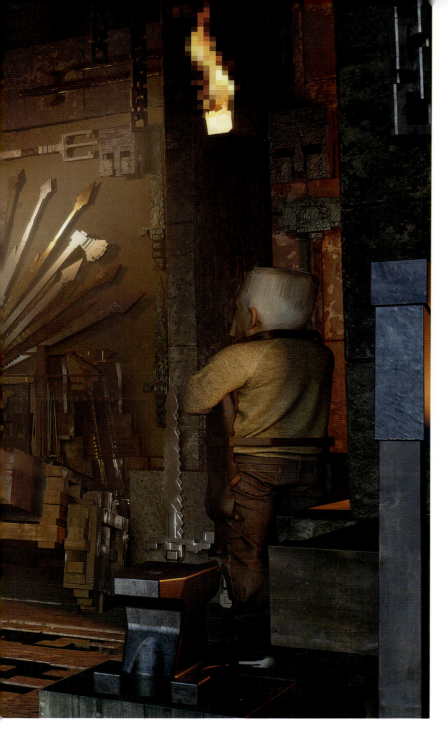

ever-expanding mythos and community, but official updates on the movie were as rare as a Dragon egg.

Mojang knew that *Minecraft* was no flash in the pan, and that the high standards of quality they'd established would allow them to be patient while they developed their approach and the philosophy of the *Minecraft* feature film, and that they would rather have no movie at all than one that didn't capture the spirit of the game. "What we wanted to do, what we absolutely had to do, was to find the right team," says Bui. "And that is more difficult than you might think. They didn't all work out because we've been trying to find that right mix of people who could bring a movie to life that was true to the *Minecraft* game, and could capture the sense of humor, the sense of fun, and some of the scariness, too. To bring all of those elements together.

"If you read anything we write, even on *minecraft.net*, or watch any of the trailers we make, humor is such a big part of our company. How we think about *Minecraft*, things we make around *Minecraft*. We knew that we wanted to bring humor to the movie. Some of the early takes for this movie were very serious, very emotional, with scenes that would choke you up and bring tears to your eyes because they were so emotionally powerful. But it didn't feel like that was necessarily what people would really want out of a *Minecraft* movie.

"When I think about people coming to watch a movie [of a game] that they've maybe played for a few years, or watched others play, or have otherwise been around it, I think they all have some version of *Minecraft* in their head. And almost everyone I've ever talked to has said that *Minecraft* is a fun and funny game that doesn't take itself too seriously. And it also has very scary moments that make it feel super-real. I think it's taken us this long to find the right team that could bring together that combination of elements.

"For years, my main focus was trying to get the *Minecraft* of it right, making sure that the movie stayed true to our values and a lot of the things that were important to us. As someone who's been playing it since Alpha, I know the game very well, and what I want when people watch the movie is that it doesn't feel at all detached from the *Minecraft* that they know. I want all of these characters to come together to represent everyone and everything we love about the game and its community.

"A huge part of what makes *Minecraft* special is the huge community of creators around it. The movie will give people even more fuel to create, and that is very exciting to me."

Like every *Minecraft* player, Mojang knew the importance of selecting the right materials and having a solid plan before embarking on a major build. But they also know that things rarely come together exactly as planned, and that versatility and improvisation are some of the greatest assets in the *Minecraft* toolbox, and sometimes the greatest adventures are those that take us completely by surprise.

"I think divine intervention is the simplest way to put it," says Legendary Pictures producer Cale Boyter, looking back on his own

OPPOSITE (Concept art) Garrett and Henry learn the importance of finding the right tool for the right job as they explore the village armory.

1. LIMITLESS POSSIBILITIES 17

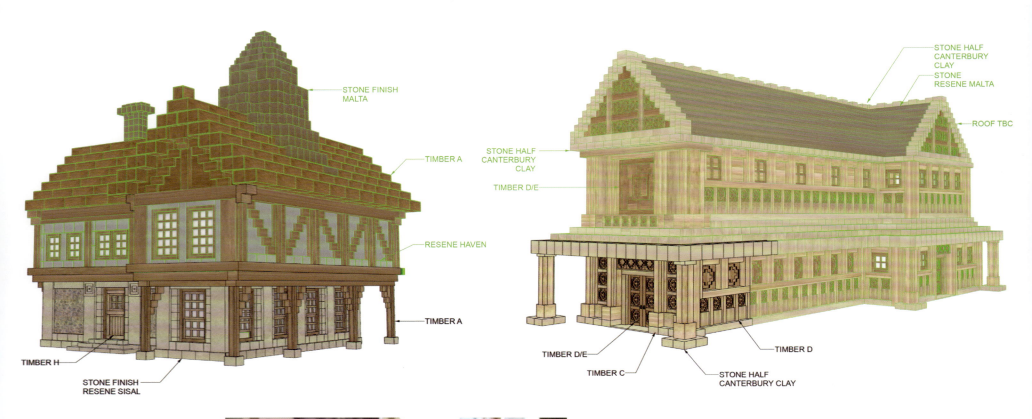

ABOVE Each structure in Midport Village was carefully designed and built using only techniques that are possible within *Minecraft* itself.

OPPOSITE Steve welcomes his new friends to Midport Village, a town that holds wonders unlike anything they've ever seen before.

Minecraft journey. "My son discovered the game very early on, long before it was out there as a potential Hollywood property. It's a weird game that kind of became more than a game. I knew it and loved it . . . then watched the game really take off."

In the years that followed, several different producers and directors were attached to the film, but none were able to bring the *Minecraft* movie to the finish line. "It wasn't the right time," says Torfi Frans Ólafsson, Mojang senior creative director of entertainment. "I think the contract with [Warner Bros.] was signed in 2014, and the movie's been in development forever. It's gone through different directors, producers . . . people have gone on and off the project. Sometimes people weren't the right fit for the movie, and sometimes the schedules did not cooperate." Other factors, including the box office performance of other video game adaptations, also impacted the development of the film. The phenomenal success of the *Minecraft* games and the brand itself meant that Mojang could afford to be patient, however, and could wait for the right conditions, the right team, and the right story.

And finding that story—out of all the infinite paths available to *Minecraft* players—was no simple task. Many of Hollywood's most in-demand screenwriters wrote treatments for the film, including Chris Galletta, whose acclaimed coming-of-age film *Kings of Summer* showcased the heart and humor that would be essential to any *Minecraft* film adaptation.

"Right after *Kings of Summer*, which was ages ago, I had a meeting with Jesse Ehrman at Warner Bros.," says Galletta. "*Minecraft* at the time was with another director. That version of the film had been in development at least as far back as 2017, probably much earlier.

"And I did a draft on it, and I enjoyed it, but that version of the

movie never came to fruition. It went through a number of other iterations and producers and directors."

The search for just the right story proved elusive, but Mojang, built on the "one block at a time" principle, was more than content to wait until the time and conditions were right to proceed with the movie. "The simple reason that the production took so long is that we could not find the right story to tell," says Jens Bergensten, chief creative officer of *Minecraft*. "*Minecraft* doesn't have a story of its own. Coming up with a story that makes sense is very hard. Writers came and writers left, and it was hard to find scriptwriters who understood *Minecraft*. People would come in and write a script, and we would provide notes, like, 'this is not *Minecraft*, you need to do this to make it more *Minecraft*-y.' Then another writer comes in to do what is called punch-up on the script, and removes all of the *Minecraft* stuff that we had argued to put in.

"And now we're back to square one again, and we have to educate this new writer with things like, 'No, this donkey won't eat black beans, because there are no black beans in the *Minecraft* world.' You know, stuff like that. Trying to keep things as close to the game as possible while still being fun. So that took a long time, but another thing changed as well. I think it was that we at Mojang matured a little bit in the way that we regarded *Minecraft* stories."

As Mojang brought more storytellers into the fold, Bergensten's approach to the *Minecraft* mythos evolved, and that change and that willingness to accept new and different perspectives opened new doors for the *Minecraft* movie. "We did *Story mode*, we did *Legends*, we did *Dungeons*, and over time we learned that it's not so much about telling *the Minecraft* story, because there isn't one," says Bergensten. "There isn't a single one. Every player tells their own story, with the game they're playing. When we began thinking about it that way, it allowed us to take liberties with some of these things. We regard this as 'A *Minecraft* Movie' because it's *a* possible story. It's not *The Minecraft* Movie, and there might be other *Minecraft* stories in the future. That made it much easier to get the project rolling, actually. Give and take."

Embracing that approach changed everything, agrees Torfi Frans Ólafsson. "Because *Minecraft* is a sandbox game, it's open-ended, it has no linear narrative. It has some goals, like killing the Dragon or going into the Nether, but *Minecraft* is so many things to so many people. It's not possible to capture everyone's experience. And that's why we decided to go more specific, having one single story rather than try to explain the entire backstory of the world and how it came to be."

> "We regard this as 'A Minecraft Movie' because it's a possible story. It's not *The Minecraft Movie* ..."

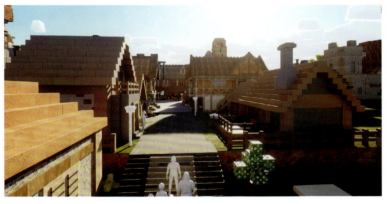

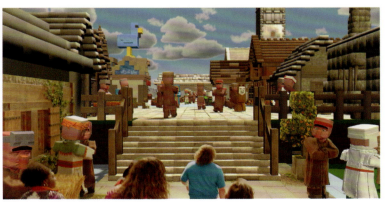

> "The first thing with a property is that you want to find the essence of it, and to capture and celebrate it."

Legendary Tales

In 2019, five years after the first *Minecraft* movie announcement, the stars aligned and production on the film began in earnest, with Cale Boyter at the helm. "Many years later, I was with Legendary Pictures, and I did the *Pokémon: Detective Pikachu* movie, and that was a big success for Warner Bros., adapting a licensed property. Not long after that, Warner Bros. reached out to me and said, 'We can use some love and affection on our *Minecraft* movie,' and I was like, 'Holy crap! Really?' So they came knocking on our door to produce the movie.

"And that led to a bigger role. Mary Parent [chairman of worldwide production & television for Legendary Pictures] and I were able to inherit producing responsibilities on *Minecraft*, and that was just going full circle in the universe, since the game had been such a big thing in my house."

As a parent who had seen *Minecraft* grow and change over the years and as a storyteller, Boyter had strong opinions about what a *Minecraft* movie needed to be to capture the essence of the game, stay true to its audience, and to craft a film that would appeal to die-hard fans as well as friends and family who were along for the ride.

No small task for someone inheriting a movie that was still trying to find its voice five years into its development.

"The first thing with a property is that you want to find the essence of it, and to capture and celebrate it. That's where it starts. Then you need a filmmaker to drive that vision.

"With *Minecraft*, the people at Mojang are very serious about being absurd. It looks like the game is made by a bunch of counter-culture Europeans taking a lot of 'shrooms, then you learn no, they don't do 'shrooms. And then you need to find a director who can understand that. And I looked toward a director that I'd known for years, an independent director, Jared Hess, and I told him, 'Hess, come be weird in the sandbox.' I thought he was going to bring the right amount of weird to this commercial movie."

Convincing Jared Hess, best known for eccentric, indie comedies including *Napoleon Dynamite* and *Nacho Libre*, to sign on as director was not as difficult as one may have guessed. Cale Boyter wanted a unique visionary at the helm, and with Hess he found the perfect director for the job. "My experience with *Minecraft*, initially, was just with my kids," says Hess. "They started to play around 2013,

when they were really going to town and having fun with it. I'd hear them laughing their brains out, playing the game in our basement with their friends. They'd prank each other, building some absurd fort and spawning a million wolves inside of it. Just chaos and the creative aspect of the game was so fun. Then we started playing it together as a family, and so many amazing memories came from playing *Minecraft* with my kids.

"As far as how I came to this project, I'd been working and developing a bunch of different things with Mary Parent and Cale Boyter at Legendary Pictures, and one day they called me and said, 'Hey, do you like *Minecraft*?' Then they asked if I'd be interested in pitching it to Warner Bros. It came out of nowhere, but it seemed like a fun challenge. It's such an incredible world. It's been an amazing journey.

"It's a miracle whenever any movie gets made. The stars have to align, the budget, the actors' schedules, script development—so many things, just the timing of it all, ends up being miraculous. This was one that I came on board in 2019—there have been different iterations, different concepts with different directors over the years. It's been a tough one to crack because there's no inherent story in the game," says Hess. "Every person that plays the game brings their own stories and their own ideas to how they experience the game. And Mojang has always been very dogmatic about not being intentional with aspects of the game like 'Who is Steve? What's his story?' Everybody has to come up with what they think the story is as they're playing it, and that's really cool. You can create your own adventure, and that's just a beautiful aspect of the game.

"Maintaining specificity and trying to keep things personal on some level is so critical. When you're approaching something that has already had its own life before, people have a very intimate and very personal relationship with the game, and everybody on the crew, including myself, we all wanted to bring our personal relationship with the game to the film. Bring those experiences to the table. There are so many different mobs and creatures, and everyone has their personal favorites, and their experience with them."

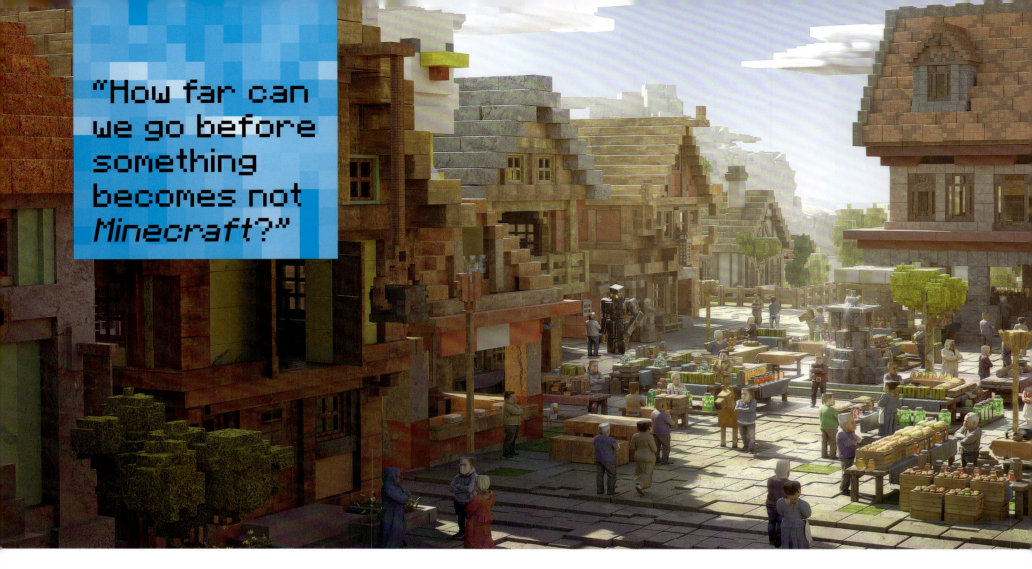

"How far can we go before something becomes not *Minecraft*?"

Production Line

ABOVE (Concept art) Midport Village is home to a thriving marketplace where anything under the sun — as long as it's cubic — can be obtained.

The "Fellowship of the Dingdongs," much like the fabled Fellowship from J.R.R. Tolkien's *The Lord of the Rings*, brings together a disparate group of people united by a love of storytelling and a never-ending quest for new cinematic challenges.

For some, such as Warner Bros. executive producer Cate Adams, the call came early. In her case, it was before anything else regarding the production, from the director to the script to even the basic premise of the film, was locked into place. "I have worked on this project a very long time, as long as it's been at Warner Bros. We had a couple of starts, different designers, different looks, different art," says Adams. "We were always going to be live-action, so the question was how to integrate the look of the game into a live-action environment in terms of what the world looks like and what the characters look like. It's an adaptation, but there are millions of people who play the game. How do we create something that, while you can't please everybody, will please most of them?"

To answer that question, the Fellowship looked to a galaxy far, far away. "Before I took this job, I was at Lucasfilm for thirteen years, working on *Star Wars*, as part of that team," says VP of Minecraft franchise development Kayleen Walters. "When I was recruited for this role, I knew of *Minecraft*, but I wasn't a *Minecraft* player. At the time I had a five-year-old who was just a little too young for this, so I started playing on my own, not very successfully, I'd say. Before my son turned six, though, he became a pro at it and he taught me how to play, and that's when I really learned it. It's something that's really

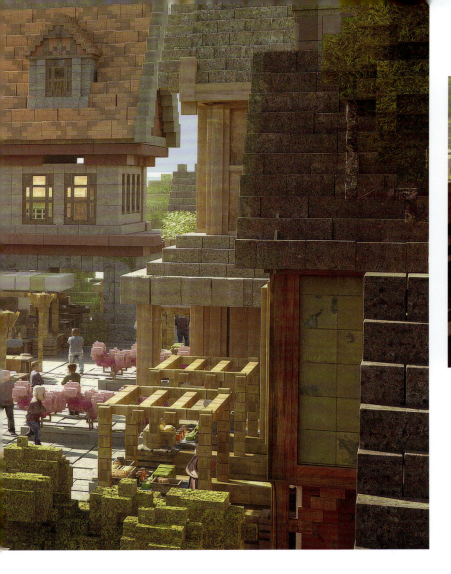
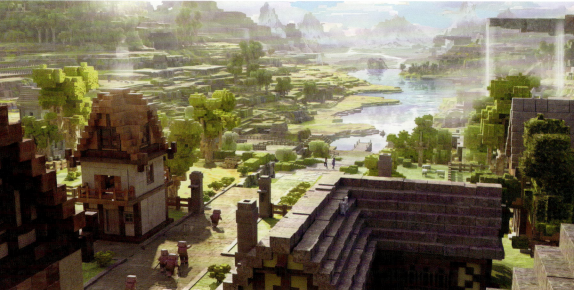

bonded us. We'd play in Survival mode, and he'd consistently take the iPad from me to show me what I was supposed to be doing, so that he could fix it for me.

"There were many, many hours playing that way, and gaining confidence. When I joined the team and played alongside the pros, that's when I really leveled up."

When it was time for Walters to move up to expert level, help was just an international flight away . . . no X-wing required. "Early on, I went to Stockholm and spent time with the team at Mojang and spent time discussing the origins of *Minecraft* and what was important to them and the brand, the brand perspective, what the values were and the importance of the community, and how to embrace the community as such as a part of the brand as well. How far we can take the brand in certain directions, and when does it break? How can we try things that are different? What are the parameters we can put in place to try something different? So we had a lot of really good discussions around both business and creative. How far can we go before something becomes not *Minecraft*?

"*Star Wars* was different, because they had years more time under their belt, and years more thought around the canon and the timeline and how everything fit in, since there's so much rich narrative around *Star Wars*, so many more assets," Walters continues. "I actually had a lot of experience from *Star Wars* that I was able to bring to Mojang: how you handle a brand, how you set up for that scale, how do you think about what's authentic to the brand so that you can branch out and do things like this movie or the Netflix series or the experiences that we're doing. Who is it for? What is the brand and what is authentically *Minecraft*? What a creeper is, what the mechanics are, what the lore is behind the creeper, even if we're not sharing any of that. How much of that do we need to know internally so that we can put that into our story? I think that I brought a lot of what *Star Wars* had done to help think about how we grow *Minecraft* without losing the essential identity of *Minecraft*."

Finding that identity was part of the fun, according to Cate Adams. "It's been a journey. It is fun watching everyone because everyone has a connection to it, whether they played it, or their children play it, or some children in their life play it, everyone wants to get it right," says Adams. "We don't want to let anyone down. Which is hard when you've got millions of people and they all play it in different ways, seven- and ten-year-olds playing it and thirty-year-olds playing it. It's fun."

ABOVE (Concept art) The sunny streets of Midport Village provide a safe haven to all . . . until nightfall.

1. LIMITLESS POSSIBILITIES 23

"The movie feels wholesome, in a way. It's never cynical, it doesn't really make fun of anyone, and there's a lot of heart."

Storytime

ABOVE Henry's sketchbook is his most valued possession.

OPPOSITE Transforming robots, engines, and hybrids populate Henry's daydreams, and his sketchbook is full of imaginative designs and complex mathematical calculations.

With the production team in place and Jared Hess at the helm, the *Minecraft* movie had literally found its direction. As the production and design teams came together, Hess turned his attention to the film's story, and he and Legendary Pictures assembled a dream team of writers to bring the fun, the challenges, and, above all, the humor to the *Minecraft* movie.

Chris Galletta, who had written an earlier draft of the screenplay, returned to the *Minecraft* writers room at the behest of Legendary Pictures, because he was already working with them on another project and they felt that he would bring the right sensibilities to the film.

"Jared Hess and Legendary Pictures had put together a roundtable of comedy writers, and I was one of them," says Galletta. "I had a really good time working with Jared and just clicked with him, and I did a draft of the movie with him, late 2021, probably, and then we had an awesome experience that was only a couple of weeks, but Jared and I really hit it off. Then after the strike ended and production really ramped up, and we were getting closer to the endzone, so to speak, they asked me to do one more punch-up, one more draft, as the movie was getting ready to shoot in January of 2024. The Hollywood writers' strike ended early October of 2023, so it was kind of a DEFCON 1 thing, actually. It was intense, but it was awesome."

Although the writing team was not starting completely from scratch, previous drafts of the script had been developed with other directors and production teams in mind, and storylines that would

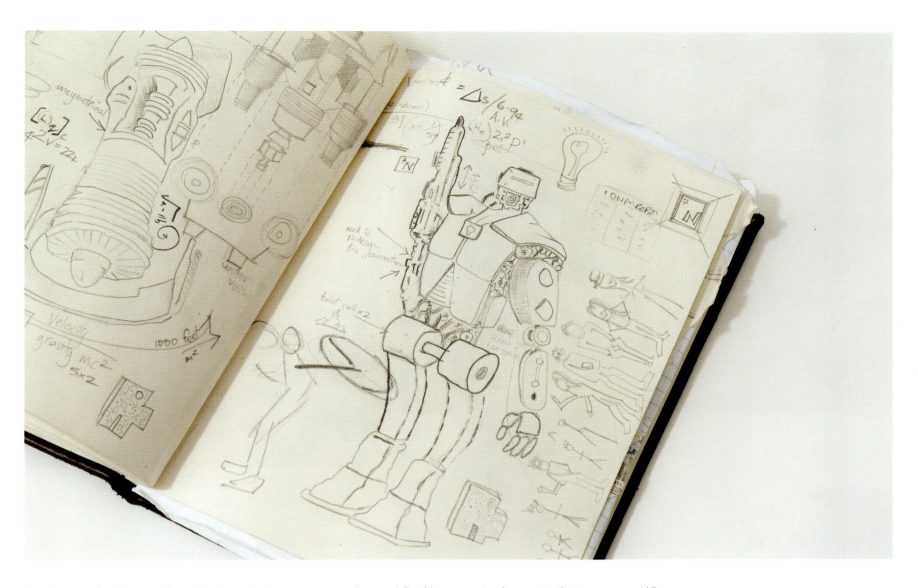

have been perfect for an action-adventure director or someone who specialized in dark comedy were not necessarily going to be a good fit for Jared Hess and his team. "When I came onto the project as a producer around 2020, that's when Jared Hess came on," says Torfi Frans Ólafsson. "And Jared completely transformed the project when he came on board. Obviously because of his vision and sense of humor, but also he's a very charismatic person. He's a warm family man who has retained that mischievous twelve-year-old part of him. So he can dance, he can make a fart joke or do a dumb joke that will land really well with that demographic, but he's also an adult, and he's got that sense of humor, too. That's one of the great things that he brought to the project.

"The movie feels wholesome, in a way. It's never cynical, it doesn't really make fun of anyone, and there's a lot of heart. Even [in] his work in animation in recent years, he's got a sense of pacing and jokes, and VFX, for plotting a story in a very visual sense. So that was very cool."

Bringing that heart to the *Minecraft* movie was essential to everyone who worked on the film, according to screenwriter Chris Galletta. "I played a lot of *Minecraft* with my younger cousins and godkids while working on the film, and everyone involved in the production either plays or they have friends and family who are really passionate about it," notes Galletta. "People who have built entire worlds in Creative mode, which I think our film really is . . . more inspired by Creative mode, that kind of freewheeling sense that anything is possible is one of the themes of the movie.

"That's what we really love about the game, and we had a lot of conversations with Torfi and Kayleen Walters and everyone at Warner Bros. about how the perfect experience with the game isn't supposed to keep you in there forever. It's supposed to fill your cup, then send you back into reality with a feeling of having been inspired

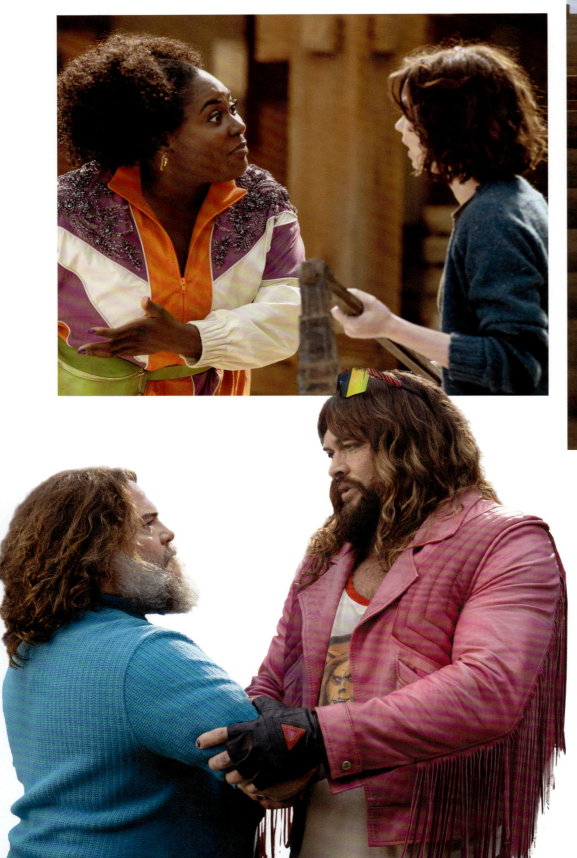

and wanting to bring that into your day-to-day. They're not trying to keep you locked in for the rest of your life. They see it as an enriching experience."

Bringing that experience to the screen was at the core of every story discussion between Legendary Pictures and Mojang, but opinions were strongly divided on just how to make that happen. "We went through a lot of scripts, a lot of different iterations over these four years. Everything evolved over that time," says Torfi Frans Ólafsson. "We knew almost from the beginning that we wanted this to be a live-action movie, a 'four-quadrant' film that would be accessible to a lot of different audiences. To be able to express emotion through a character-driven story. Human actors would bring the fidelity that we needed.

"And that humanity is one of the keys to *Minecraft*. It is simple to play, but incredibly deep and complex to master. It is multiplayer so that you aren't always playing with or against the system, you are playing with or against other people, which is a far more infinite source of content."

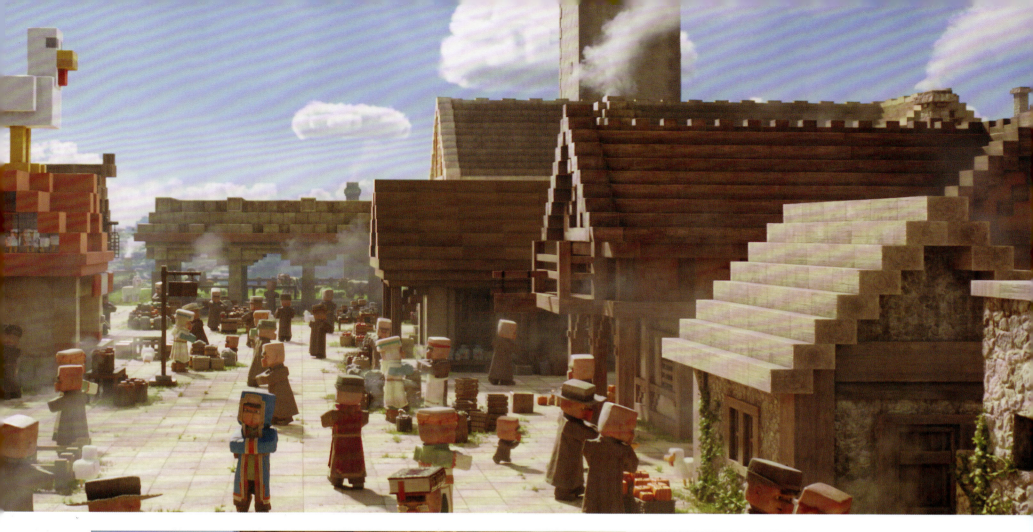

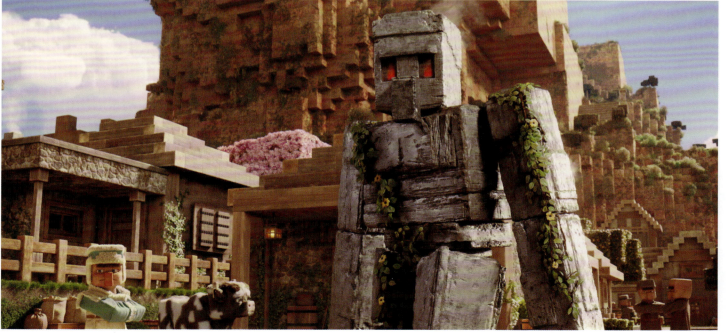

ABOVE AND LEFT Henry, Natalie, Garrett, and Dawn are convinced that Midport Village, with its blocky buildings and plant life, is the strangest place that they can possibly encounter in the Overworld.

1. LIMITLESS POSSIBILITIES

Character Studies

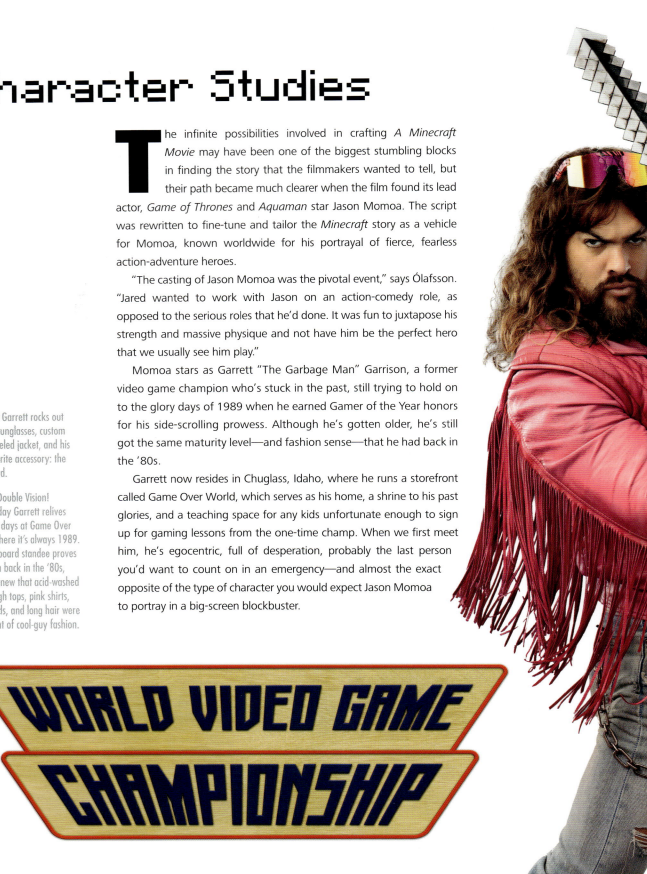

The infinite possibilities involved in crafting *A Minecraft Movie* may have been one of the biggest stumbling blocks in finding the story that the filmmakers wanted to tell, but their path became much clearer when the film found its lead actor, *Game of Thrones* and *Aquaman* star Jason Momoa. The script was rewritten to fine-tune and tailor the *Minecraft* story as a vehicle for Momoa, known worldwide for his portrayal of fierce, fearless action-adventure heroes.

"The casting of Jason Momoa was the pivotal event," says Ólafsson. "Jared wanted to work with Jason on an action-comedy role, as opposed to the serious roles that he'd done. It was fun to juxtapose his strength and massive physique and not have him be the perfect hero that we usually see him play."

Momoa stars as Garrett "The Garbage Man" Garrison, a former video game champion who's stuck in the past, still trying to hold on to the glory days of 1989 when he earned Gamer of the Year honors for his side-scrolling prowess. Although he's gotten older, he's still got the same maturity level—and fashion sense—that he had back in the '80s.

Garrett now resides in Chuglass, Idaho, where he runs a storefront called Game Over World, which serves as his home, a shrine to his past glories, and a teaching space for any kids unfortunate enough to sign up for gaming lessons from the one-time champ. When we first meet him, he's egocentric, full of desperation, probably the last person you'd want to count on in an emergency—and almost the exact opposite of the type of character you would expect Jason Momoa to portray in a big-screen blockbuster.

CENTER Garrett rocks out with his sunglasses, custom pink-tasseled jacket, and his new favorite accessory: the iron sword.

RIGHT Double Vision! Modern-day Garrett relives his glory days at Game Over World, where it's always 1989. The cardboard standee proves that even back in the '80s, Garrett knew that acid-washed jeans, high tops, pink shirts, wristbands, and long hair were the height of cool-guy fashion.

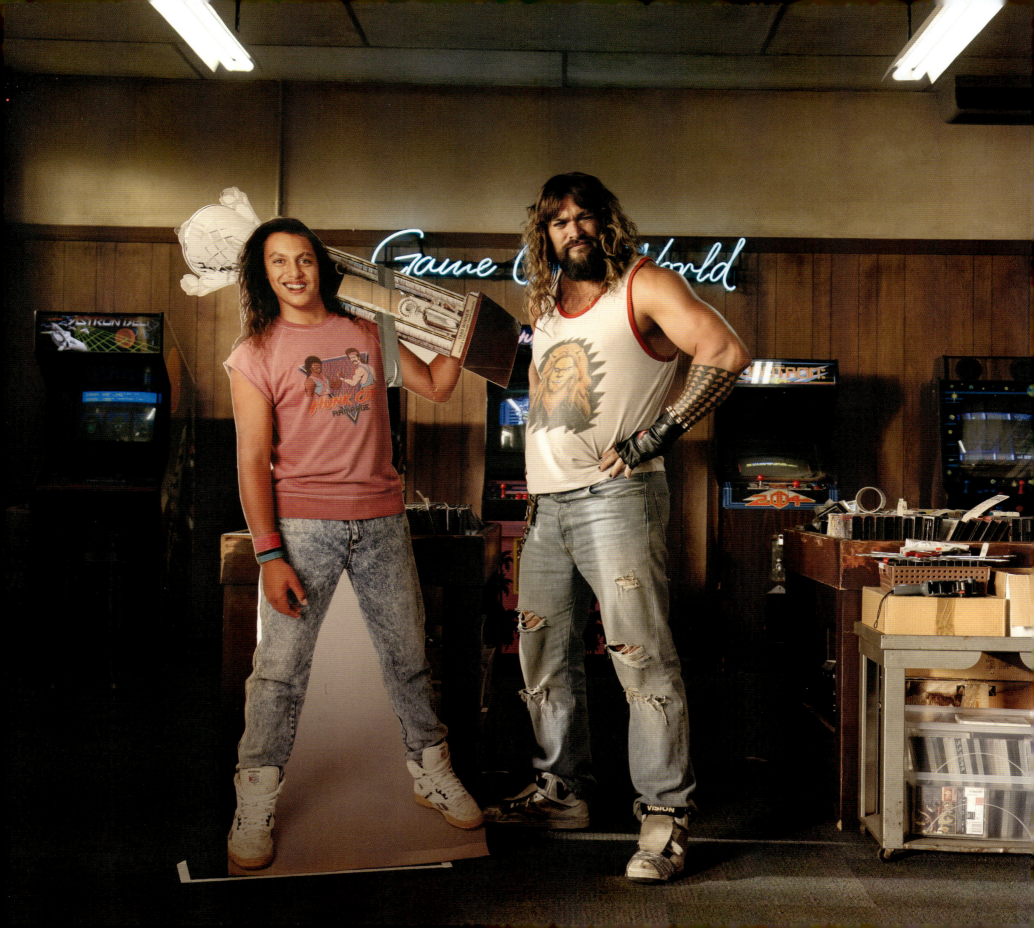

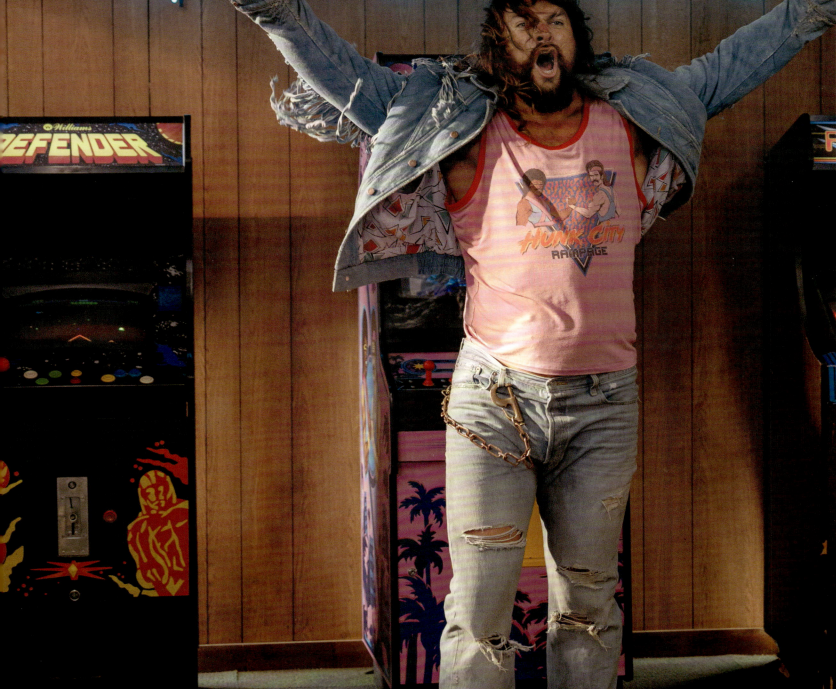

> "Momoa, sneakily, will get cast as a comic actor after this. He's kind of blown everybody away."

"Whenever you make a big-budget movie, you've got a discussion about who you're going to put into it that's going to get attention internationally," says Legendary Pictures producer Cale Boyter. "With Jason Momoa, I'd worked with him on *Dune* and gotten to know him, and I realized this guy's really f***ing funny. How do I find the right movie, the right story to bring him into *Minecraft*?

"I affectionately refer to him as the Buzz Lightyear of our movie. What you want to do when you're working with actors who aren't comedians, you've got to give them a premise for a character that allows them to be funny where they don't feel like they're just telling jokes. That's really essential. And that's the benefit of having someone like Hess who can craft something so stupid and lovely. When I say stupid, I mean that in the best possible way.

"And Momoa is fearless, but getting him to buy into what we wanted to do took a minute. Once we got him there, though, it's one of the discoveries of the movie. He's hilarious, without trying to be."

Screenwriter Chris Galletta was also impressed with Momoa's comic talents, and expects *A Minecraft Movie* to open new doors for the actor in the years ahead. "Momoa, sneakily, will get cast as a comic actor after this. He's kind of blown everybody away," Galletta says. "We were always cracking up with him on set. He gets the joke, and he was so good at playing the guy who doesn't get the joke. He gets it. He's super dry and funny in this movie. It's a revelation. Warner Bros. and everybody else said this is really interesting, that he's going against type, and I think everyone's going to respond to that. Taking a chance with his image, that's endearing, and makes you root for him, in a meta kind of way. It's not the usual Momoa 'shirtless gun show' kind of thing."

Decades after his triumph at the world championships, Garrett finds another opportunity to rise to the occasion and to become the hero that he's always considered himself to be. That path to a better

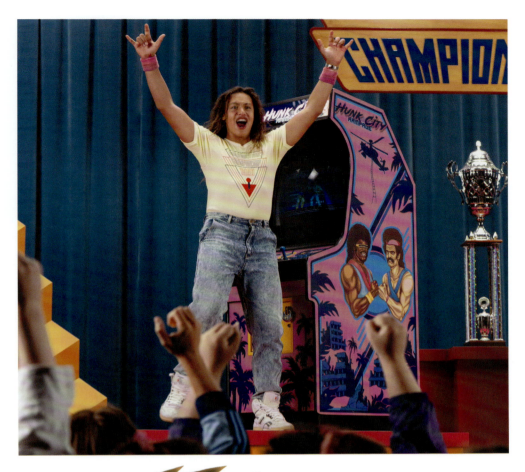

ABOVE Garrett wins the grand prize trophy at the 1989 World Video Game Championship.

LEFT Garrett's beastly avatar, seen on one of his favorite T-shirts, lets his competition know that he's always ready to roar.

OPPOSITE Garrett demonstrates his championship form for his adoring fans at Game Over World.

1. LIMITLESS POSSIBILITIES

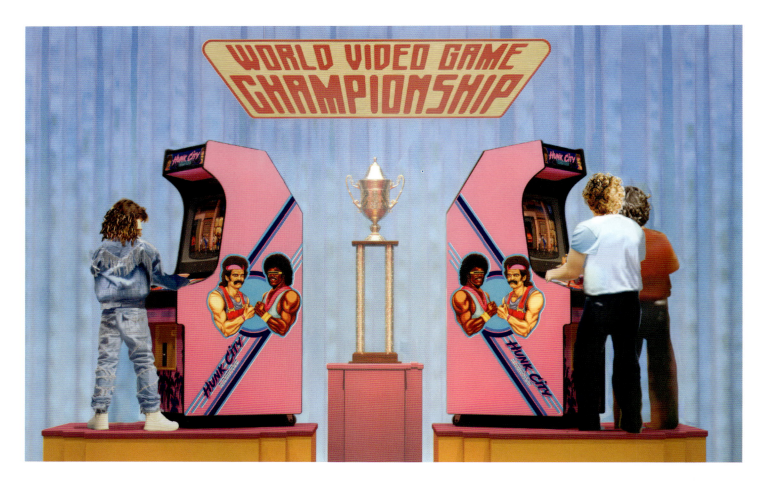

way reveals itself when he meets Henry (portrayed by Sebastian Hansen), a newcomer to Chuglass who's in need of a mentor, and, more than that, a friend. He's smart, funny, and incredibly creative, but he's a misfit who just can't seem to find his place in the world.

Looking out for Henry is his big sister, Natalie (portrayed by Emma Myers), who became his legal guardian when their mother passed away. Natalie's new job as the social media and advertising director of the town's largest potato chip factory has brought them to Chuglass, and she's taking these new responsibilities—and everything else—very seriously. She finds a kindred spirit in Dawn (portrayed by Danielle Brooks), their realtor, who's also struggling to find her sense of purpose.

"Henry's your classic kid who's struggling to find wonder in the day-to-day. Kind of lives in his head," says Galletta. "Their family's trying to heal, and Natalie's trying to protect Henry from himself, and his stranger, odder perspective. It comes from a good place. I always thought Natalie was pretty cool in high school, and she's like telling Henry, 'No, you don't want to be a weird kid'. And Henry almost believes that, in Act 1, that he'd be better off taking the path of least resistance. And that's reflected in him. Kind of giving up, like Garrett."

Henry meets Garrett when he stops at Game Over World the morning before his first day at his new school, and they don't exactly hit it off. "I think Garrett is very selfish and only thinks about himself when we first meet him," notes Sebastian Hansen. "He doesn't know how to be a real friend. There's a scene early on where he takes advantage of someone and tells him, 'I'll pay you back, whatever,' and really doesn't think about how that's going to affect anyone else. As for Henry, I think he becomes more aware of what friendship is, and how to have a friend. He doesn't really have anyone but his sister, and moving into a new town, he has to put the effort into reaching out and connecting to people.

"Henry is really curious, and that makes him a lot like me—that's how I got into *Minecraft*. In the movie, the curiosity is why Henry meets Garrett. I can very much relate to him. Over the course of filming, I became more like him, and I think he became more like me. The character took shape a lot once they cast me as Henry."

ABOVE The final round of competition at the 1989 World Video Game Championship was a no-holds-barred slugfest on the brawler Hunk City Rampage.

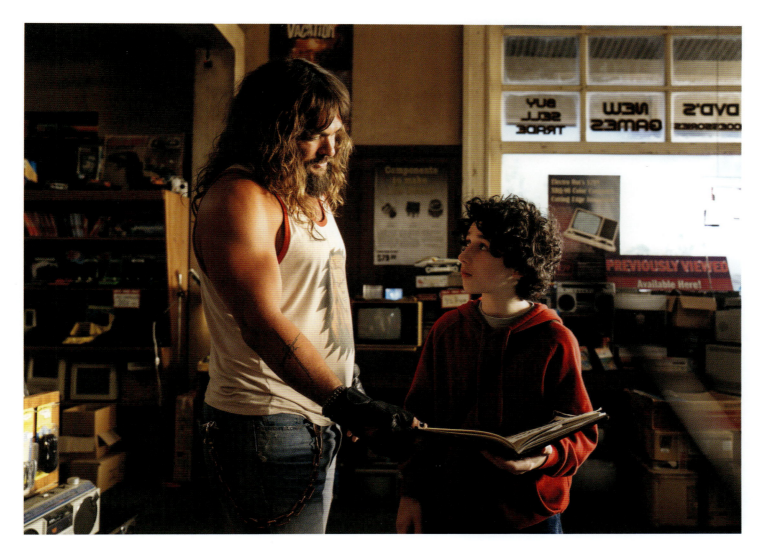

The day goes downhill from there, as Henry encounters his over-enthusiastic vice principal and an under-enthusiastic gym teacher who doubles as the school's art teacher due to recent budget cuts. While trying to impress his new classmates, Henry visits the school's science lab and crafts a jetpack, which he attaches to a model skeleton. The field test goes awry as the skeleton flies out of control and crash-lands in the midst of the potato chip factory, a disaster that's going to disrupt the entire nation's potato chip supply chain.

Inspiration strikes when Henry is sitting in the vice principal's office, and rather than break the bad news to his sister, he calls Garrett and offers him all the money in his pocket—twenty-six dollars of it—if he'll meet with vice principal Marlene and pretend to be Henry's uncle. On their way back to Henry's house, they stop off at Game Over World and discover that the contents of a storage unit that Garrett recently purchased include a pair of mysterious artifacts, including an Earth Crystal and the Orb of Dominance. When they combine the Orb and the Crystal, a strange force compels them to follow the Orb to an abandoned mineshaft, where they discover a glowing portal to another realm. They are soon joined by Natalie and Dawn, and without warning, the portal draws them in and sends them to the Overworld, an uncanny, blocky realm unlike anything they've ever seen before.

Pink sheep! Villagers! Skeletons! Henry, Natalie, Dawn, and Garrett are bombarded by the sights and sounds of the Overworld. They don't know anything about the world around them, a world ruled by the villainous Malgosha, and their arrival has awakened a horde of zombies! They're in need of help. A hero. A friend.

STEVE.

ABOVE Henry opens up himself — and his sketchbook — when he meets Garrett at Game Over World.

> "The principle at Mojang for fifteen years has been that Steve cannot talk..."

I...Am Steve

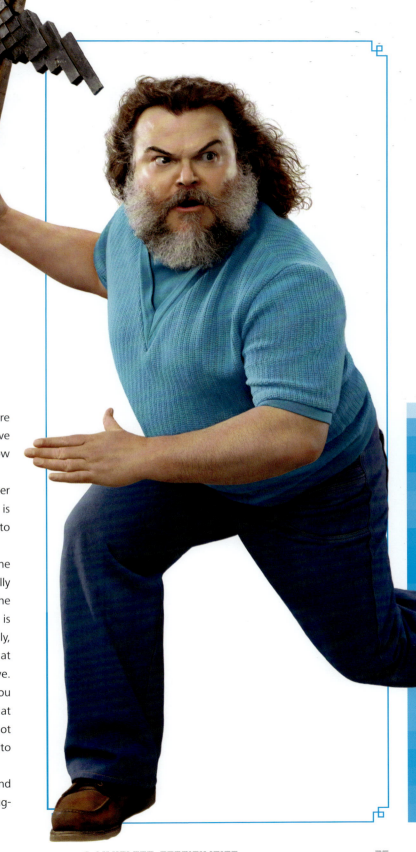

As every *Minecraft* player knows, though it's fun to figure things out on your own, you'll learn a lot faster if you've got an experienced gamer on your side who can show you the ropes.

Fortunately for our team, the first human they meet on the other side of the portal has spent several years learning everything there is to know about the Overworld, and the time has come for him to teach them the ways of *Minecraft*.

"We had decided a long time ago not to use Steve or Alex in the movie," says Ólafsson. "Unlike Lara Croft or Mario, they aren't really characters in the same sense. Lara Croft has a backstory, and she really wants something, and she has a cinematic backstory. Steve is the ultimate game character, who has zero personality, intentionally, like in our trailers and our promotional material. The way we at Mojang have always seen it, is that you project yourself onto Steve. He's a vessel for your intent. In a sandbox game, he wants what you want. To protect Steve and keep him that open, the principle at Mojang for fifteen years has been that Steve cannot talk, he cannot be in any story. In the books and comic books we've made prior to this, Steve is not a character.

"In selling Cale Boyter on this, and Jared Hess, I went back and called Jens Bergensten, our creative director in Stockholm, and suggested to him that we break this rule."

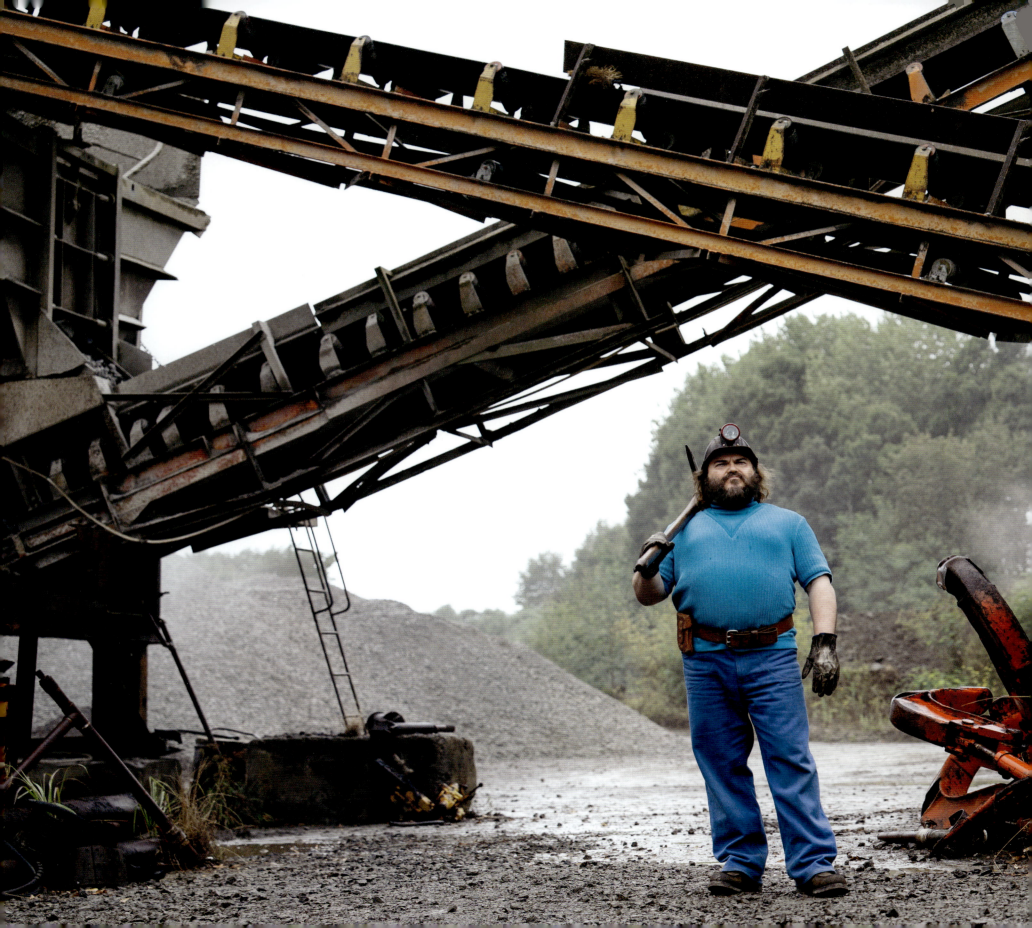

This was a big change for Mojang. They had not even considered the possibility that Steve would appear in the *Minecraft* movie, and they were taken aback when Ólafsson relayed this proposal to the Mojang brain trust. "The background is that Steve and Alex and the other default characters, they are supposed to represent players, so they are not supposed to [have] personalities or backstories," says Bergensten. "They represent whatever the player wants them to be. So throughout the entire history of trying to build a script for the movie, we'd always argued against adding Steve to the script.

"But the problem is that we always needed some kind of character that could explain the rules, in a sense. In one version of the script, the characters encounter someone called 'Wiki,' which is very on the nose, yes? That could explain things. In another version of the script, one of the piglins is a traitor who escapes and joins the heroes and can explain things. But once we made the decision to bring Steve in, it really made the story much simpler. Then we could just have Steve as a player in the world who could guide others through the experience."

Mojang's decision to allow Steve to appear in the film seemingly saved the day.

ABOVE Steve contemplates his next build project.

OPPOSITE As a child, Steve yearned for the mines . . . until he eventually fulfilled his dream.

1. LIMITLESS POSSIBILITIES 37

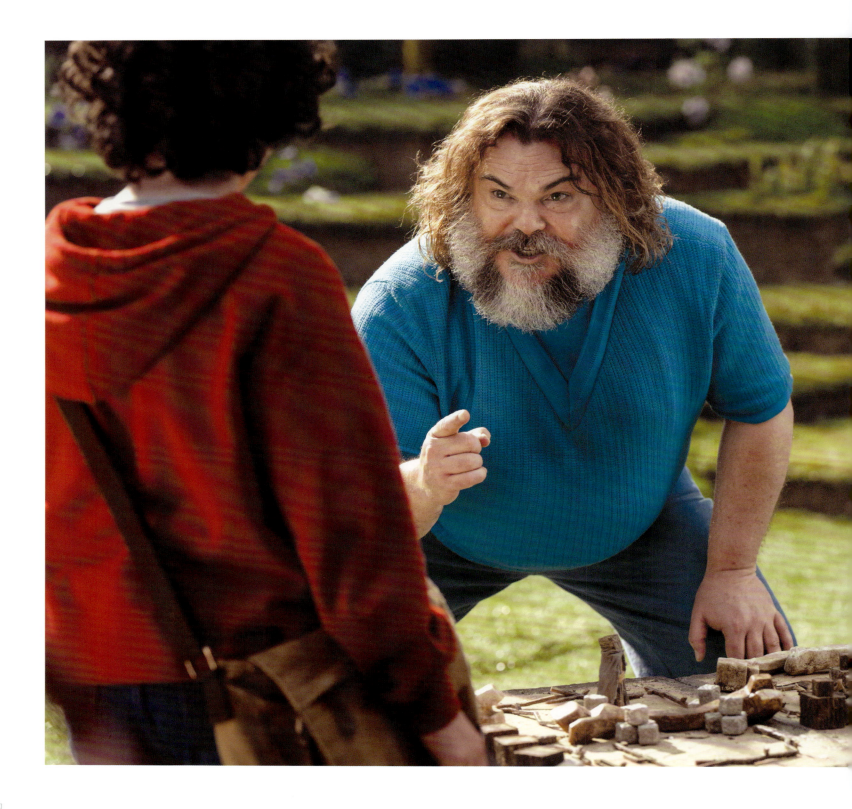

RIGHT Steve delivers a pep talk to Henry, who needs a confidence boost if he's going to navigate the Overworld.

Ólafsson continues, "Understandably, Mojang is very protective of its narrative, to not break the law or retcon anything or come up with midi-chlorians. After much discussion, Jens and I had to decide, what is the movie? Is it canon or is it not canon? Because up until that point, we felt the movie was as much canon as *Minecraft* is, as *Minecraft Legends* and *Dungeons* are, and other projects.

"But when we thought about it more, I thought, what if we approached this kind of like Batman? Because there is no definite Batman movie. We may feel that Chris Nolan's Batman or *The Batman* . . . some may feel that [Schumacher's] Batman is the platonic ideal of a Batman and everything else is a copy. Or Adam West. But ultimately these are interpretations of different artists seen through the lens of the zeitgeist of each era, and it's pretty liberating when you think about it like that. That's when it became *A Minecraft* Movie and not *THE Minecraft* Movie. It's not trying to be canon, so we can break some rules about how we craft things, who can talk and who can't. What we don't know yet is whether the audience is going to like it or if the fans are going to burn us at the stake."

And so it came to pass that Steve would be a vital part of the story, that he would serve as the team's guide through the world of *Minecraft*, and, after much deliberation, it was decided that he would have the ability to speak.

But who would be that voice? One option was to cast an actor who would quietly fade into the background, speaking only when necessary, and would, as in the game, serve as a nondescript stand-in for the audience.

But this is *Minecraft*, the biggest-selling video game in history, and this character would need to match the intensity and the screen presence of Jason Momoa. Ultimately, there was only one actor on the planet who could fill Steve's light-blue shirt.

And with Jared Hess as the film's director, it was inevitable that the director would convince the star of his 2006 hit comedy *Nacho Libre* to join the Fellowship. "Mojang didn't want to define who Steve was, or to canonize him in any way, like an actual movie depiction of Steve," says Hess. "They were concerned that people might think this is who he is, officially, that this is his origin story, but it became clear to them that this is just one story of many; everybody who plays the game has their own idea of who Steve is. Once everyone accepted the one-of-many concept, we could have fun with it. This is the Jack Black version of Steve. In different iterations of the movie, Steve didn't exist at all as a character. Then everybody came around to the idea that this is a good thing, having the original, iconic *Minecraft* character in there."

"It's not trying to be canon, so we can break some rules about how we craft things, who can talk and who can't."

1. LIMITLESS POSSIBILITIES

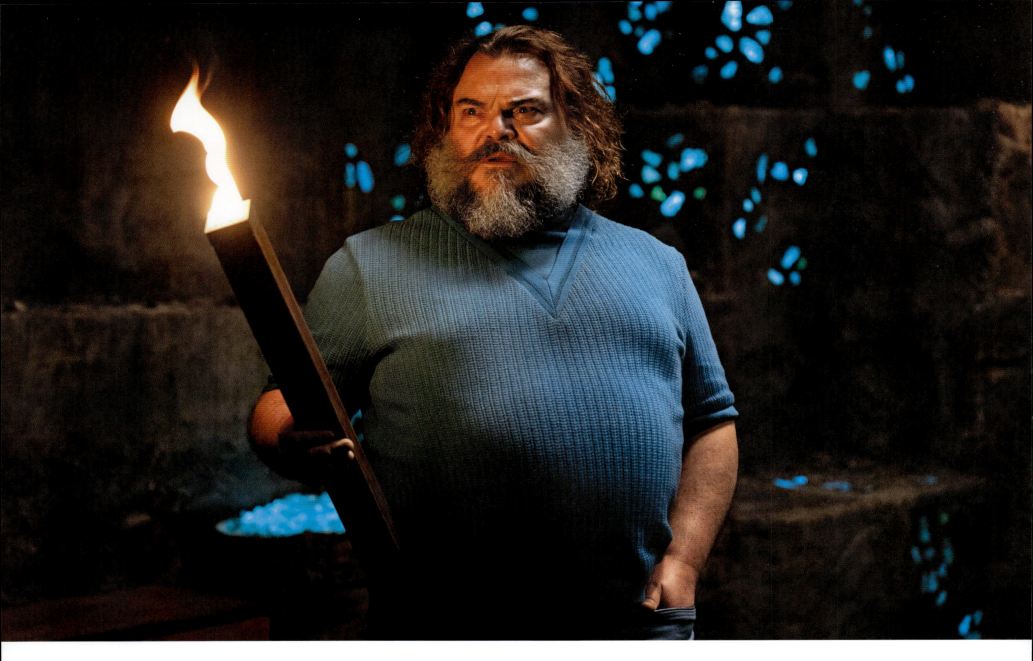

The Fellowship of the Nerds

With Jack Black cast as Steve, the *Minecraft* movie had its voice and its direction, and it was full speed ahead for the screenwriters. "The story came together once we established Steve as kind of the Gandalf, the guide who understands the Overworld and can shepherd everybody through it, is great at it, and who's had a lot of practice," says screenwriter Chris Galletta. "And he makes this grand, heroic gesture at the beginning of the movie to save our world. I don't think there's ever a point where you don't like Steve, don't relate to him. Especially early on, when he's at his job, making copies, and eating his lunch at his desk, and he just says, 'Nope, this is not what I want.' Then he walks into a mineshaft, literally. 'I'll see what that offers, that sounds better.'"

Legendary Pictures producer Cale Boyter compares Steve to another iconic movie character, in a classic film that few kids from the *Minecraft* generation are likely to have seen on YouTube. "Mojang originally had reservations about telling a story that featured Steve, and once we were able to crack through that, we were able to craft a character," says Boyter. "I think of him like Dennis Hopper in *Apocalypse Now*, Jack is

RIGHT Steve and Garrett work hard, and they play hard—with mushroom hats and blocky saxes.

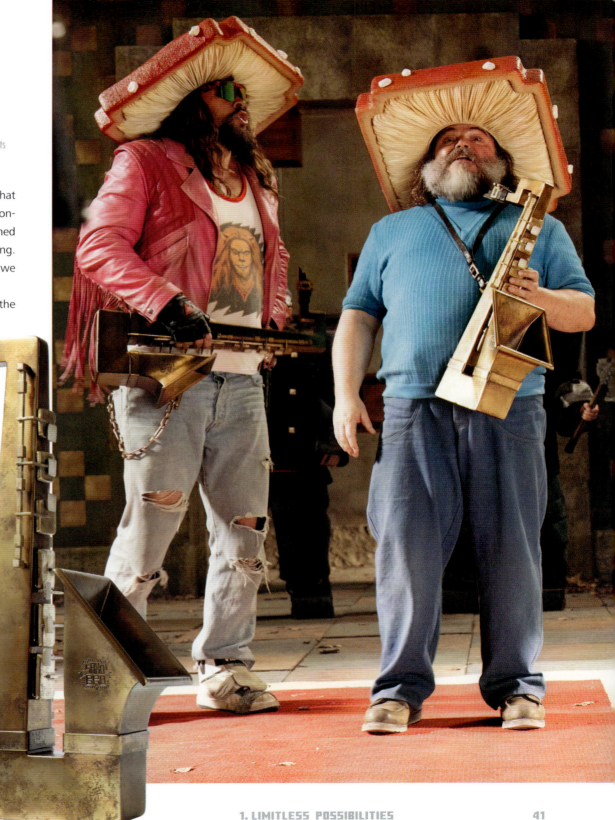

that to the Overworld," says Boyter. "Once we started to chase that idea, that role started to come alive. Jared had a preexisting relationship with Jack from *Nacho Libre*, and the same way that I warmed Momoa to this, Jared warmed Jack to the story that we were building. It's nothing unique, but once we got the green light on Steve, we were able to shape the role and dangle it in front of Jack."

Shaping that role was the responsibility of Chris Galletta and the writing team, but with Black on board, everything fell into place. "Jack Black is just such a warm presence, and he is the perfect actor to embody the fun and the joy of making stuff, of being creative. He turns it into a contact sport, a weird hybrid of parkour and ballet. Like when David Letterman used to cover his body in paint and have people throw him against a wall," says Galletta, whose script describes Steve as "nimble—part Jedi, part WWE, part Gene Kelly."

"And he brings the music element, too, so it's not just visual. To get to know the guy, he is exploding with creativity. He's just so good at so many things, that he has that natural vibe of 'I never don't want to be making something or doing something.' To cage that bird would be sad."

Cale Boyter agrees and knows that you don't bring Jack Black onto a production so that he could quietly stand in the background. "Jack is such an enormous triple threat—great actor, songwriter, and musician—how do we bake that into what we're doing?" Boyter asks. "And I think we were really able to do that."

And for the man himself, it was an easy sell. "Well, my involvement with the movie started when Jared Hess called me and said he had a part he wanted me to play—Steve. He sent me a script, he told me who was involved,

1. LIMITLESS POSSIBILITIES 41

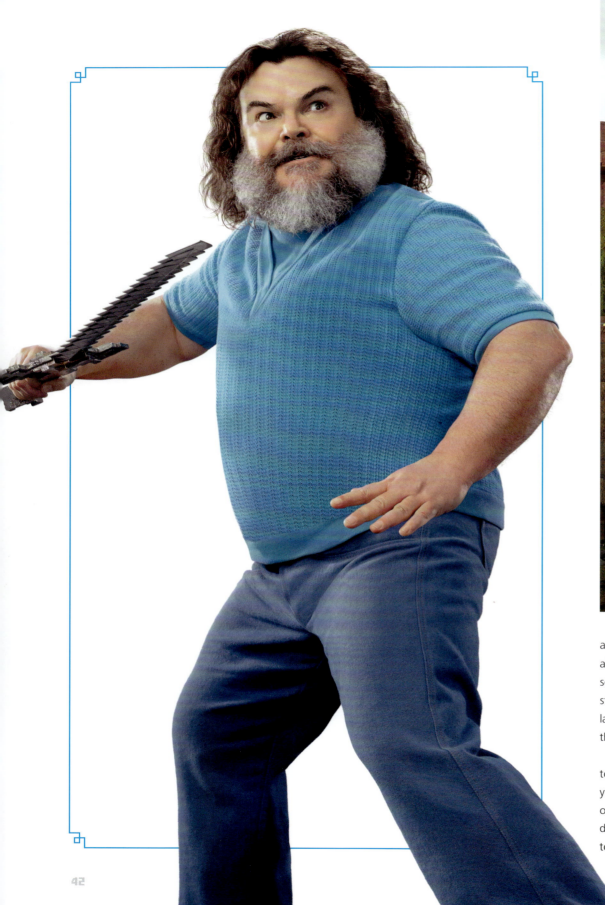

and I was excited to work with Jared again," says Jack Black. "And also, I had already been introduced to the *Minecraft* world through my sons. They were both playing *Minecraft* years before this movie got started. And I learned how to play *Minecraft* just so I could speak their language. And it was hard. It took me a while to learn the language of the *Minecraft*. How to build, how to mine, how to craft.

"And then once I got the hang of it, I really kind of got addicted to it. I really understood why so many kids were loving it. Because you kind of learn how to build houses and build structures. And go on crazy adventures. And scary monsters come at night! You build defenses. It's its own world, its own universe. And it's got a beauty to it. Even though everything's shaped like cubes, there's sort of a

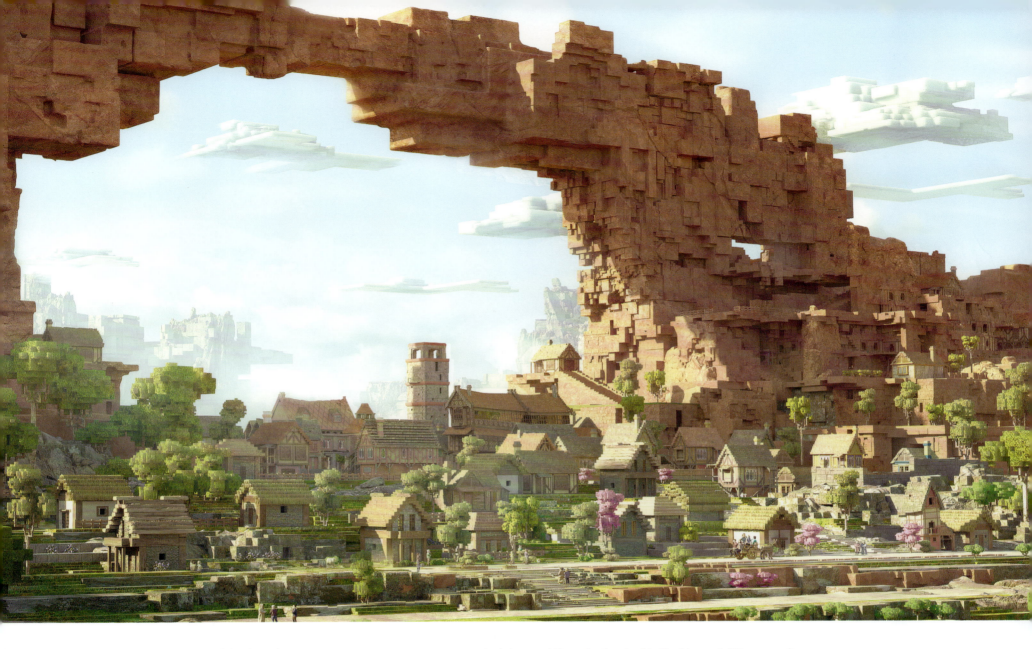

peacefulness and a beautiful color palette . . .

"So anyway, when I got offered the part in the *Minecraft* movie, I said, 'Hey guys, do you think I should do the *Minecraft* movie?' And they're like, 'Yes, of course! Do it! Are you kidding me? I can't believe they're making a movie!' I always check in with my boys to see if I should do something or not, and they never steer me wrong.

"Jared's involvement is a huge bonus, since we had such a great experience on *Nacho Libre,* and I loved working with him so much. I was always looking forward to getting another opportunity. And this came up, and yeah, it was like a well-worn glove. We already knew each other's senses of humor, so it was fun to jump back into that world, too."

And that world is perfectly suited to Black's sensibilities, according to Chris Galletta. "In the game, you've got portals that lead to different worlds, the Nether, the Overworld, that we would be strapped into that portal concept that you've seen in movies time and time again," says Galletta. "A lot of the weirdness that comes from Hess protects us from that feeling of being a rip-off, it makes it strange and unique. I think the tone and vibe is closer to *The Princess Bride*, with that little bit of absurdity. What Hess would say is that it's *Napoleon Dynamite* meets *Lord of the Rings: The Fellowship of the Nerds*. And it is that.

"But we have to make sure the audience is going to feel that. That it feels like they're on a completely different ride. We want to

ABOVE The natural terrain of the village is an essential component of the town's architectural layout.

1. LIMITLESS POSSIBILITIES

make sure that the people over twenty-five are going to see the trailers and think this is going to be funny as hell, and think it feels like a stoner comedy. Which is what the game plan feels like."

As every *Minecraft* player knows, Steve's personality is, by design, no personality at all. So how does an actor approach a character who is perceived differently by every single person who has ever played *Minecraft*? "Like you say, it's a blank slate, and Steve can be anyone you want him to be," Black observes. "So I just sort of made him me. More of an architectural/artist version of me. Someone who doesn't quite fit into the quote-unquote real world, so he escapes into the universe of *Minecraft* and he LOVES it. He loves mining and crafting. And it was fun to dive into that role."

Diehard *Minecraft* fans—and there are millions of them—were skeptical when they learned that Jack Black, one of the most dynamic personalities in the entertainment industry, would be portraying a character whose defining trait is his complete lack of personality, but it's his love of *Minecraft* and its fanbase that makes him a perfect, if unexpected, choice to fill Steve's blocky gray shoes. "A lot of comments that came out when we released the film's teaser complained that Jack is just Jack, that he doesn't look like Steve," notes Jens Bergensten. "But to me, he's great to have on this project, because he really takes his roles seriously and wants to understand the material that he's representing. He's a great ambassador for *Minecraft* and the movie."

Black's love of *Minecraft* came through in every scene, according to everyone involved in the production. Although some may have approached this as a kid's film or just another video game movie, that attitude is not in Jack Black's DNA. "We didn't rethink the arc of the character, but we did rethink the voice of the character, to reflect Jack once he was cast," observes Chris Galletta. "And he's incredible. He's a really great, disciplined actor who cared about every scene, even the scenes he wasn't in. We talked about the story a lot, and we definitely tried to hear his voice when we were rewriting stuff, when we knew that he would be Steve.

BELOW AND OPPOSITE (Concept art) *Minecraft* experts will find a treasure trove of Easter eggs in Steve's stash: golden shovels, potions, TNT, and various enchanted items that Steve has added to his stockpile.

OPPOSITE TOP Steve's real-world co-workers weren't prepared for the all-out rocking that accompanied his pitch for Steve's Resort.

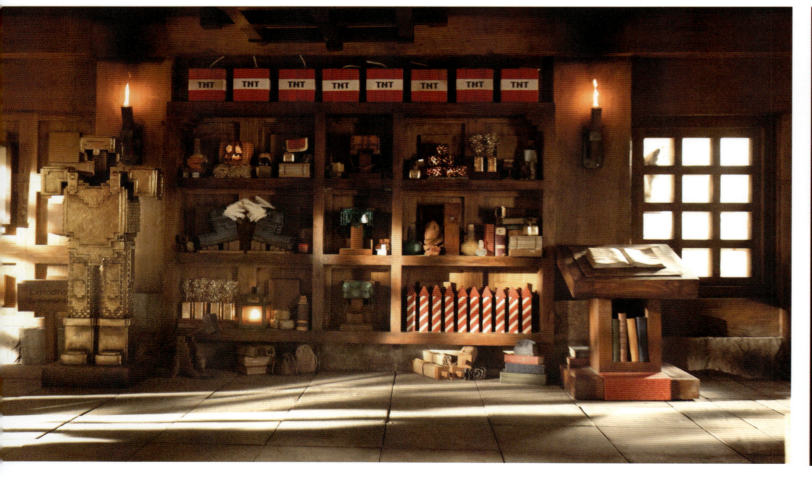

44 A MINECRAFT MOVIE: FROM BLOCK TO BIG SCREEN

"And he also was really smart about the emotional logic of the character, what he would do and what he would say. And if we would pitch him jokes in the moment, he would always be thinking from ten thousand feet, would this be the right thing for the character? He's got a great story mind and a great movie mind, and has made over a hundred movies, so he's got amazing storytelling instincts."

Those storytelling instincts helped Black get into Steve's mindset and to make the iconic character truly his own as he tried to find his place in the Overworld. "He's got the love of his wolf. Dennis. And he's sort of hiding in the world of *Minecraft*, hiding from his real-world responsibilities. And sort of hiding from adulthood. Losing the creative soul," says Black. "That's why he's hiding in *Minecraft*. He doesn't want to lose the innocence and the magic of creativity. And I think a lot of people can relate to that. In a way, it's a movie about growing up. Even though Steve is a fifty-year-old graying adventurer, he's kind of learning how to be a man."

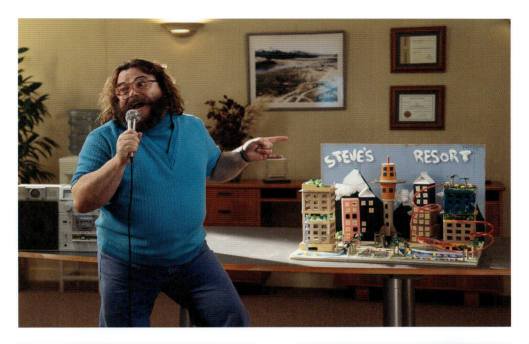

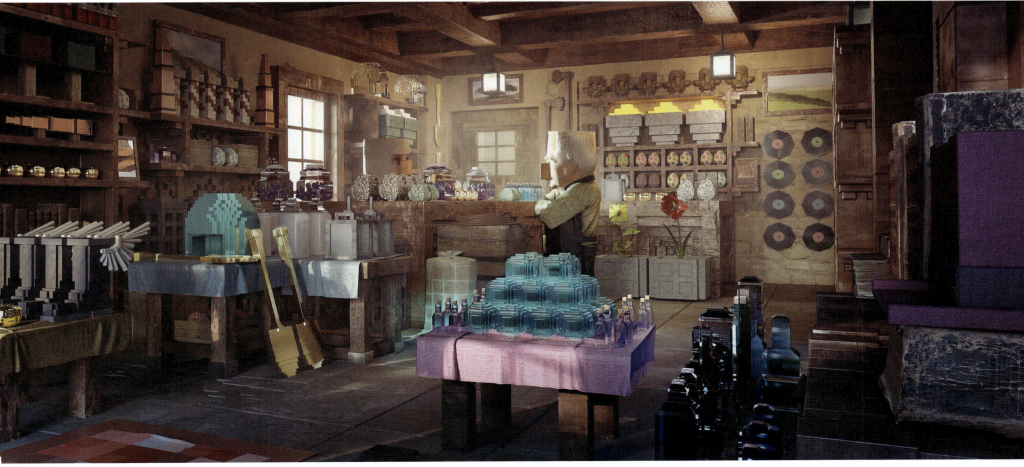

1. LIMITLESS POSSIBILITIES 45

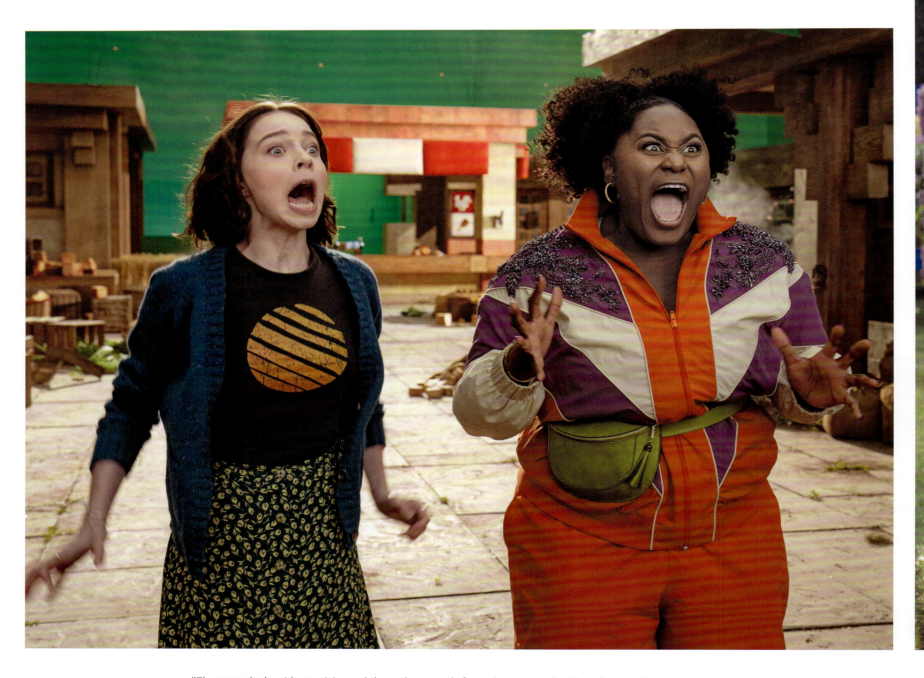

ABOVE Just another quiet day in the Overworld for Natalie and Dawn. Nothing to worry about!

"The story deals with creativity and those themes. It's funny how the game has the Survival mode, and also Creative mode. And in Creative mode, you have an infinite supply of materials to work with. You can make an entire castle out of lapis lazuli, my favorite of all the materials. I love that color blue. But in Survival mode, it's a lot harder to come across those materials. You're not going to have enough unless you really are good at the game and really are smart about where to go mining. You're not going to have enough lapis lazuli to build a whole castle.

"But there's something way more satisfying about building stuff with stuff that you've earned in Survival mode. So that's kind of a tradeoff. [In] Creative mode, you can build whatever you want because you have all the materials, but maybe you don't feel as proud of those structures as you are in Survival. It takes creativity to survive in this movie, and in this game, and this movie definitely takes place in the Survival version of the game. Because there's lots

46 A MINECRAFT MOVIE: FROM BLOCK TO BIG SCREEN

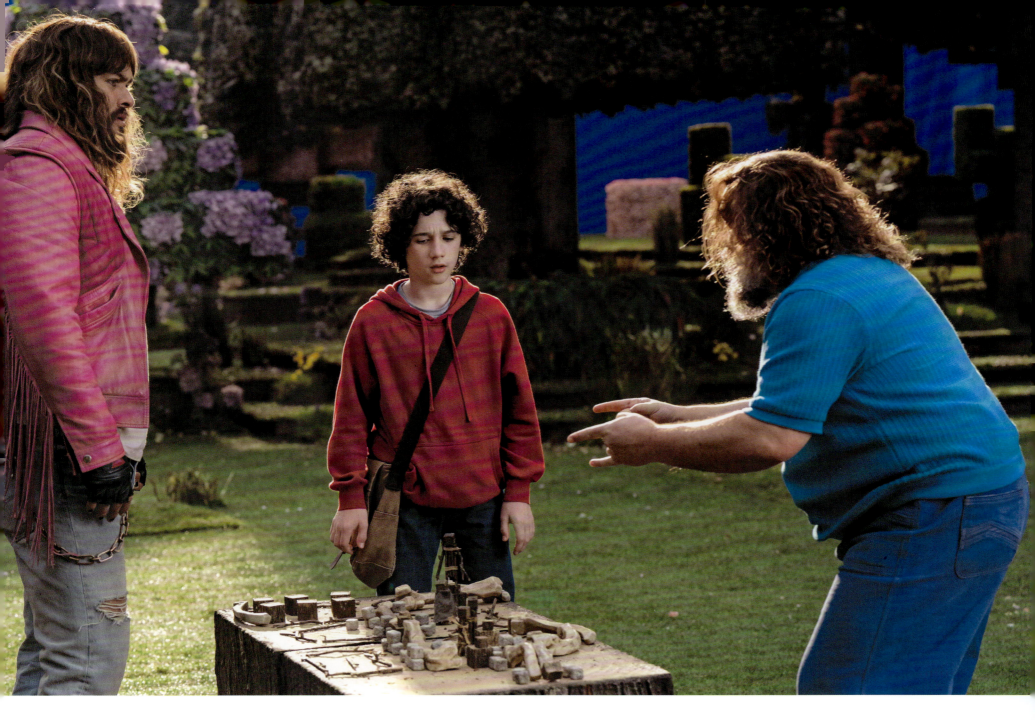

of dangerous situations, life-or-death scenarios."

Sharing those scenarios with his castmates was an incredible experience, according to Black, who shared the soundstage with both veteran actors and newcomers. "I was super stoked to work with Jason Momoa. Because I was a huge fan of his from *Game of Thrones*, and also the work he did on *Aquaman*. I thought he was really funny, and swashbuckling. And I really liked him in *Fast X*, the villain he played. I thought, 'This dude gets it.' He's funny, he's strong, he's action-adventure, he's a leading man. Great qualities. So I jumped at the chance.

"And Danielle Brooks is a force of nature. I've loved her ever since I saw her on TV on a little show called *Orange Is the New Black*. And she really popped off the screen. She's got star quality even when she's in a scene with a bunch of different people; your eyes just go to her. You want to see what she's going to say. She's got such an amazing face and she's also a great singer it turns out.

ABOVE Garrett and Henry aren't sure that they can trust Steve, but they may have no other choice.

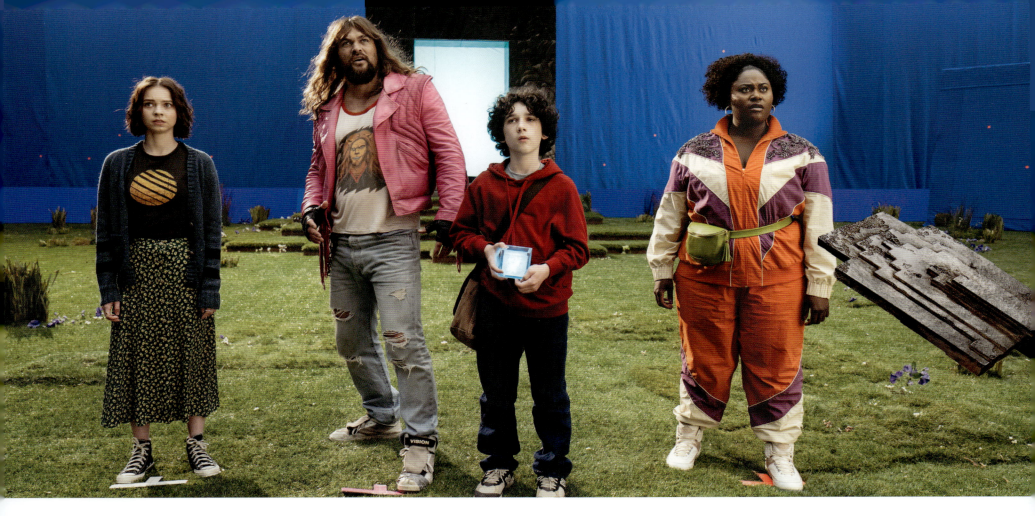

A New Dawn

Anyone familiar with Danielle Brooks and her stellar career, from her breakout role in the award-winning Netflix series *Orange Is the New Black* to her Academy Award®–nominated performance in the 2023 musical production of *The Color Purple*, isn't surprised by her talent and her versatility, but many were surprised that she followed up a run of heartfelt dramatic performances with a comedic role in *A Minecraft Movie*—but Brooks loves to keep people guessing. "It wasn't hard to convince me to join the cast, I can tell you that much. I'm always looking for different, I'm always looking for outside the box, and this felt right up my alley," she says. "I feel like I have the capacity to do anything, and this just felt like, yes, let's do this. I'm a big kid at heart, huge kid at heart. I love to use my imagination, and to play in the comedy world. This felt right for me, especially after coming off something so serious, like *The Color Purple*, and like *The Piano Lesson* on Broadway. This was a breath of fresh air.

"Starting out with *Orange Is the New Black*, I really like to live in both worlds. So getting to tap back into comedy was like PHEW! Just a relief."

Living in two different worlds and finding your place in them is one of the central themes of *A Minecraft Movie*, and that helped Brooks and the screenwriters when they developed her character, Dawn. "The starting point in acting is coming from a place of truth. So for me, tapping into Dawn, it really did start with being a kid. Stepping into a world that's unfamiliar but inspires curiosity. I just let my inner child lead the way. We're figuring out who Dawn is as we go along. A lot of times, people think that with movies, the writers and the director know all the ins and outs of each character, but sometimes you're on a discovery path, finding out who the character's going to be. And we kind of molded Dawn to be who she is while working on the project.

"She's definitely someone who's explorative," Brooks continues.

ABOVE Henry, Earth Crystal in hand, and his team stare in disbelief when faced with the strange new world before them.

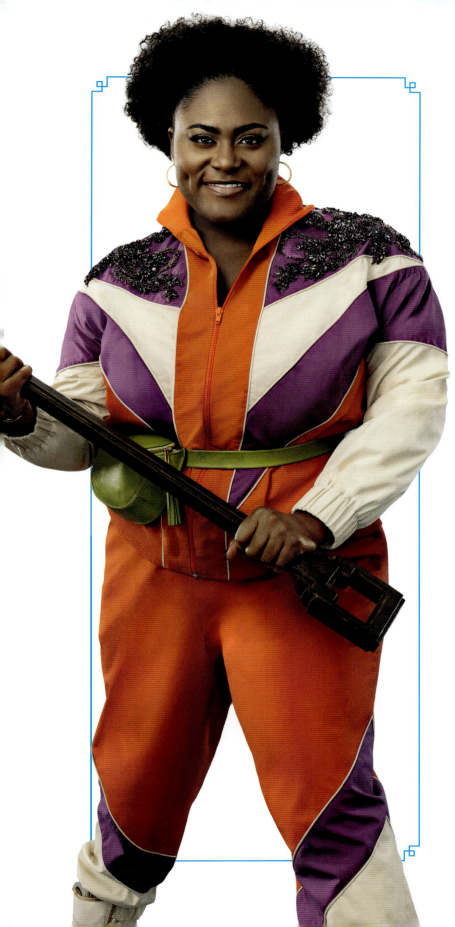

"She's got her hand in so many different jobs, trying to figure out her place in the world, and trying to figure out who she is, honestly. I kind of went on a similar path as her, as an actor, learning who she is. And ultimately, we came to the conclusion that she is a jack of all trades, and she is an explorer, but she's also a nurturer, ready to take on that big sister role, to guide Emma's character and Sebastian's character into this world."

When it came to finding guidance for herself, however, Brooks was grateful for the support and generosity of her director and co-stars. "Working with Jared was the best," she says. "He's one of the kindest, sweetest directors I've ever worked with. He was definitely hitting me with, 'Try this! Try that!' Changing up lines in the midst of shooting. Which I love. I am not afraid of improv, of a director handing me a line in the middle of the scene. That actually excites me, keeping it fresh and fun. I think he's also on the quest of figuring out just how to make the movie the best it can possibly be. He comes from a place of knowing what he wanted but also making room for the best idea to kind of take over.

"I think working with actors like myself, or Jack Black, and Jason Momoa, too, you should leave room for that. We all have this innate sense of play and fearlessness that we all carry. So I think you need a director that will allow that inner child to run wild while the camera is on. I think that's where you're going to find the best stuff."

BELOW Dawn's "Zoo On Wheels" brings the zoo to you! Hope you llike llamas!

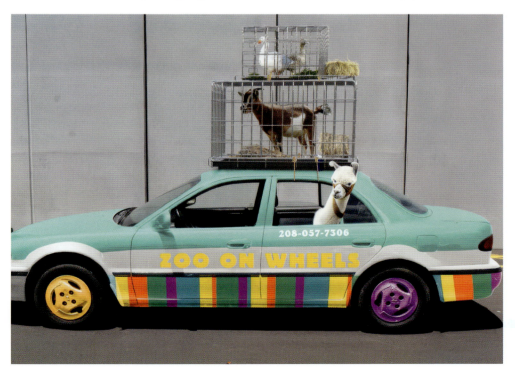

1. LIMITLESS POSSIBILITIES 49

My Brother's Keeper

Whereas Jack Black and Jason Momoa play characters who never really grew up, their young co-stars Sebastian Hansen and Emma Myers portray siblings Henry and Natalie, who both had to grow up very quickly after the loss of their mother.

Black was very impressed by his young co-stars, and has high praise for their acting prowess. "The kids are great. First time for our young star, Sebastian Hansen, who takes us into this universe. And he handled it fantastically."

Although this was by far Hansen's biggest acting role in his young career, he came to the set armed with a firsthand knowledge of *Minecraft* that none of the other performers had, which proved to be a valuable asset when he and other members of the cast or crew played the game together on a custom server set up by Mojang's Torfi Frans Ólafsson. "I played *Minecraft* my whole childhood and could tell you everything about it," says Hansen. "I played with my friends for hours at a time after school.

"When we heard there was a *Minecraft* movie happening, my agent/manager said, 'Sure, we'll audition for that!' They put my name out there, and we got a callback, then auditioned and got a director callback. Jared was very nice, and the audition went so well that I had this feeling that I kind of got it. A few weeks later, they called us up and said, 'Hey, you got it.' Definitely a big thing, with *Minecraft*.

"My knowledge of the game really helped with my performance, since I knew this world so well and how it all worked. I had a much better understanding of *Minecraft* than my castmates did," Hansen continues. "When I played on the server on my Xbox, it was fun to hang out with everyone. Jack was really into it. But he took the creativity route. I took more of the grinding and getting the best stuff route. Jack built a giant house made up of a bunch of different things, that were all just different blocks, far, far away, whether they made sense together or not. He's like a ten-year-old in a grown man's body; that's definitely what he is sometimes."

Hansen helped the cast and crew navigate the Overworld, and they, in turn, made sure that he had all the guidance that he needed on the *Minecraft* set. "Jared Hess is such an amazing man. Working with him so long built such a bond between us," says Hansen. "He

> "My knowledge of the game really helped with my performance, since I knew this world so well and how it all worked."

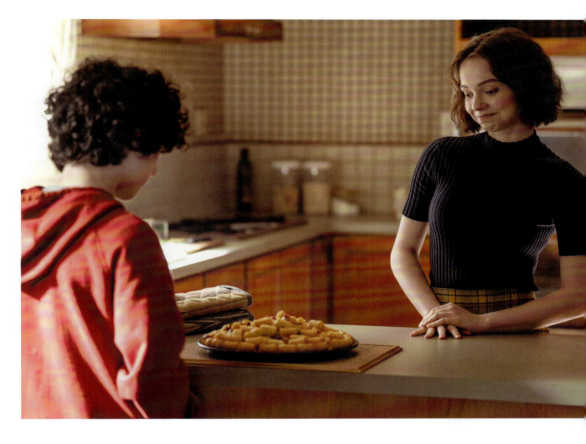

ABOVE Natalie reassures Henry that their mom's famous breakfast tater tot pizza will help him win friends and influence people on his first day of school.

understood me and how I worked as an actor, and he was really helpful as far as my performance.

"As for acting itself, I think the best advice I got from Jack and Jason was just them being there, doing their jobs and teaching by example. That was what I needed, to see how a good actor acts. The way they did things, how professional they were to everyone around them. They're very different people, so watching each of them gave me a lot of insight that was really helpful to me as a young actor, seeing how an experienced actor is on the set."

Jack Black was just as impressed with Emma Myers, "Emma is absolutely fantastic in that show *Wednesday*." Black continues, "Emma. She's great. And *Flight of the Conchords* is in there, and that makes sense, since we shot it all in New Zealand. Anything those guys touch is gold as far as I'm concerned."

Despite his own considerable fame and talent, everyone on the cast and crew felt right at home working alongside Jack Black, even if they'd grown up watching him on the silver screen. "I was so nervous going into it, because obviously there's an amazing cast of big, just incredible actors," says Emma Myers. "But they were all so amazing and I had the best time. Jack is a childhood hero of mine, and just getting to work with him was amazing. To see the way he conducts himself on the set and behaves, it was good for a young actor to see that."

Although Black shared several fun moments onscreen with Emma Myers, most of her scenes paired her with Danielle Brooks, who loved getting to know and working alongside the young actor. "Emma's so talented, so professional. And we really bonded. I was so happy that she bonded with me," says Brooks. "She plays a teenager, but she's a grown woman, if we can consider twenty-one, twenty-two grown. But I was nervous, with me being a bit older than her, but we hung out, we watched movies together, went on hikes together, so we really built that relationship genuinely and authentically outside of our characters, which really helped when it came to working together on this film and building this sisterhood.

"We had so much fun, and we had some really kick-ass scenes where we were fighting zombies and pigs, so we got to do some stunt work together, which we were excited about. And we have dreams of winning MTV's Best Duo Fight Scene at the movie awards, which would be really cool. I had fun bonding with her."

Performing her own fight scenes was a big draw for Emma Myers, a longtime *Minecraft* fan who'd grown up playing the game's Pocket edition with her friends on their smartphones. "I love stunt training, and I love stunts," says Myers. "I wanted to do all of the stunts myself if I could. I used to be a dancer, so I really love physical work and choreography. So that was all just fun for me. Stunt training was like having a free gym day. It was great, especially when Danielle and I got to work together.

1. LIMITLESS POSSIBILITIES 51

OPPOSITE (Concept art) The iron shovel is one of the most useful implements in every *Minecraft* player's toolbox.

BELOW The iron hoe is useful for gardening and for fighting mobs, as Natalie soon discovers.

"There was a fight scene with me and Sebastian that was so much fun. It was my first time doing weapon work. I never actually got to use a sword before. And I worked with a garden hoe and a shovel . . . I'd never used anything like that for a fight sequence. It had always been just my hands, or my stunts would be falling over, or running away. I really enjoyed myself on this one because I got to use a sword."

Downtime between filming *A Minecraft Movie*'s action sequences allowed for plenty of bonding with her castmates even when they weren't wielding swords and pickaxes, fortunately. "I had such a good time with Danielle. We were definitely the dynamic duo on that set. I loved working with her. She's such a great friend and is just hilarious, and I felt like I could talk with her about anything. And Jason as well, he's such a funny guy. They made it feel like fun instead of work, we were there to work on this really fun film and just have a blast."

That directive to "just have fun with it" came from the very top. Jared Hess's philosophy is that a fun environment for the cast and crew will translate into a fun experience for the audience, according to Emma Myers. "I love *Napoleon Dynamite*," Myers says. "My sister showed it to me when I was young and I just thought, this is such a crazy film. Then, when I was approached about *Minecraft* and they told me Jared Hess was directing it, I knew that it was going to be great, and it was going to be hilarious. I just had to be part of it.

"He's such a funny guy, and it never feels like work with him. It always feels fun. He even told me when we were going in for prep before we started shooting, 'I want this to be fun, I don't want this to feel like work. I don't want to feel like I'm directing you or bossing you around. I want this to be a good time where we just try things out and feel silly.' And he definitely made it feel like that. He's got such vision and such great instincts for comedy. He'd often yell out lines on set for us to just try out. Such a great guy and such a visionary.

"He told us that if we ever had ideas that we thought would be funny or good for the script, just try it out. Because Jack's always improvising, Jason and Danielle, too. Just throw it on in, we'll try it out. It's a collaboration. He encouraged that a lot."

That collaboration between director and actor helped Myers and Brooks to find their characters and ensure that Natalie and Dawn would hold their own against the action and spectacle that surrounded them onscreen. "Natalie is a girl who's all of a sudden acquired this immense responsibility," says Myers. "Her mom's just passed, so now she's the guardian of her younger brother, and she has to step up and take that role along with moving across the country and getting a new job. And it's a big corporate job, a really big deal for someone that's her age. So she comes across as very uptight, very strict to her brother Henry, but she's really dealing with a lot. Making sure that he's on the right path for his life. Trying to be a parental figure as well as a sister figure is really hard for her. When they go into *Minecraft*, she has a hard time loosening up and letting go and just letting her brother enjoy things and be in his own space. She's worried about how things will turn out for him. But the more they explore *Minecraft* and meet these other interesting characters, she realizes that she can let him have his fun and she can also have her own fun within *Minecraft* while also being a parent. She's got quite an interesting journey in her.

"Natalie learns her own strength going into *Minecraft*. She's never had these experiences before. And she's got her younger brother there as well, which puts more pressure on her than on any of the other characters because she's not just looking out for herself, but also for her little brother. Within that she struggles a lot, but she really finds herself within this world. Like me, I've never gotten to fight with tools and weapons before, but she finds herself thrown into it and she rises to the occasion and ends up saving the day. Taking down the big pig alongside everyone and finding her creativity. I think it's a great character arc. It teaches the lesson that everyone has something special inside of them, even if they don't believe in themselves."

The film's themes of fun and family were present throughout the entire production, which made the filming of *A Minecraft Movie* an unforgettable experience for every actor from Sebastian Hansen, starring in his first major motion picture, to Jason Momoa, who sometimes films multiple blockbusters in a single year. Despite their

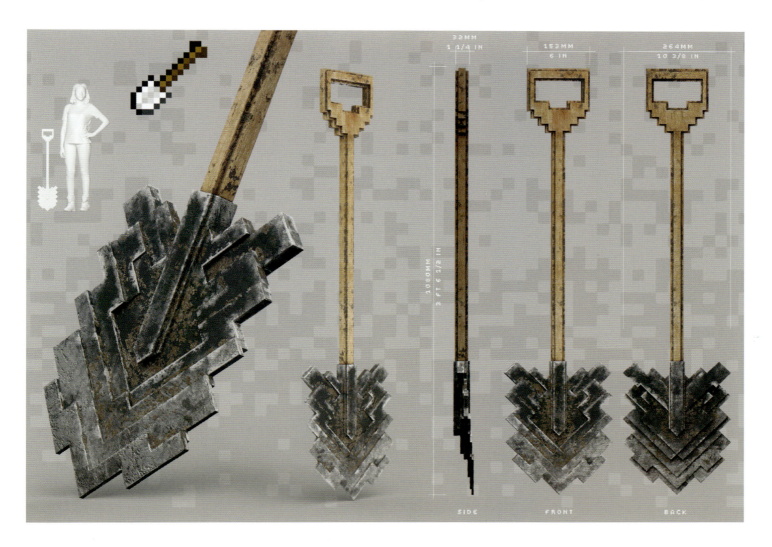

different backgrounds and experiences, everyone lifted each other up and brought out the best performances in their fellow castmates. "You definitely have to know who you are, coming into this project and working alongside those two gentlemen, Jack and Jason," says Brooks. "You have to be very secure in who you are. We all had to do that, even Sebastian and Emma. I'm appreciative of having those two leading the charge with such kindness. And open arms. There were no divas, no divos on this set, just a bunch of clowns. Us having a good time in New Zealand telling a fun story, living in this crazy *Minecraft* world together for a few months. It was a highlight for me, it really was. Some may not picture me in a role like this, but to me, it makes sense. And it's the beginning of me getting to show the world how much versatility I have in my work. I'm excited for people to meet Dawn, and to get to know the clown in me."

1. LIMITLESS POSSIBILITIES 53

Castles Made of Lapis Lazuli

Jack Black's experience in playing *Minecraft* with his sons helped him form an immediate bond with the cast and crew, and thanks to Torfi Frans Ólafsson and Mojang, he was able to dive right back into the Overworld to sharpen his skills and fully immerse himself in the world of *Minecraft*.

"We have a generation of people now in the job market, late teens or early twenties, who grew up playing thousands of hours in *Minecraft* as kids. We even noticed this on set. I set up servers for the cast and crew, and gave all the actors Xboxes, and put them in their trailers, and then we were just all playing," says Ólafsson.

"Jack Black, he just spent all his spare time in the mines, always playing. I should have checked how many hours he clocked, but it was quite a lot [it was over 100]. People of all ages, set designers, prop designers, actors . . . all ages, all playing together. Especially when Jens came back on set, there were a lot of these guys who were absolutely starstruck that Jens was there, because he was their childhood idol, and they'd grown up watching him on YouTube videos. And they hadn't played *Minecraft* in ten years or something, and they started playing again because they were working on the movie and they fell in love with it again. And that's part of the audience. It's not just today's ten-year-olds with the latest iPads, it's those kids from the 2010s who played on their parents' PC."

Or, in some cases, it's a world-famous fifty-something actor who never lost that ten-year-old's sense of wonder. "Jens [Bergensten], our guy who runs the show at Mojang, the studio that brings us *Minecraft* the video game, he was on set at the beginning, and it was great to meet him," says Black. "He and Torfi set up a server so that everyone on the cast and crew could play *Minecraft* in our own little universe, a controlled world. So I was playing that a lot, to stay in character. I felt it was part of my preparation to play the game.

"So, anyway, I noticed while I was playing in this huge, massive world that they created for us, I built up, I was surviving, I was scraping by, and I didn't really have all of the techniques down, like I'd forgotten how to make maps, and to find my way in this land, and I came across another player called, I think Jade Alexis was her name, and she gave me a map and taught me the ropes in the virtual world," Black continues. "And she said, 'Follow me,' so I followed her to a land that was called Proplandia. And it was all the prop masters from the movie, they created a little area that was their safe place.

"And they had it gated off, and they were building all these amazing structures. Someone built a Mario from *Super Mario Bros.*, but he was a hundred cubes tall. And perfectly designed. And I was like, how do you even do that? They're way beyond me in terms of their skill. And somebody else built a *Galaxian* spaceship, and a pirate ship. And I'm like, I want to build something to impress these guys, who are so good at the game, just to prove to them that Jack Black is not just an actor who's playing this video game world, that I actually am a gamer, and I can compete in this world. I wanted to show that I got some skills.

"So I came up with this idea, that I'm going to build a stairway that goes up into the sky and goes all the way to the highest mountain in that neighborhood. And I'm going to build a railway that goes from my mountain to a stairway that goes all the way down, so you can just walk to my mountain. And I built a castle on top of that mountain! This took many hours to build a gorgeous castle with a floor of lapis lazuli—not a whole castle of lapis, *that's impossible*. So I had some beds in there, I had a telescope up at the top, I had this cool thing where you could jump off a diving board and land on a bouncy [slime block]. But the best part about my castle was in the basement, I made a gallery, an art gallery, where I could put up paintings. And I put up three different paintings. If you have a smaller room and you put up a painting, it's a different painting? I don't know how many paintings there are in the world of *Minecraft*, but depending on the size and shape of the room, is the kind of painting that will pop up. In the middle of my gallery, I had this giant painting that looked like a woman pig, a piglin, and I named my painting, *Li'l Gosh*. Now that's kind of a spoiler, only if you've seen the movie do you know what that means.

BELOW The unique building elements of *Minecraft* combine to make villages and structures unlike anything seen in the real world—or anywhere else.

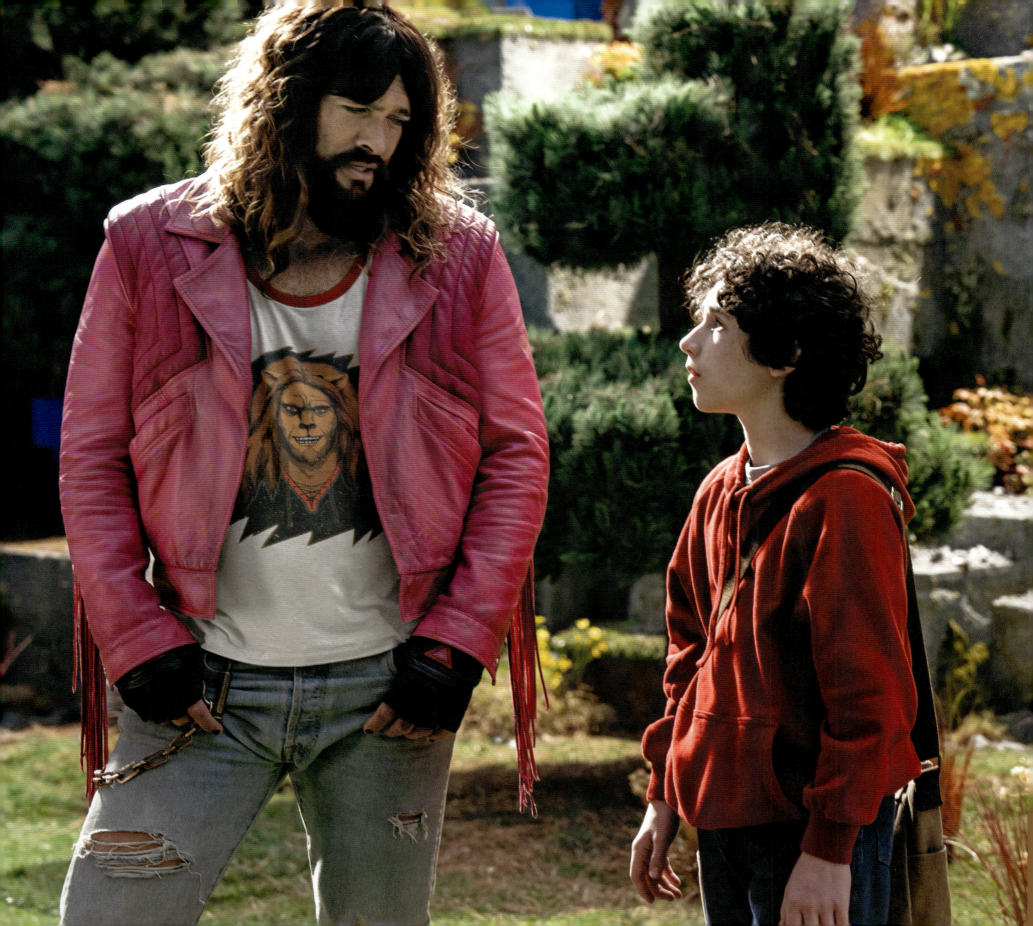

"Now I just went down there today, to check on my castle, check on my gallery, and to prepare for this interview that we're doing right now, and lo and behold, my masterwork painting, *Li'l Gosh*—gone! Someone has stolen my *Li'l Gosh* painting.

"And I know what you're saying. 'Make another one!' That's not the point. The point is, there's a burglar in our server, and I'm gonna get to the bottom of it. So starting now, there's a new movie in my head brewing. It's a detective story, of who stole the priceless—it's like the *Mona Lisa* of *Minecraft* paintings—I will find you. I know you're probably reading this book right now, and just be warned—STEVE is hot on the trail! The Pink Panther! Cat burglar stole my *Li'l Gosh*!

"In fact, I'm offering a reward. Anyone who can give me clues to who stole my painting, I will give you five pieces of lapis lazuli."

Black's painting, *Li'l Gosh*, is Steve's tribute to the villain of *A Minecraft Movie*, the piglin queen Malgosha, whose despotic rule dominates the Overworld and the Nether. Steve has been in her thrall for years, but the arrival of Henry and his friends has brought him the opportunity to break free and become the hero that he's always wanted to be. But will his example inspire others? Can Henry embrace his creativity and his unique view of the world? Can Natalie be a kid again? Will Dawn find out what's been missing from her life? And can Garrett learn to care about anyone other than himself? That may be the most important question of all.

"He's playing kind of a meathead who finds his soul," says Chris Galletta when discussing Momoa's character. "You like him, since he's relatable and living in the past and you hope that he can find his footing, so you kind of want him to dig deep and find the hero, in that Han Solo kind of way. He's selfish and in it for himself, in it for the money, and is he going to dig deep and find a selfless, heroic gesture? If we've done our job, you're really going to want him to."

The fate of our heroes depends on their ability to work together, to look out for each other, and, ultimately, their ability to let their imaginations run wild in this strange new world. "This is a place where what's in your brain can be made manifest. The lesson there, hopefully, is that you can see the real world that way, as a place where you can be creative and make your own dreams manifest," says Galletta. "The inspiration that you get in the Overworld is a huge ingredient.

"When they come back—if they come back—we hope that they can see the real world the same way that they saw the Overworld, this world of infinite possibilities. Maybe you can see reality that way, too. That's the journey of Henry, a creative kid who's not feeling quite at home here."

Natalie goes through her own transformation over the course of

their journey as well. "The family's going to heal, and Natalie's trying to protect Henry from himself and his stranger, odder perspective. It comes from a good place. We had so many conversations about Natalie," says Galletta. "In Act 2, [Henry] learns to embrace the fact that he sees things differently and has an imagination, and that he can use that imagination to his advantage, and the advantage of the town, of the world, of his family. I think Natalie comes to appreciate that quality in other people by the end of the movie, and finds a bit of that in herself as well.

OPPOSITE Garrett offers words of wisdom — and awesomeness — to Henry as they make their way through the Overworld.

ABOVE Jack Black's castle and signs found in Proplandia.

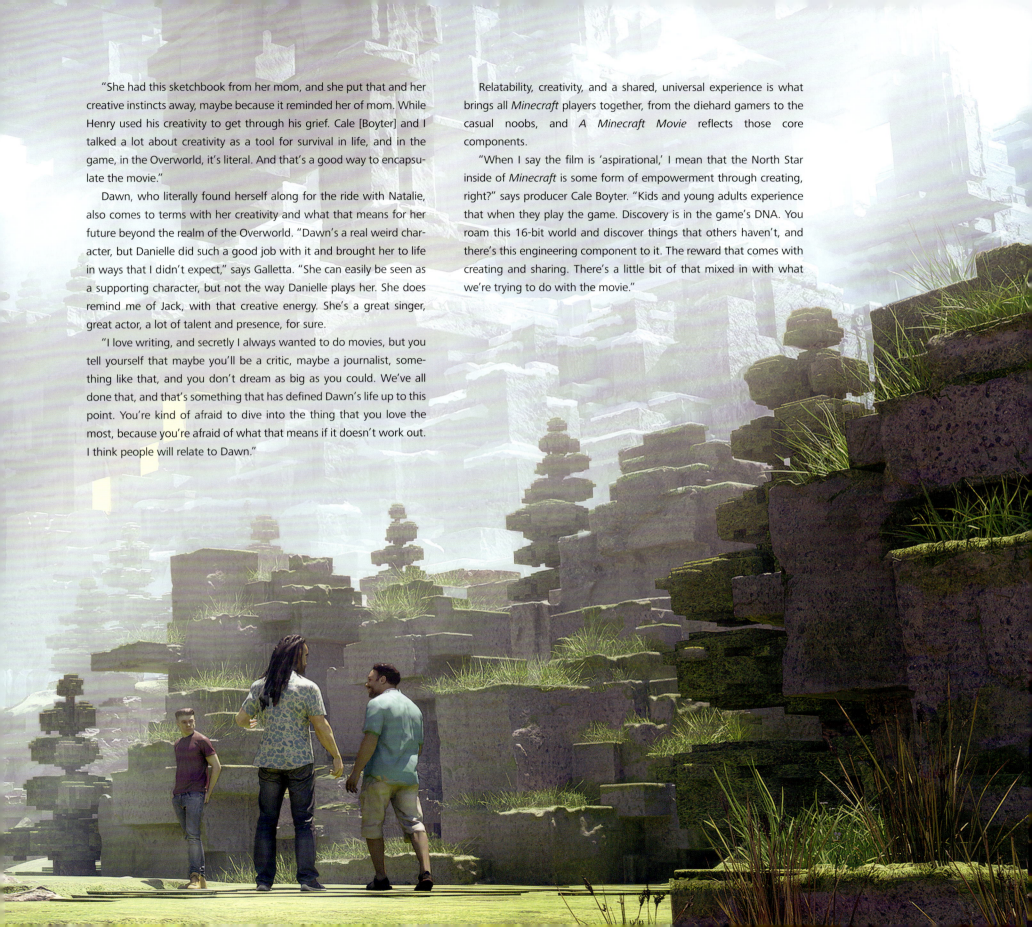

"She had this sketchbook from her mom, and she put that and her creative instincts away, maybe because it reminded her of mom. While Henry used his creativity to get through his grief. Cale [Boyter] and I talked a lot about creativity as a tool for survival in life, and in the game, in the Overworld, it's literal. And that's a good way to encapsulate the movie."

Dawn, who literally found herself along for the ride with Natalie, also comes to terms with her creativity and what that means for her future beyond the realm of the Overworld. "Dawn's a real weird character, but Danielle did such a good job with it and brought her to life in ways that I didn't expect," says Galletta. "She can easily be seen as a supporting character, but not the way Danielle plays her. She does remind me of Jack, with that creative energy. She's a great singer, great actor, a lot of talent and presence, for sure.

"I love writing, and secretly I always wanted to do movies, but you tell yourself that maybe you'll be a critic, maybe a journalist, something like that, and you don't dream as big as you could. We've all done that, and that's something that has defined Dawn's life up to this point. You're kind of afraid to dive into the thing that you love the most, because you're afraid of what that means if it doesn't work out. I think people will relate to Dawn."

Relatability, creativity, and a shared, universal experience is what brings all *Minecraft* players together, from the diehard gamers to the casual noobs, and *A Minecraft Movie* reflects those core components.

"When I say the film is 'aspirational,' I mean that the North Star inside of *Minecraft* is some form of empowerment through creating, right?" says producer Cale Boyter. "Kids and young adults experience that when they play the game. Discovery is in the game's DNA. You roam this 16-bit world and discover things that others haven't, and there's this engineering component to it. The reward that comes with creating and sharing. There's a little bit of that mixed in with what we're trying to do with the movie."

2. BUILDING BLOCKS

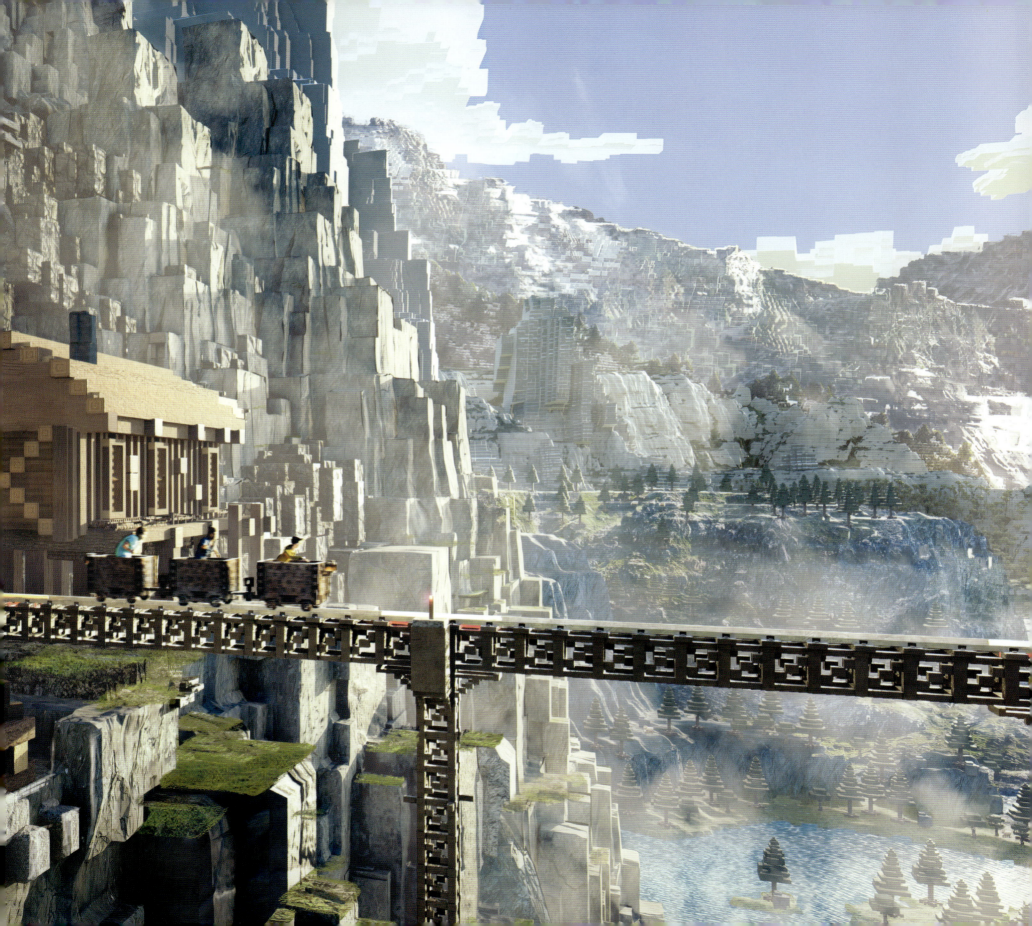

ABOVE (Concept art) The minecart track sets the stage for some of the most dynamic action sequences in *A Minecraft Movie*.

New Zealand State of Mind

A large block scale and a simple pixel grid provide *Minecraft* with its unique visual identity, recognizable to casual gamers and diehards alike. At a glance, fans recognize those core elements of the game, from the distinctive earth tones and the simple cubes that comprise the entire world to the sprawling landscapes and digital terrain that welcome each new player from the very first time they log on to play *Minecraft*. Although its aesthetic is deceptively simple, even newbs can tell right away when something feels like *Minecraft* and when it doesn't.

But how does that design philosophy translate to the big screen? How do you bring that virtual reality into the real world, where human actors will interact with characters and artifacts from the *Minecraft* realm? What are the unwritten rules that determine what is and what isn't *Minecraft*? Finding the answers to those questions would take the production team on a decade-long journey that would take them halfway across the world to a land of Hobbits, potato chip factories, and . . . Kiwis?

Location, location, location.

It's been said that those are the three most important factors in determining the value of real estate, and the same can be said when choosing the production site for a major motion picture.

After considering several options, New Zealand stood out as the only possible choice for *Minecraft*. The small island nation boasts beautiful scenery, expansive soundstages, picturesque landscapes, and, most importantly, a thriving, tight-knit film industry comprised of talented, creative people who would be up for the challenge

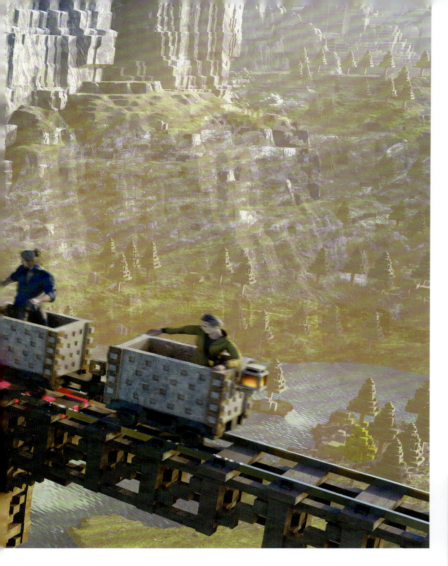

effects studio Wētā Workshop and Academy Award®–winning production designer Grant Major, a man so highly regarded that even movie stars turn into fanboys around him. "I'd worked with him before back on *King Kong*, in the 2000s. And he's LEGENDARY," says Jack Black. "In New Zealand, he is like a god. And he walks around like a normal dude, skinny guy, wearing his cap, really quiet . . . but people whisper when he walks past. 'It's Grant Major! The legend!' We were really psyched to have him on board, bringing the world of *Minecraft* to life."

Despite his long and storied career built in fantasy worlds and concepts, Grant Major's journey through the world of *Minecraft* was unlike any that he'd ever taken before. "Clearly I've never done anything like this before, bringing a digital game to life," says the veteran production designer. "It's new territory. Beyond a game, a phenomenon. There's a massive population that plays it, and it's more than just a game. Such high expectations for it.

"I do remember a similar thing being talked about with *The Lord of the Rings*. People were saying, 'Don't make this into a movie, it's never going to work as a movie, you're just going to ruin it.' So my response to that was to reference it line by line, to do the very best we could to bring Tolkien's world to life, and I believe that's of translating the world's most popular video game into a vibrant live-action film.

"Initially as we were developing it, we thought about which stages might be available, and if we were going to film in the United States," says director Jared Hess. "But once New Zealand became available, a lot of those ideas got transplanted to our new location, which ended up being perfect. I've always wanted to shoot here, and it's just such an unbelievable place to film. The crews here are world-class. They've all been trained by Peter Jackson and company, and James Cameron, so the best of the best are out here. Taika Waititi, Jemaine Clement, all those guys. Just great."

New Zealand established itself as a cinematic powerhouse in the early 2000s when director Peter Jackson and his crew filmed *The Lord of the Rings* trilogy entirely in his native country, utilizing the country's beautiful geography and taking full advantage of the nation's homegrown talent, including the groundbreaking visual

BELOW The dark oak forest holds many mysteries . . . and huge red mushrooms.

2. BUILDING BLOCKS 63

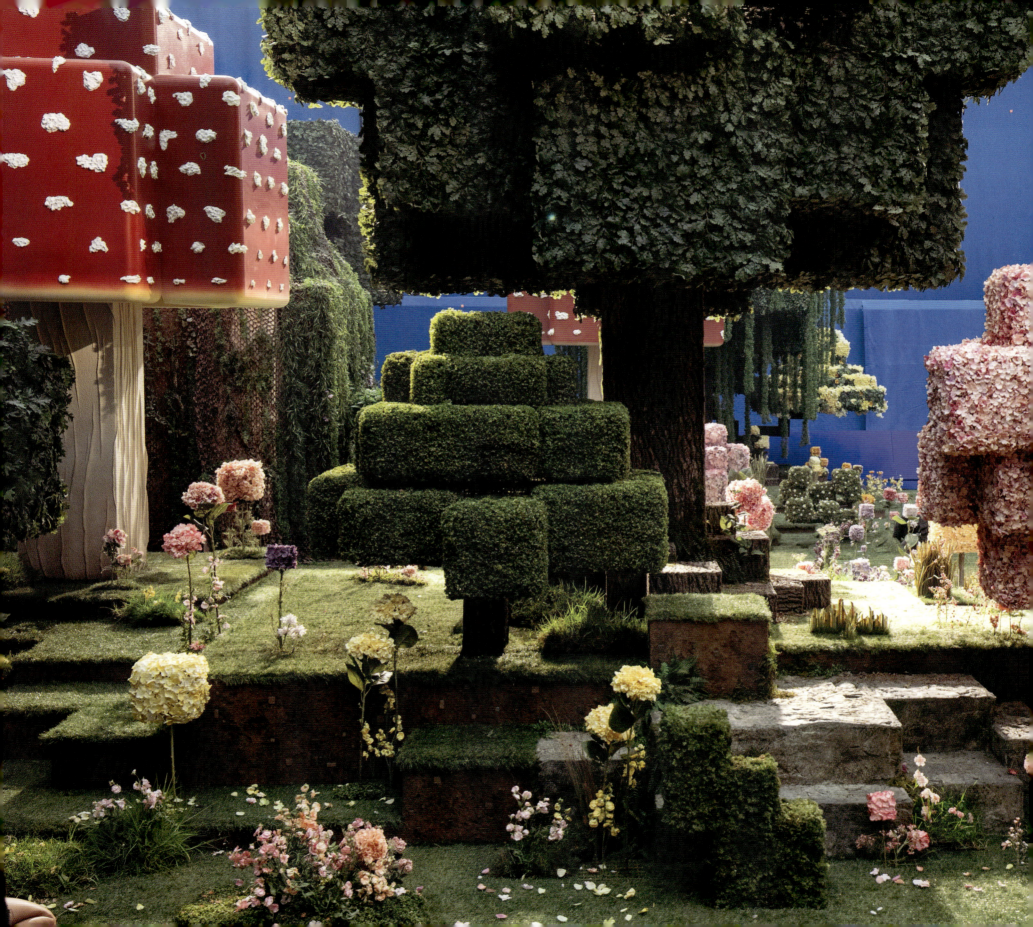

what we're doing here as well. We really had dialed down into what makes the game the game."

The visual identity of *Minecraft* is very clearly defined within the confines of its gameplay, and although elements of the game have been adapted into 3D space in creative ways, including LEGO playsets and fan-made costumes, this was the first time that a professional studio would attempt to create the biomes of *Minecraft* as a real environment. "Obviously, there's a divide between the digital world and the physical world, and this is a movie that deals with the physical world but with a massive amount of digital work done afterward. So already there was an interesting sort of frisson between the human actors and the world we built, the characters of the game," says Major. "But everybody understanding it and knowing it as a digital environment and digital world, I see that as being very exciting. Fascinating challenge to cope with.

"And every day of the production that I was working on, I was rationalizing making something physical out of something digital, and believe me, it's a very complex and very carefully choreographed thing to have to do. Very, very interesting to me and all of our crew, to bring all these things to life. It was great. It's a very daring thing to do, I reckon. And I love it."

Armed with a full complement of reference materials courtesy of Mojang, the production team scouted locations throughout New

OPPOSITE From the smallest flower to the largest trees, every living thing in the Overworld conforms to the grid and the structure of *Minecraft*.

BELOW Although pink denim always looks cool, Garrett learns that it is not the most inconspicuous fashion choice when you're hiding from creepers and zombies.

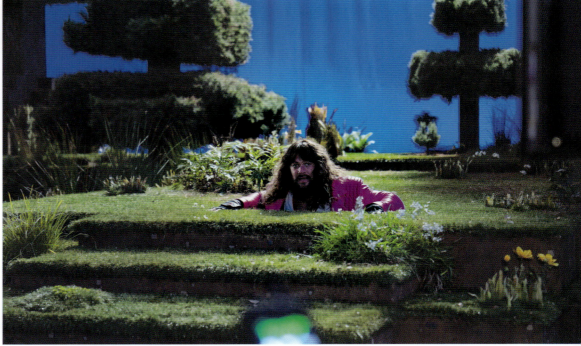

2. BUILDING BLOCKS 65

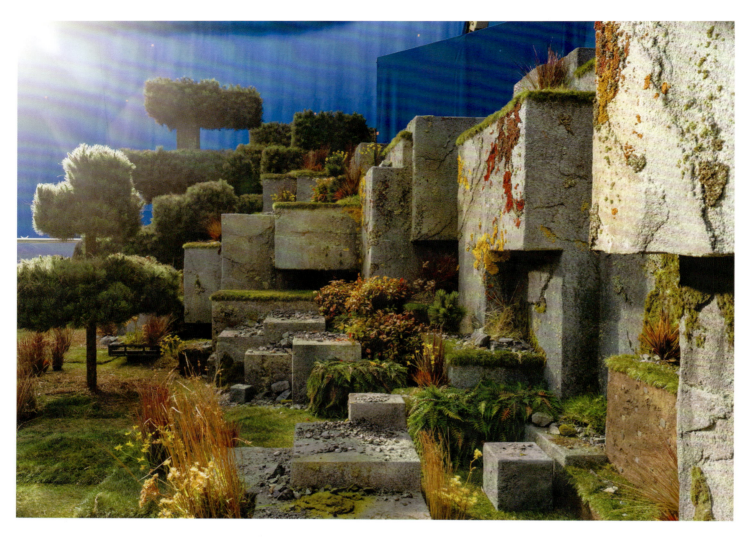

Zealand with the intention of incorporating the geometric wonders of the Overworld into the natural greenery of the country's parks and plains. "We were initially going to be filming in the winter here in New Zealand, but the weather here is so erratic," says Hess. "You get monsoon-level rainfall that will last twenty minutes, then it turns to middle of summer weather with sunshine, then it will turn back . . . We went from falling in love with this beautiful country and its natural landscape to realizing that we'd potentially get rained out for part of every single day, especially with all the sets that we had, and that with how critical our actors' schedules were. We had to fit it all into a very finite amount of time. After a couple of days of scouting we knew that we'd have to film everything on [sound] stages, but the stages here are amazing and we ended up building all of the trees that we needed.

"Grant Major and his art department were just amazing. We built forests, Midport Village where the villagers were. Pretty much everything that was within thirty feet of our actors was built, and we used set extension beyond that, anything that went beyond the physical size of our stages. It was crazy walking the set every day and really feeling like you were in *Minecraft*."

Building everything from the ground up on soundstages was not the design team's first choice, but the shooting schedule and the volatile nature of winter weather in New Zealand made it a necessary compromise. "Dan Lemmon, the VFX supervisor, had just come off one of the *Planet of the Apes* movies, and they'd shot everything outside for that," notes Major. "He wanted to do *Minecraft* the same way, building Midport Village outside, on location. We went location hunting for that, even though the location itself was going to be radically changed, cubified and all that.

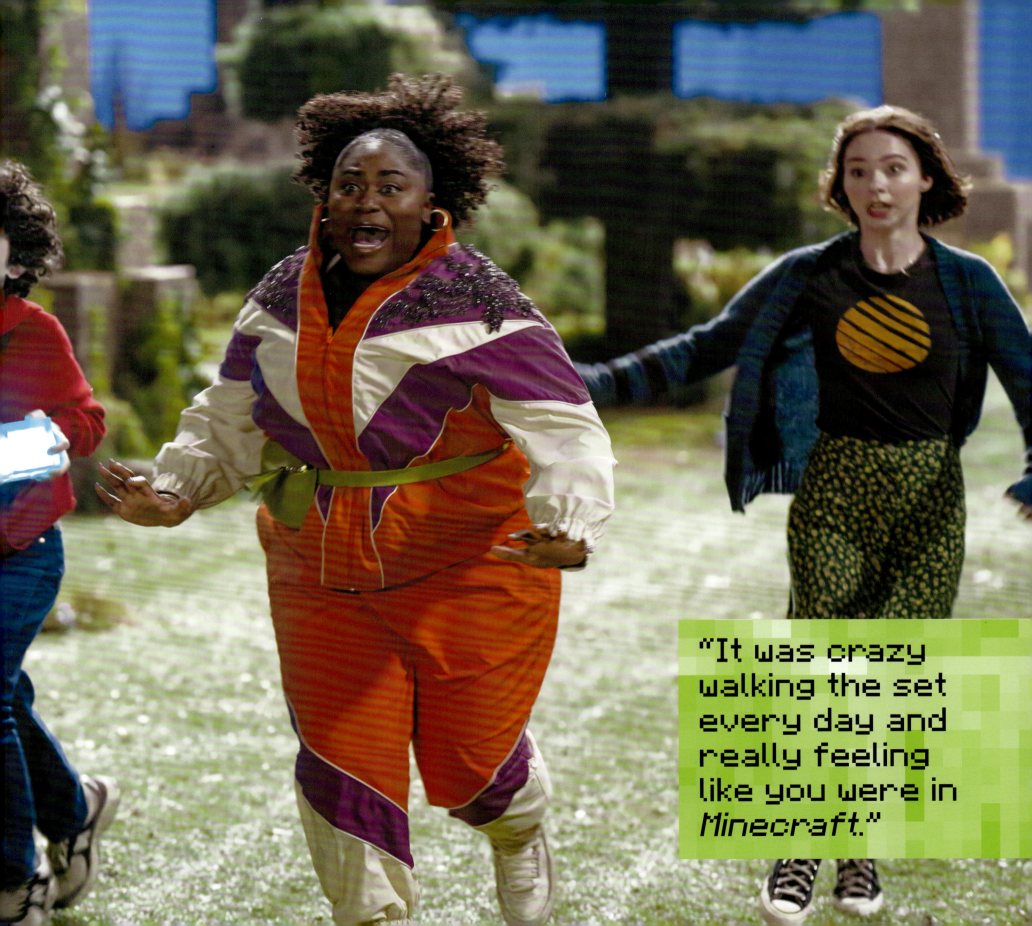

"It was crazy walking the set every day and really feeling like you were in *Minecraft*."

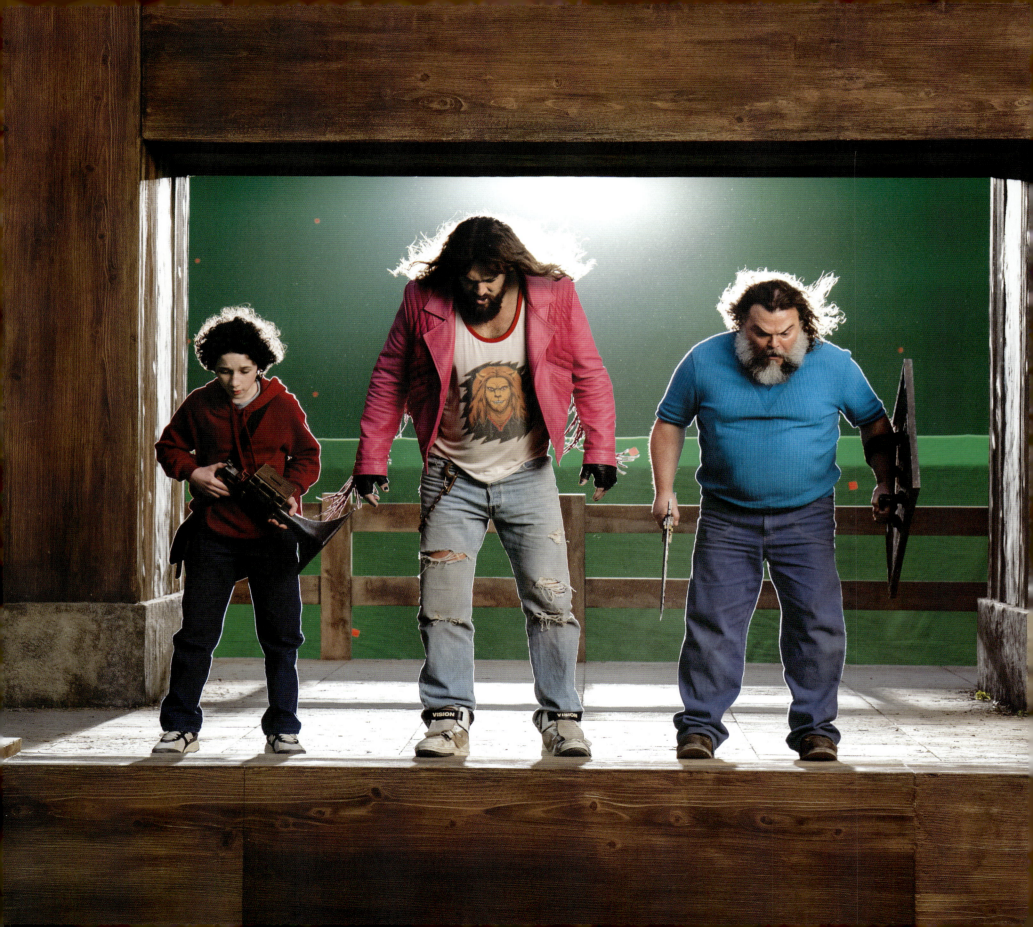

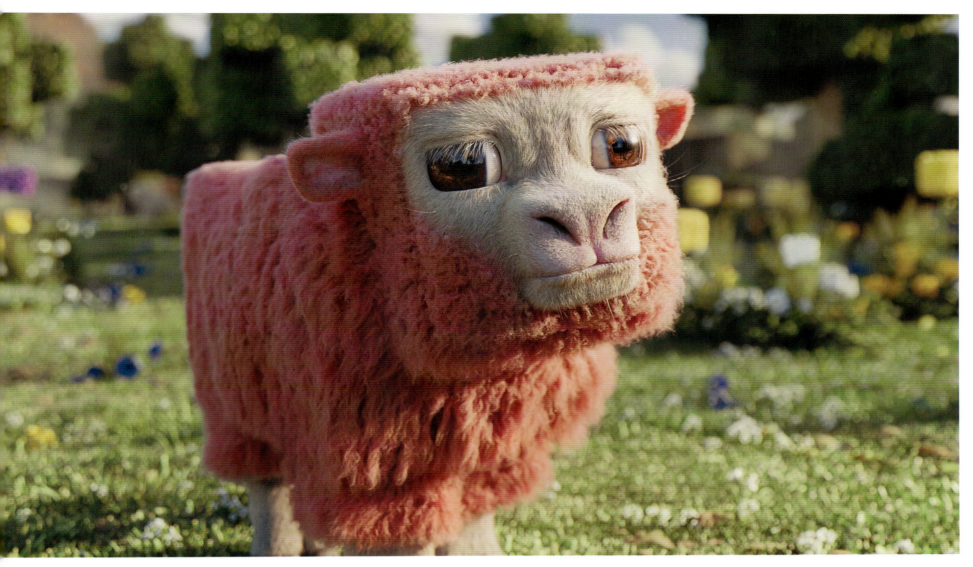

"As that progressed, though, he realized it's very muddy out there, and it actually rains; it gets really windy during the springtime. Actually very noisy on the back lot with trains and airplanes going by. And it was Jared, and I really respect him for this, he said, 'Stop everything. Why are we doing this, making it so hard for ourselves when we should be filming this on a stage? The environments are so stylized and meticulous that we ought to be inside.' And that was absolutely the right call to make. Filmmaking's a process, a discovery. Especially covering new ground like this."

Mojang senior creative director Torfi Frans Ólafsson consulted directly with Major throughout the production to ensure that his sets would remain true to the creative spirit and visual heart of *Minecraft* every step of the way. "One of the things I said to Jared and Grant is that if you pause the movie, and look at one frame of the movie, you should be able to look at it and say, 'Ah, *Minecraft*!' without having seen the movie," says Ólafsson. "Not *World of Warcraft*, not *Dungeons & Dragons*. Because sometimes, some people want it to have a more agrarian, real sense, with traditional backgrounds, traditional weapons . . . but then it doesn't look any different from these other movies, or from *Lord of the Rings*, for that matter.

"A lot of people on our movie, like Grant, had worked on *The Lord of the Rings* or *The Hobbit* film trilogies, or *The Lord of the Rings: The Rings of Power* TV series. So we kept referring to Middle-earth. Jared referred to this internally as 'Fellowship of the Nerds,' in his pitch. His biggest inspirations were *The Goonies* and *The Lord of the Rings*. We wanted to bring that together. That was the starting point."

OPPOSITE Angry piglins behind them, a deadly chasm below—all in a day's work for Henry, Garrett, and Steve.

ABOVE The Overworld can be beautiful and terrifying . . . but it can also be adorable!

2. BUILDING BLOCKS 69

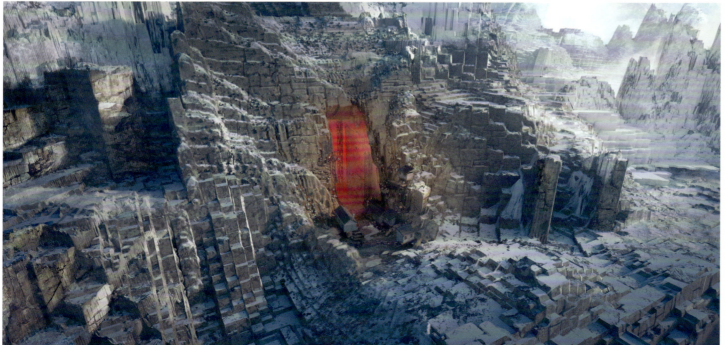

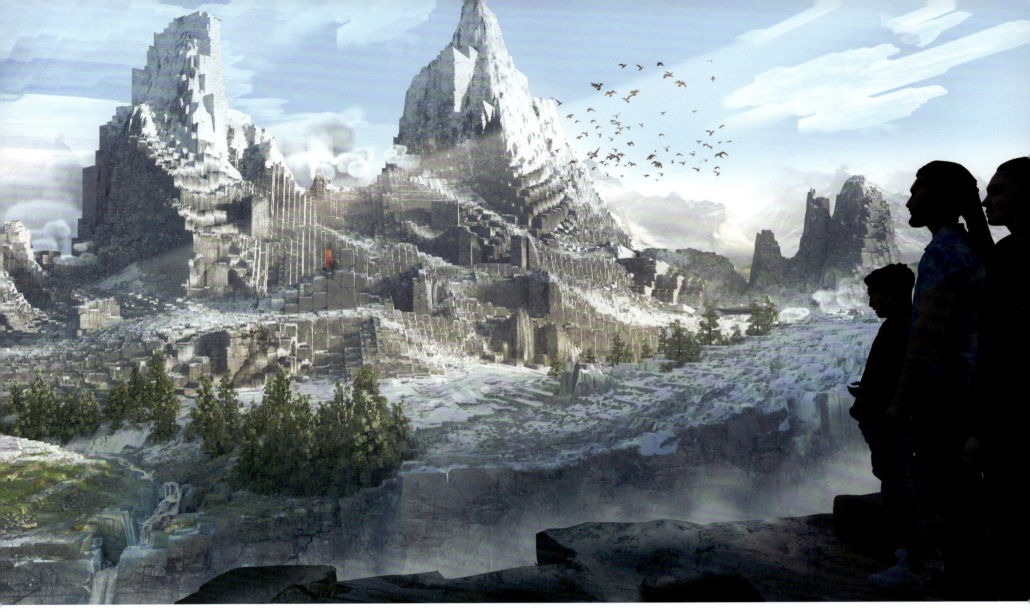

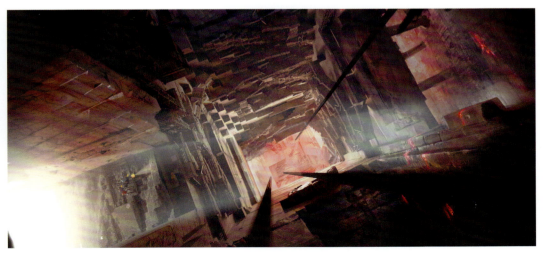

(Concept art)
The Redstone Mines can be found at the heart of one of the most beautiful — and most dangerous — landscapes in the Overworld.

2. BUILDING BLOCKS

Bit by Bit

The simplicity of the *Minecraft* aesthetic made it deceptively difficult to bring that digital landscape into the physical world. Earlier adaptations had great success translating the game into computer-generated animation, but a live-action film presented a host of challenges that even Grant Major and his crew had never faced before. "As you're aware, *Minecraft* functions in sort of a cubic world. Putting humans, real people, into that environment immediately brings up some technical issues to tackle," says Major. "What is the size of a cube? What is the size of a cube to a human being? We know roughly the size of a cube to a *Minecraft* inhabitant, but what is it to Jason Momoa and Jack Black? It looks like something that is probably about three feet by three feet.

"So we had to ask, what is the size of these cubic blocks? And then we realized that for our characters to be able to walk around an environment like that, they'll have to climb up and down these three-feet blocks, and that's going to be a very awkward environment for them to be in. So we had to decide what was an optimum size for human beings to interact with. But then they need to be able to act and to play their roles in an environment that's not going to be hazardous to them, where they're in danger of breaking an ankle,

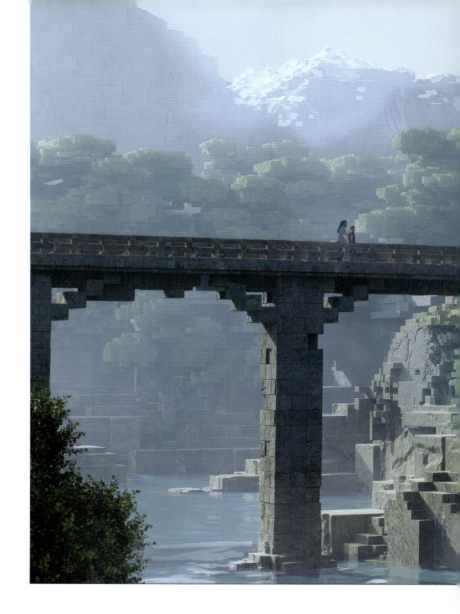

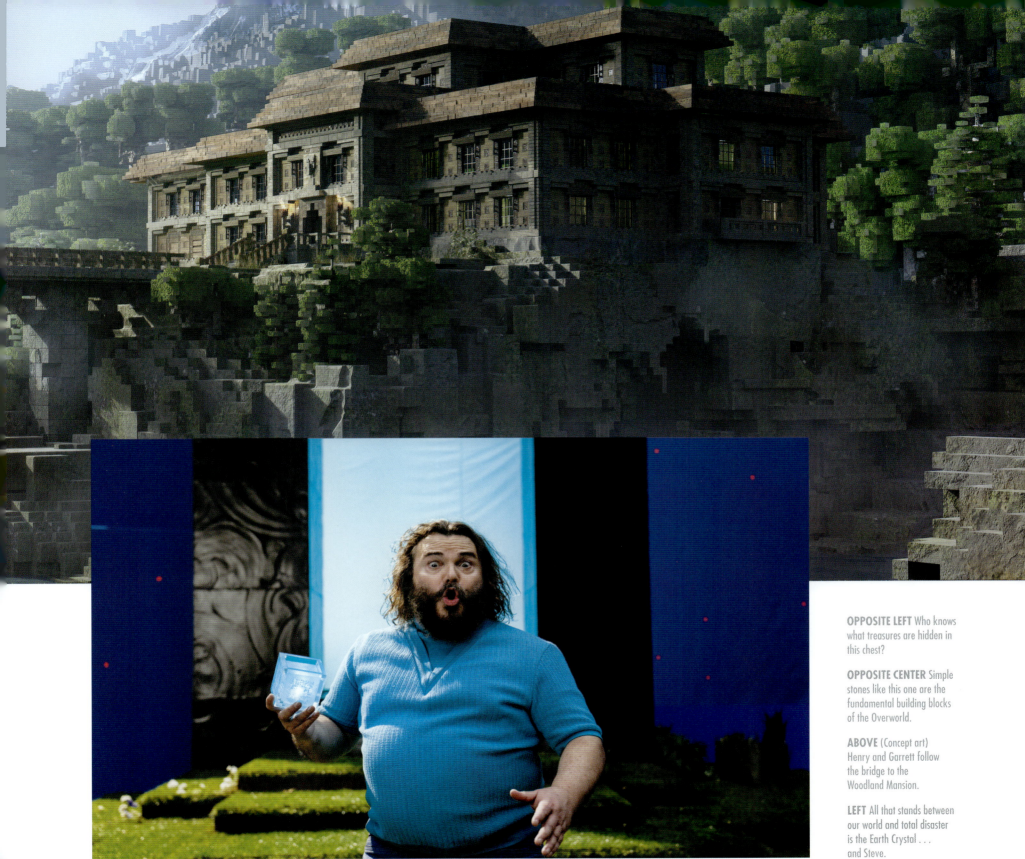

OPPOSITE LEFT Who knows what treasures are hidden in this chest?

OPPOSITE CENTER Simple stones like this one are the fundamental building blocks of the Overworld.

ABOVE (Concept art) Henry and Garrett follow the bridge to the Woodland Mansion.

LEFT All that stands between our world and total disaster is the Earth Crystal . . . and Steve.

2. BUILDING BLOCKS

getting on their hands and knees to climb over obstacles and whatnot. So we reduced it down somewhat.

"We found that in other instances, like when you hold an apple in your hand, that's not huge. The cubic size needed to have variations on that theme. We came up with a formula that could accommodate a world with three-foot square cubes, one-foot square cubes, and six-inch square cubes. Then we got a three-inch square cube. We formulated an internal logic and physics to our world. That was one of the big things."

Mojang was an essential part of that discussion, as Major and his crew grappled with the logistics of adapting two-dimensional graphics into a three-dimensional plane. "We came up with this rule, that the entire world has some sort of crystalline structure to it," notes Torfi Frans Ólafsson. "A block is like three feet by three feet, but when you break it in the game, it becomes small and hovers. So how do we show that? And we thought about the world's physics. And what we hit upon was the Hoberman sphere. The kids' toy that can unfold but can collapse upon itself into a very condensed position. So we decided that there would be two states—if they're attached to the world, they expand, just like magnets; but when throwing things, they're small, like throwing a small magnet at a fridge. When you jostle it out of that magnetic attachment in the world of the movie, it touches the ground and expands into the large Hoberman sphere. But when you touch it, pick it up, break it out of that magnetic attachment, it collapses and becomes a miniaturized version of itself.

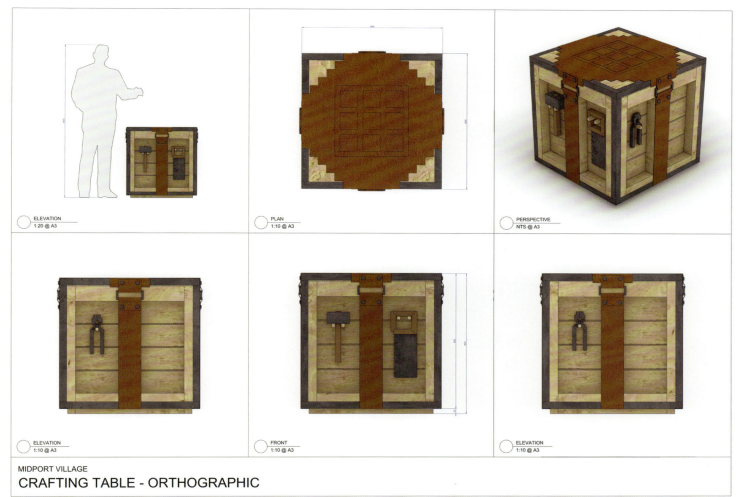

MIDPORT VILLAGE
CRAFTING TABLE - ORTHOGRAPHIC

OPPOSITE Garrett learns that the power of the Earth Crystal is nearly impossible to resist.

ABOVE Every player starts a new world by making a crafting table.

BELOW CENTER Along with the chest, the barrel is one of the essential storage items in *Minecraft*.

BELOW RIGHT Where would we be without the cartography table? And where are we now? This tool is a centerpiece of every village cartographer's house.

"We tried different sizes, we 3D-printed different sizes of blocks to see what they would look like in the hand, to see what would make the most sense. In the game, the blocks are quite large, an eight- or ten-inch cube, and that makes sense in the world of the game, because you need to see it in your hand, or other people's hands. In the movie, we had to make the creative decision to scale it down to about two inches. We did screen tests, and we hope the fans will forgive us, but that was all part of the adaptation process. For the format, the perspective, the lenses. We went with a more subjective approach: punch the tree, get the small block. At one point, we were thinking that the blocks would be small, like dice, and you could fit them in your pocket, when we went super deep into thinking about things like how many blocks Henry would need to build a particular thing, but the movie would have been six hours long if we'd done that. At some point, you have to surrender to the fact that it's an adventure story, not a scientific simulation."

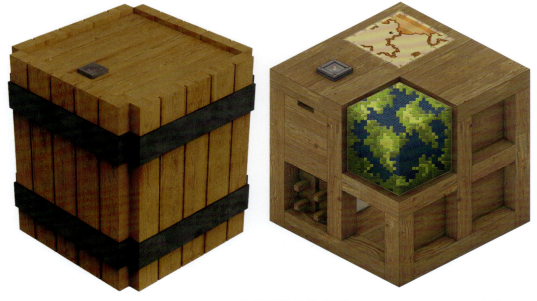

2. BUILDING BLOCKS

That decision freed up Major and his team to create an environment with a consistent internal logic that would honor and celebrate the game without stifling their own creativity. "The other big thing was the physicality of our world. So here's a real human being interacting with this digital environment, and that digital environment needed to have a certain physicality to it. For example, *Minecraft* has these cubes of stone. Does a physical-world cube stone weather? Does it form cracks? Does it have a surface texture? Does a surface texture have shape to it, like a real stone in the real world? In our film, yes it does. A cube shatters when it breaks—does it break down into smaller cubes? Does that break down into gravel?

"It sounds like a very curious little detail to dwell on, but all of these are things we had to consider when we were developing these concepts into a physical form. Grass, how are we going to produce all this grass? The world has all this digital grass, and we had to manufacture grass, leaves, trees. Every single component of the physical world in our film has been made. It's been designed, it's been workshopped, vetted by the studio people. Gone through this whole process. Mojang has been a massive part of the formulation of it, to make sure we don't stray too far from the path that the players will recognize. It's been a huge journey to produce what we produce."

RIGHT Oak logs can be found in a variety of textures and colors.

OPPOSITE The only expression of creativity permitted in the Nether is artwork that celebrates Malgosha, like this statue. All hail Malgosha!

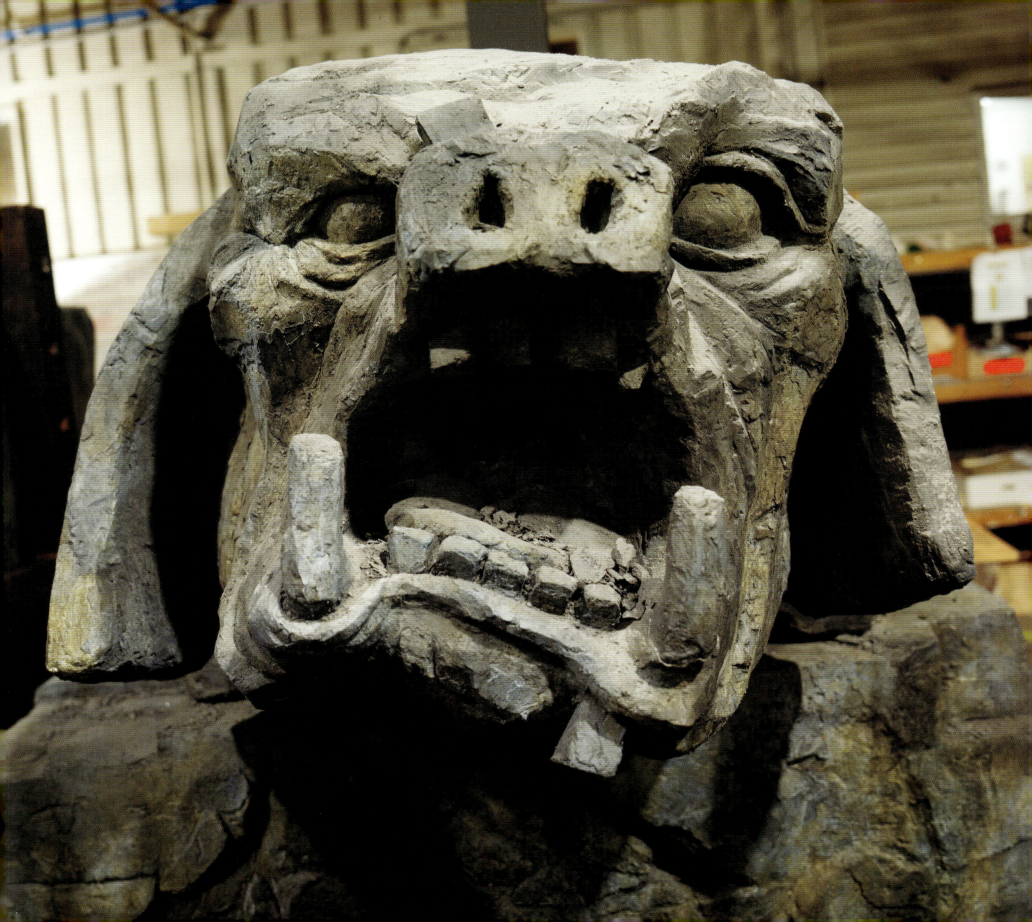

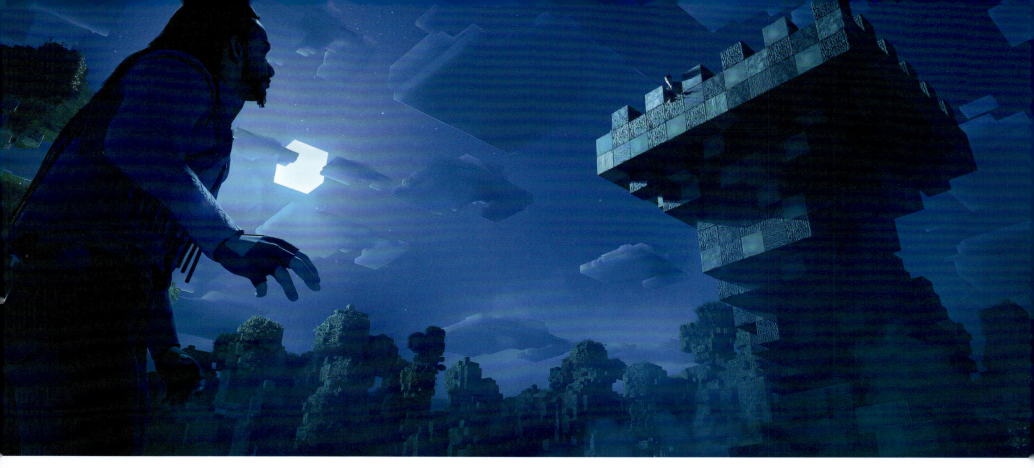
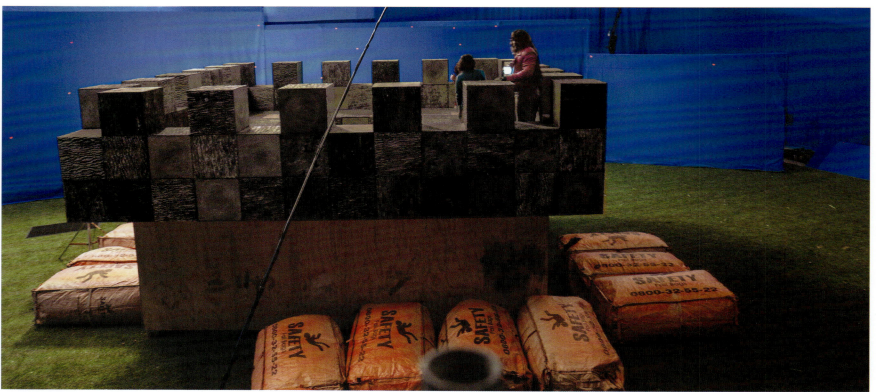

All the World's a Stage

Within the game itself, the world of *Minecraft* has no limitations and no boundaries. For all intents and purposes, the Overworld's terrain stretches into infinity. Fortunately for Grant Major, his corner of the *Minecraft* world was a bit more manageable. "Todd Hallowell, our executive producer, at the very beginning, said, 'Grant, you're only going to be making a limited environment around the actors, where they're going to be on the stage, and everything else is set extension," says Major. "'Ten feet around where people were going to be.' And he was right, and he was wrong at the same time.

"We built really quite big environments for the physical world, but my job, in the production design, wasn't just the physical world. It was also brainstorming and manufacturing the digital environments, even though a lot of this work was happening in postproduction. All these environments were visualized to the nth degree about how they were going to look in the film so that we could make this physical set and make sure that the extensions were compatible. This was new to me, as I've done set extensions before, but not for every single shot, not to this extent. The *Minecraft* world and its digital extensions all had to be designed."

Major started with a team of concept artists who immersed themselves in the world of *Minecraft* and determined exactly what steps they would need to take to bring it to life. "We have to figure out what needs to be built, then we have a construction department, making things, rocky environments, grassy environments, and what have you," Major continues. "A greens department, who physically made all the trees, physically made all the bushes, made the grass, made the flowers, made the mushrooms, everything. That side of things.

"We made the decision to stick to all of the recognizable stone types, and tree types, and metal types. We were continually interacting with Mojang, and there was a lot of visual material available to us, and we were very, very thorough as far as that went. Same reason as I was talking about with *The Lord of the Rings*, that we were taking these source materials seriously and doing this as close as we can to the original rules and regulations of the game. That was very important to us."

ABOVE
When the sun goes down, the zombies rise.

OPPOSITE ABOVE
(Concept art) Garrett learns that nightfall comes quickly in the Overworld.

OPPOSITE BELOW Henry's shelter provides him and Garrett with protection from the mobs that come out at night.

2. BUILDING BLOCKS 79

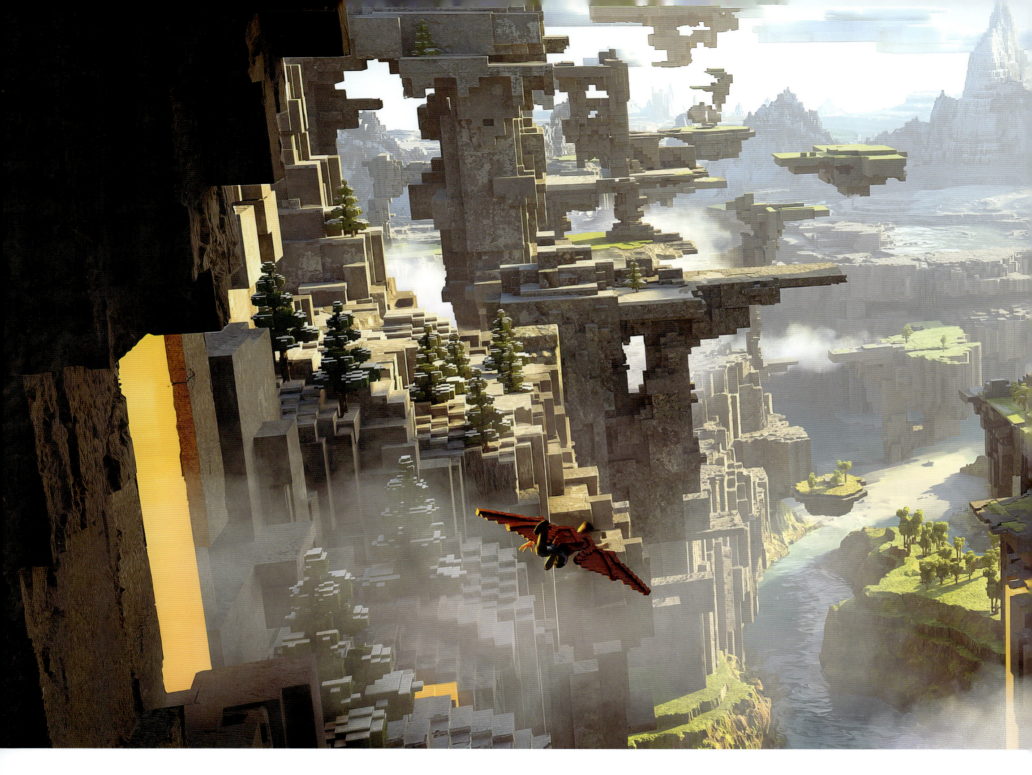

Although Major had the artistic license to change things up as needed for the sake of practicality, he knew the importance of adhering to the classic designs that millions of gamers around the world know and love. "The Overworld and the Nether are very graphically described in the game, so we knew that we weren't going to change things much from that. They're both very vivid. We just had to bring the elements that make the Nether into our version of the Nether. Building on that to make our own environment. It was a matter of researching. The Mojang original game is the bible, as it were. There's a massive amount of fan art out there, too, and we did want to take stock of their contribution to the *Minecraft* universe. We didn't use anything that fans had actually produced, since we don't own that work, but

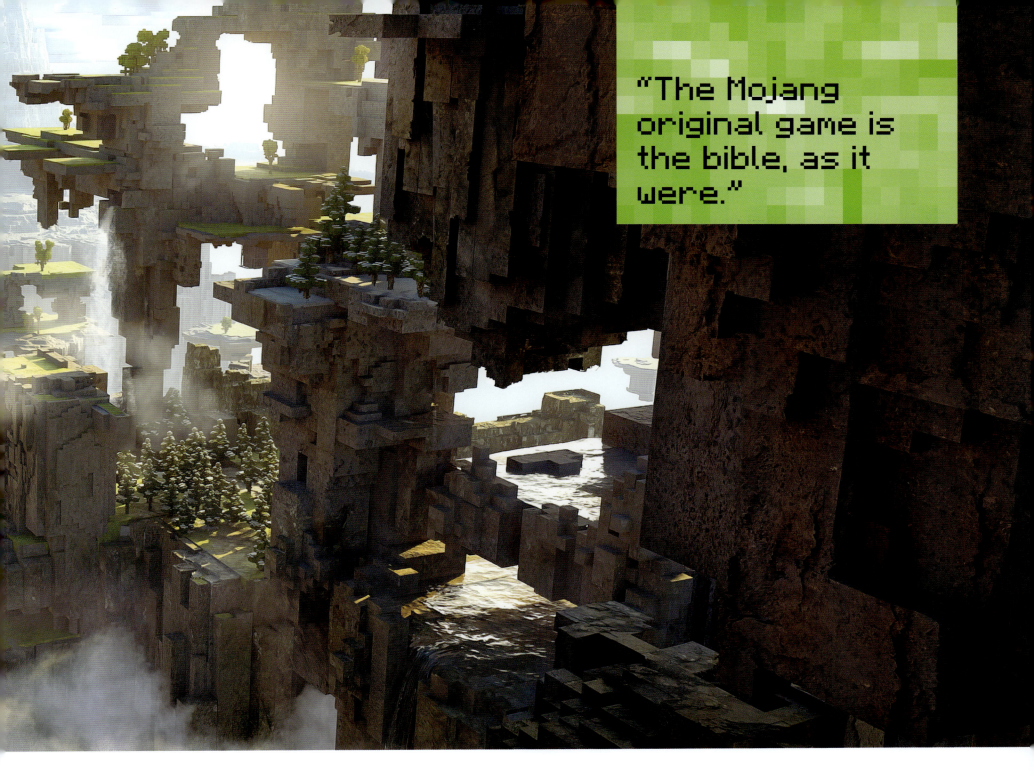

"The Mojang original game is the bible, as it were."

we wanted to be aware of their interpretations. We ourselves stayed within the realm of the vanilla version of the game.

"The Overworld has very vivid blue skies, and it's very atmospheric. We had to look at the real world, where we live, and the *Minecraft* world, in the game, to find a space in between there.

There's no rainbows in *Minecraft*, but is there dust? Is there atmospherics? All these things had to be workshopped and discussed and taken seriously."

Ultimately, the "space in between" is where the movie found its voice, as Major and Mojang established the visual language that both

ABOVE (Concept art)
It takes a tremendous amount of effort to soar above the Overworld, but the view is spectacular.

2. BUILDING BLOCKS 81

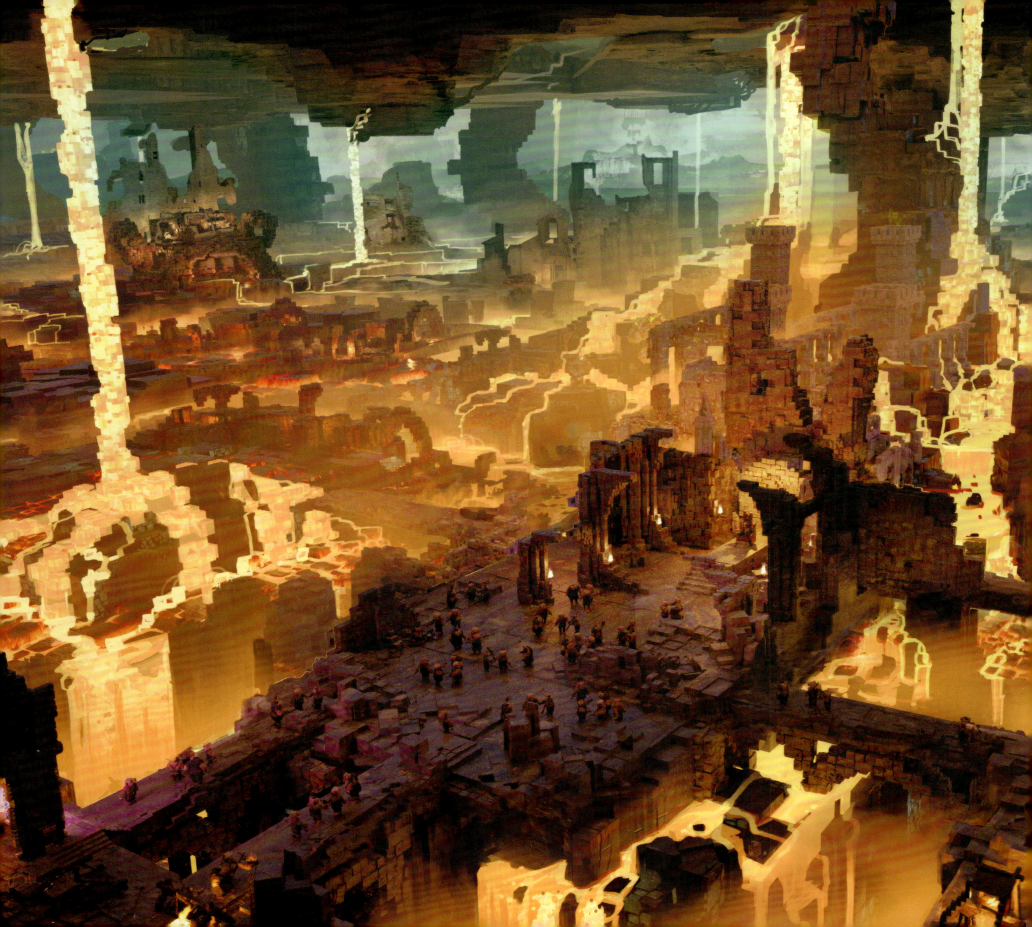

respected the original source material and allowed one of the most celebrated production designers in cinematic history to do what he does best. "*Minecraft* is a very valuable product, and they are obviously very aware of that and don't want to wreck it. I would produce a final product, then go to them, and we'd have a video conference and talk about it, analyze what was in the visual, then they would send back an image with circled areas and say, 'This is not *Minecraft*, this is not *Minecraft*, we like that, maybe you can change this,' and things were being massaged and adjusted throughout the process," says Major.

"But they're creatives, we're creatives, and we all understood that not all of these things had solid parameters. They were all sort of changing throughout. And I did go through our set and would note areas where we seemed to be moving too far away from the *Minecraft* world, and we would sort of pull back. For example, the Woodland Mansion, our design was a bit more fanciful, and they just said no, we want the same as the game. Back to the iconic shapes that were in the game, working with that, and that's what's in the movie. And they helped us with that, all the time bumping us back, bumping us back to what's in the game, and I respect them for that."

OPPOSITE (Concept art) The piglin forces gather in the Nether, ready to serve the dreaded Malgosha.

BELOW (Concept art) A moment of calm before the storm at a village marketplace.

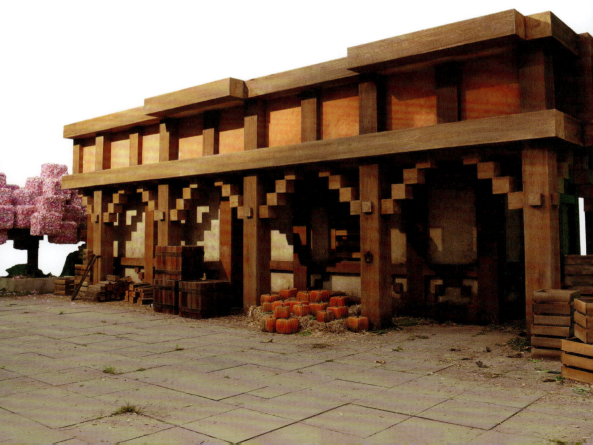

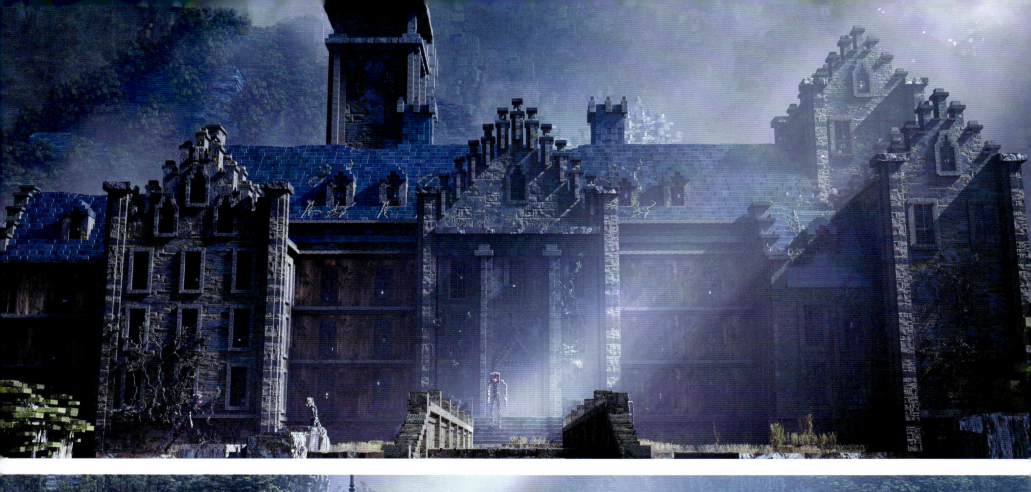
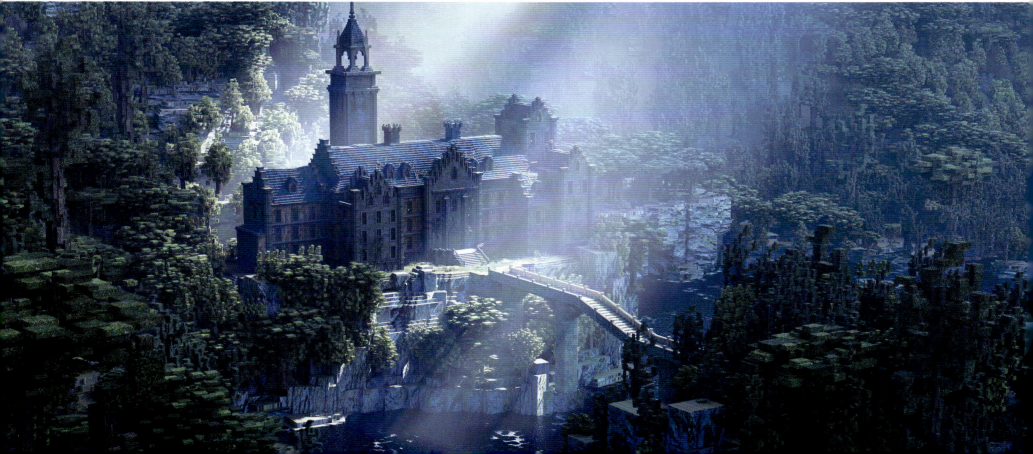

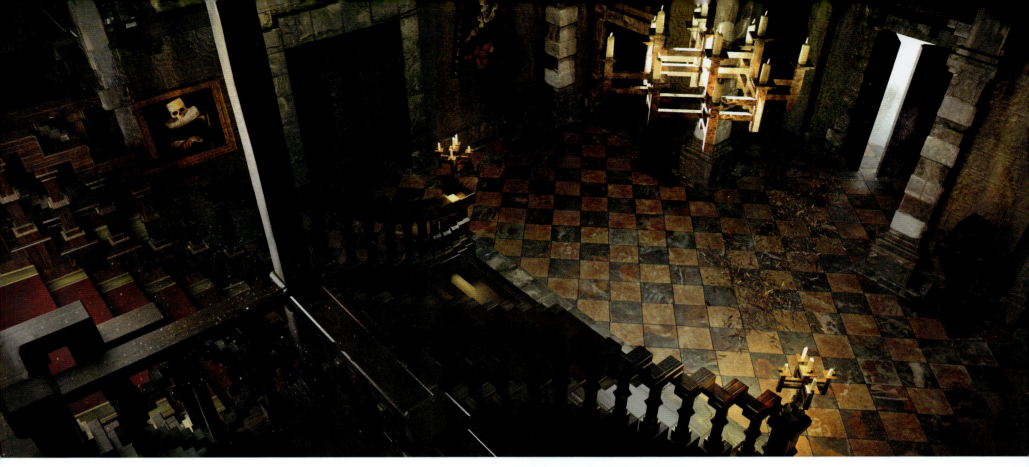

Concept art for the iconic Woodland Mansion.

2. BUILDING BLOCKS

Giving Props

Every *Minecraft* player knows that although you start the game with nothing but your bare hands to alter and transform the world around you, you can't unlock the full potential of the game without the right tools. From the simple wooden pickaxe to the majestic diamond sword, every object in the game has its own unique visual identity and properties. Bringing those items to life would take a village.

"The props department, with all the swords, bows, and arrows, items used by not just the live-action characters but also had to go through the digital department for use by the digital characters that held props," Grant Major notes. "All of those had to be designed, manufactured, and given their own logic. A massive amount of brainpower went into all of this. And there are a lot of judgment calls. What are the fans going to recognize?"

To answer that question, Major turned to veteran prop master Matt Cornelius, who had recently collaborated with him on the series *The Lord of the Rings: The Rings of Power,* which had been produced and filmed on location in New Zealand. "I got the call from Grant Major's production company, and like everyone on earth, I had some familiarity with the game, mainly through my children, but I played it a little bit in the past," says Cornelius. "When the opportunity came about to work on a live-action version of that, it was super exciting, because knowing about the very simple props that are in the game, very pixelated, every prop has to be very simplified to be in the game—some of them are just glorified tubes—the challenge of developing those into real handheld things was exciting for me, the opportunity to bring those ideas into the real world.

"When we started the design process, it involved a lot of discussion about bringing the *Minecraft* tools and weapons into three dimensions. We went through many, many iterations to determine what a sword would look like."

Assisting Cornelius was props designer Polly Walker, whose work would provide the template for the majority of the 3D props that would be utilized by actors and incorporated into set decoration. "We made more than sixty-five props. Quite a few, it was a massive list. Once we developed the first few weapons, the pickaxe, the sword, and the crossbow, once we got our language going, we applied that to other objects, and we could pass that pretty easily. Trying to find the balance where it worked in the real world but still felt very *Minecraft*.

"We started with very specific rules, like everything has to be on

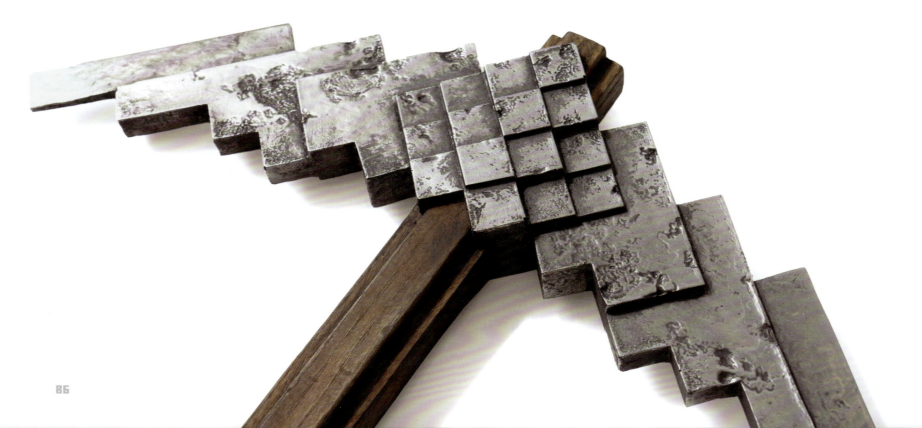

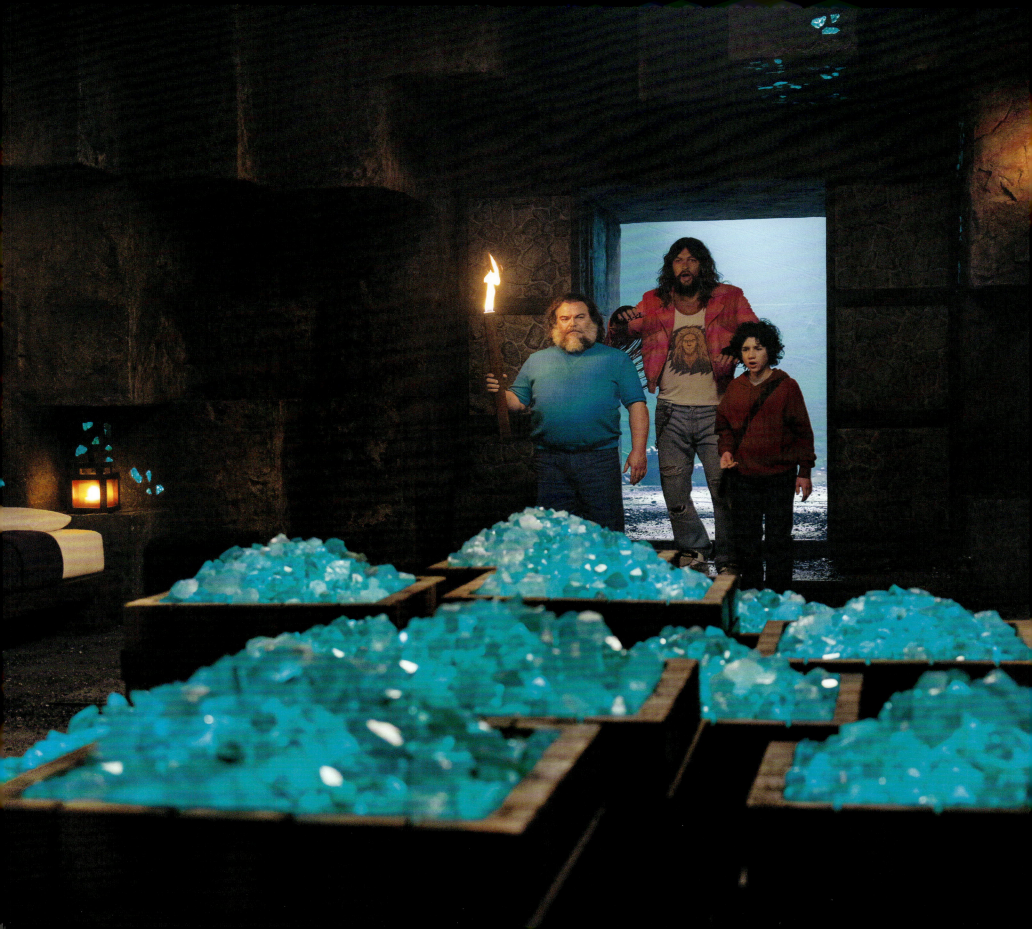

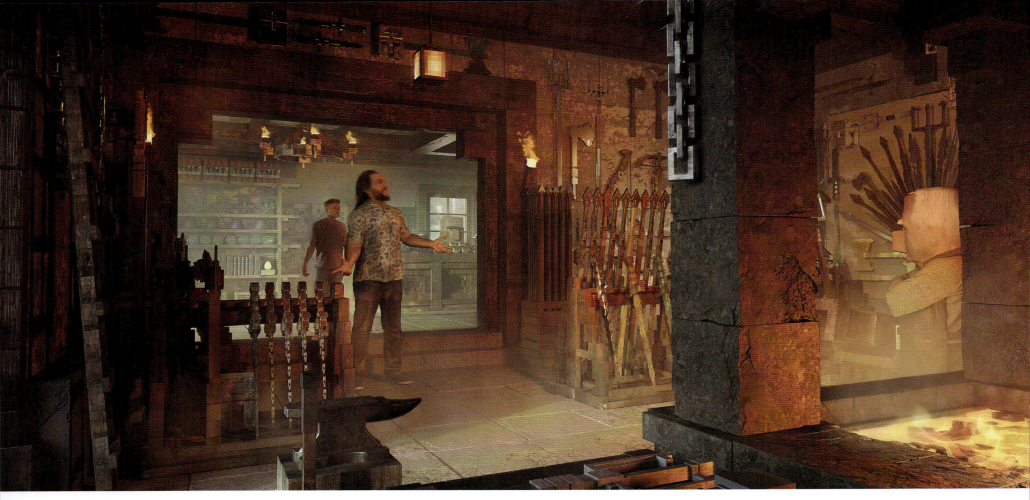

ABOVE (Concept art) The village blacksmith stands ready to craft new tools for Garrett and Henry.

RIGHT Each satchel is decorated with items that relate to its owner, such as orange tulips and blue cornflowers that indicate farming and agriculture.

grid. Building from the icons from the game and building off that grid," says Walker. "The sword has to be on an angle. The development of the sword was the first thing we had to get down. We went through five stages of design of the sword. We went from pixel to pixel, but brought into 3D world, the icon. So you only have sixteen-by-sixteen squares. Then one that was slightly higher res, then more and more and more. A slightly pixelated sword, which looked a little bit whack. So it was kind of finding the in-between, which I think we landed on.

"So originally, it was that sort of staggered handle as well, which wasn't very comfortable to hold. With the input of Matt and I designing it in the office, and then it went to Grant, for his feedback, and then to Mojang for their feedback as well. We landed on the middle one, and then adjusted to either side of that."

As many cosplayers have learned, objects that look right at home in the game don't necessarily translate into practical items in the real

ABOVE AND LEFT *The crossbow and bow are valued for their ability to attack at range. Only problem is that skeletons and pillagers also wield them . . .*

"We went through many, many iterations to determine what a sword would look like."

2. BUILDING BLOCKS 89

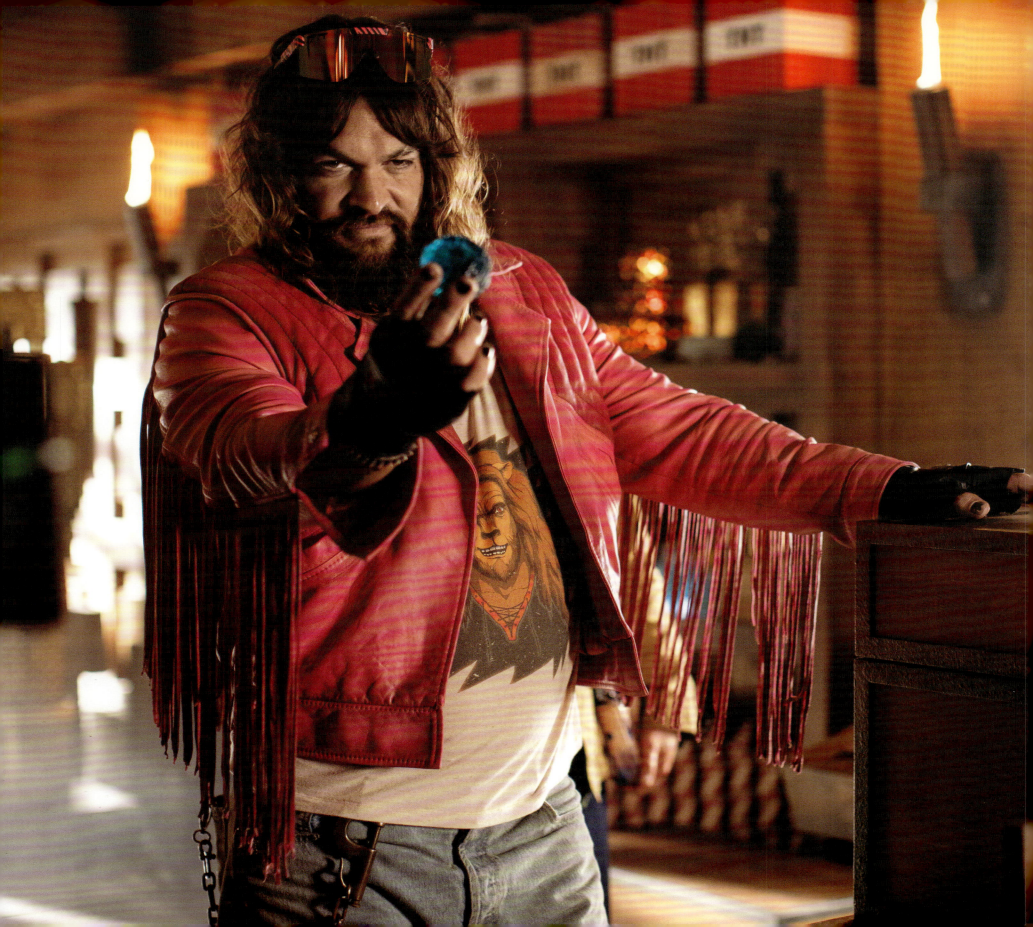

world. "We made a one-to-one copy of a *Minecraft* game sword, and we tried to scale it for a human, but it was impossible to hold," Cornelius recalls. "Just a series of stacked diamonds, and the handle was two diamonds, basically, so you just couldn't hold it. The whole scale, as based on the game, was wrong, so we had to determine just how much detail to put into the pixels, and how many cubes would fit into each sword. The handle of the sword had to look and feel real, and we had to be practical about it, but when you look up close, you can see all of the cubes that went into each individual object. Then we had to figure out the right scale of those cubes, the right square size, that would allow us to build anything that we wanted in the real world. And that was the biggest challenge right there.

"Once we got those rules and the laws and could apply those to

OPPOSITE Ender pearls are incredibly rare and should not be used unless — never mind, Garrett's going to give this one a shot.

ABOVE Remember — iron swords are prone to rust without proper maintenance!

2. BUILDING BLOCKS 91

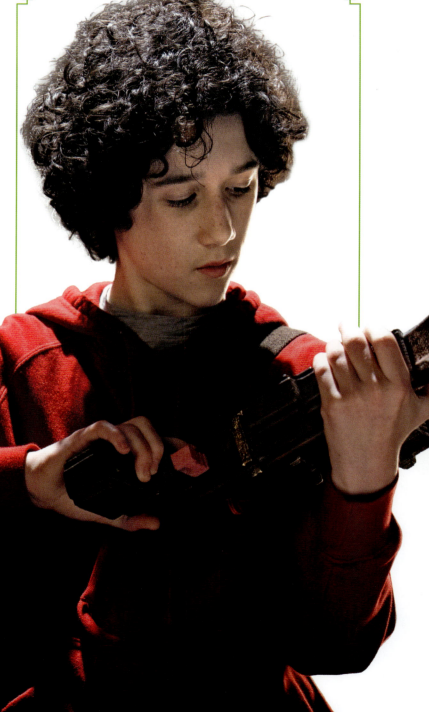

you can make objects that would appear to be very heavy actually very lightweight, like swords and other metallic objects; the versions made for stuntpeople will be lightweight and incredibly safe at the same time. Utilizing new technology saves a lot of time and makes my job a lot easier."

ABOVE Every profession in the village has its own tools of the trade, whether you're a weaponsmith or a butcher.

RIGHT Henry's tot launcher is just one of the new inventions that he'll use to help his friends navigate the Overworld.

OPPOSITE Natalie had no combat experience before her journey to the Overworld, but she's a fast learner!

all of the props, we had a bit of a language that we developed in the design world, that made it easier and easier. In the beginning, it was very difficult, but soon we found our feet and our way forward, which was excellent."

Many of the swords were crafted using digital models and 3D printing, a necessity in modern filmmaking, especially for a production on the scale of *A Minecraft Movie*. "We embraced 3D printing technology, and we really had to," says Matt Cornelius. "We would have loved to have a hand in every single piece in the production, but we literally didn't have the time, given the production schedule. Although we were tweaking models as opposed to tweaking drawings, that allowed us to go from the computer screen to a hand-holdable prop within a couple of days. From there, we have the molding process, then we use carbon fiber technology to produce an item, and that technology has advanced quite a lot over the years, especially here in New Zealand.

"It's really quite amazing. We can put armatures into things to make objects both superlight and superstrong, and it's amazing that

92 A MINECRAFT MOVIE: FROM BLOCK TO BIG SCREEN

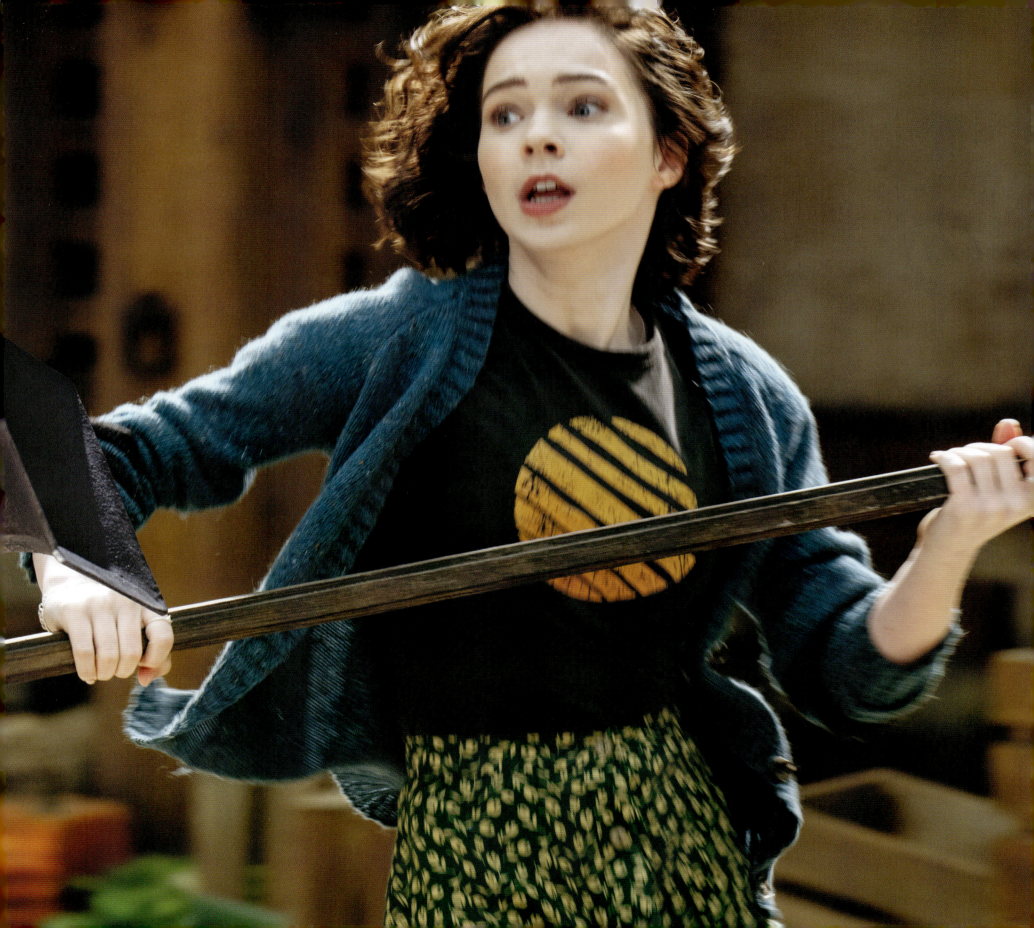

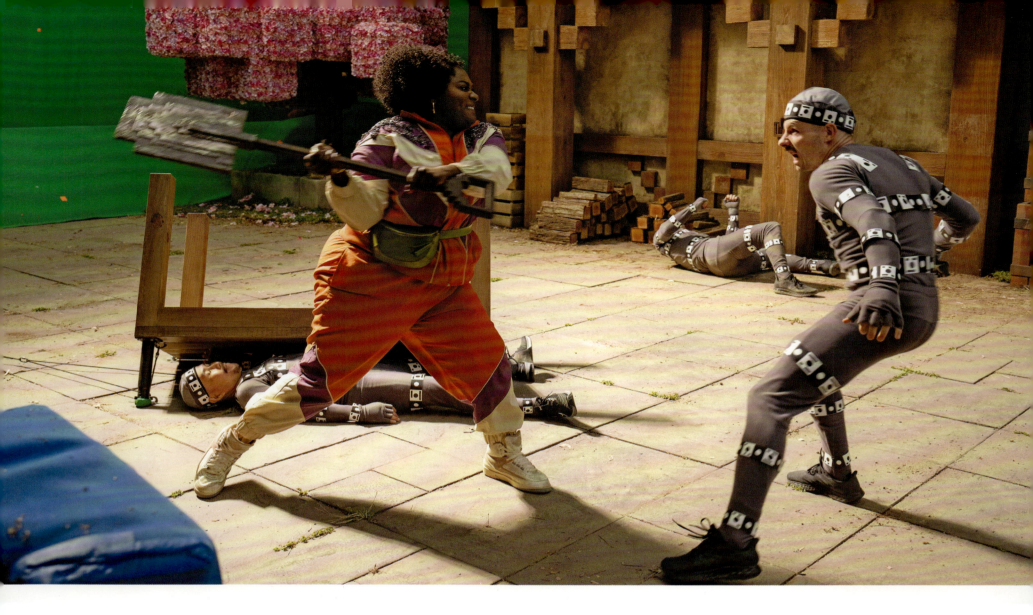

Stunted Development

ABOVE Swingtime! Dawn wields an iron shovel to keep the mobs at bay.

OPPOSITE ABOVE Garrett learns that you never know what you're going to get when you combine unexpected objects on your crafting table.

OPPOSITE BELOW Chains and buckets combine to form bucket-nunchucks . . . Buckchuckels!

The mix of traditional methods and cutting-edge technologies is essential for a film that features as many dynamic stunts, complex scenes, and intricate props as *A Minecraft Movie*. "Most of the props were 3D printed, especially during the prototype stage," notes Polly Walker. "We would try many different approaches, then the one that looked best would be molded and cast. All kinds of materials were used, but there was a lot of thought put into what would be most practical for each item. Some of the swords that were made were too sharp, so we had to make rubber ones for the stunt people to use.

We had hard resin ones, rubber, foam . . . I don't know how many swords and crossbows and spears I've painted.

"The handle was square on these as well, and for the stunt team, it was difficult, even painful for them to hold. So I would say pretty much every product that could be used was used in *Minecraft*. Sometimes it looked like a research lab as the prop team figured out how to make everything real."

Prop master Matt Cornelius brought all of his experience to the crafting table for this production, as his workshop utilized a full complement of traditional and digital techniques to fabricate each

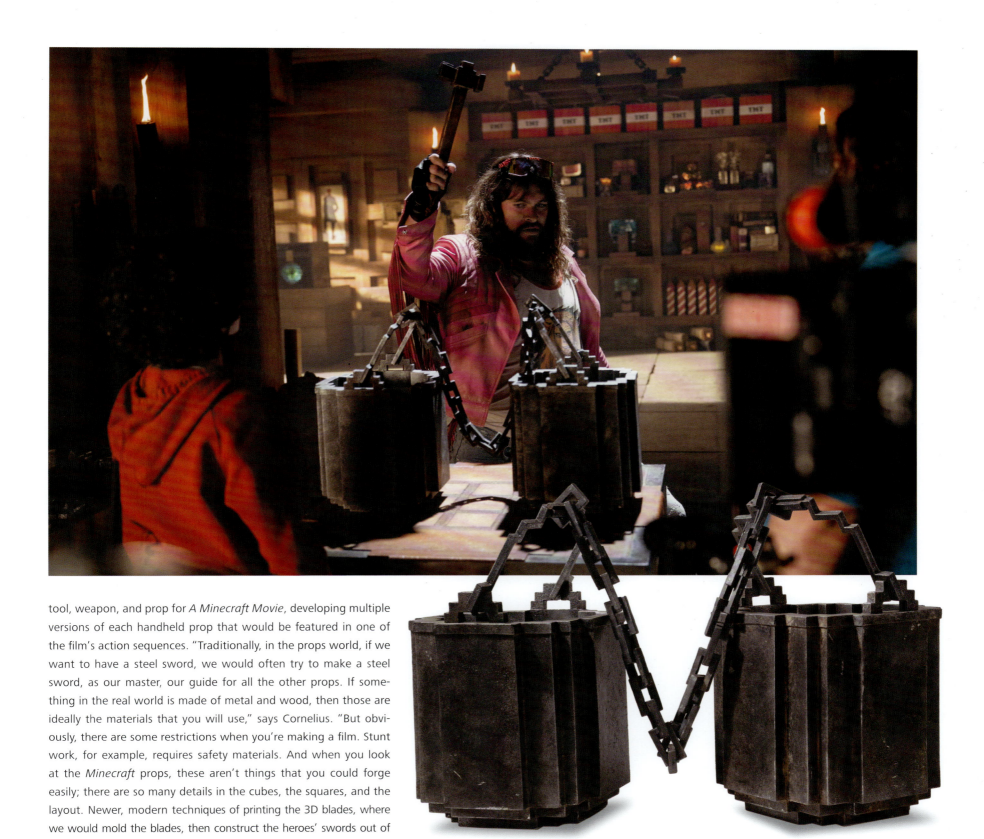

tool, weapon, and prop for *A Minecraft Movie*, developing multiple versions of each handheld prop that would be featured in one of the film's action sequences. "Traditionally, in the props world, if we want to have a steel sword, we would often try to make a steel sword, as our master, our guide for all the other props. If something in the real world is made of metal and wood, then those are ideally the materials that you will use," says Cornelius. "But obviously, there are some restrictions when you're making a film. Stunt work, for example, requires safety materials. And when you look at the *Minecraft* props, these aren't things that you could forge easily; there are so many details in the cubes, the squares, and the layout. Newer, modern techniques of printing the 3D blades, where we would mold the blades, then construct the heroes' swords out of

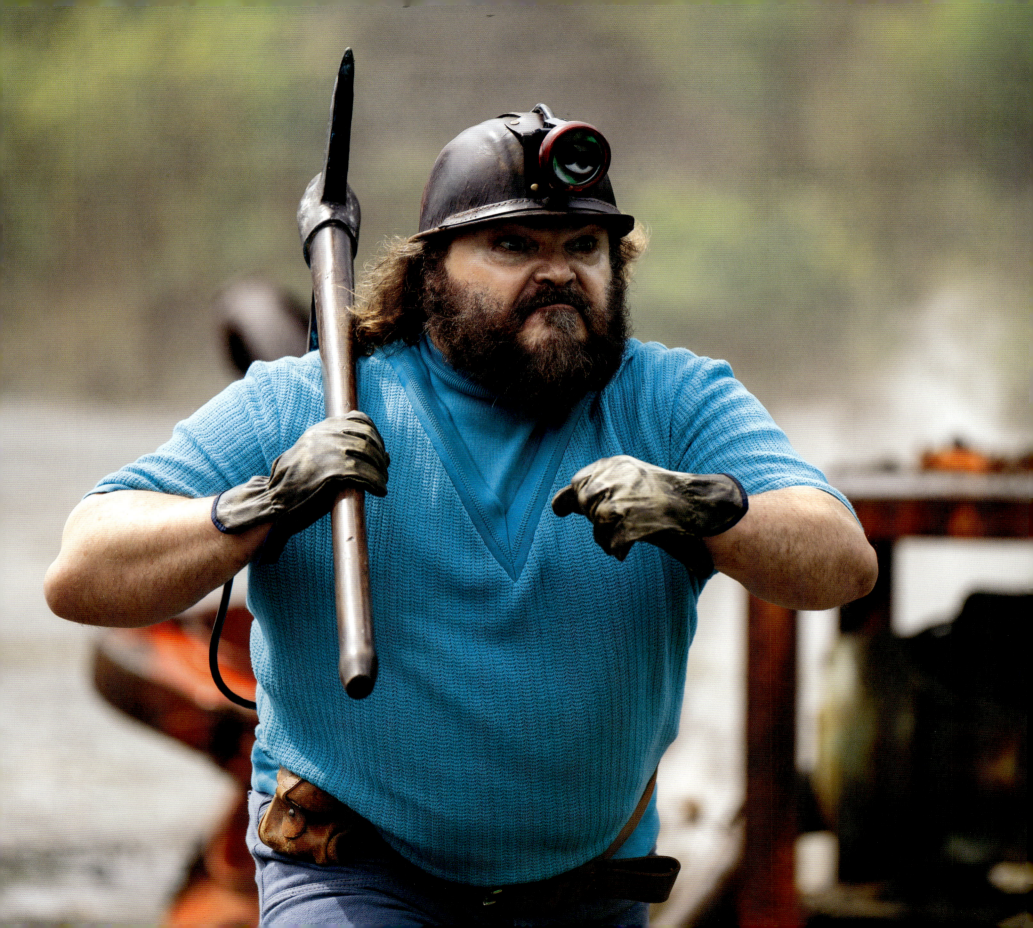

"We worked hard to make sure everything looks real."

carbon fiber, and urethanes, then spend a lot of time with the extras, with the painters stepping in and bringing that level of detail and craft to every piece on the set. Giving everything that needs it that proper metallic finish. You wouldn't know that any of the weapons on the set aren't metal.

"Fun fact: They're very light. For a stunt sword, we can't have carbon fiber and urethane; we need to make it soft, so the stunt players can swing it. It needs to be light and safe. Again, we have to concentrate on the design and the print finishes to make sure that they still look absolutely real, to the point where if you line up three or four of our props, you wouldn't know which is the real one because of the paint finishes. And we worked hard to make sure everything looks real."

It was the duty of stunt coordinator Jon Valera to incorporate those weapons into the action sequences featured in *A Minecraft Movie*. The non-traditional look and feel of those props forced Valera and his actors to think outside the box when it came to action choreography. "The prop master gave us a lot of weapons that were true to the game. The diamond sword is not a smooth blade, so a lot of the choreography is not what you think it's going to be. We used a lot of the weaponry that was true to the game, and it was fun seeing those props in action.

"It was great because everyone got to come into our stunt gym and train with us, and we got to find out their strengths and weaknesses and build on that," Valera continues. "Obviously Jared had his idea of what each character was going to be doing, and each character's style. Everybody is going to think that Jason Momoa is going to be the badass character, but he played the complete opposite of what he normally does. Everyone's going to be in shock as far as his character, because it's so completely different. Jack Black was amazing to work with. He came in and trained hard, and he wanted to make his character stand out. A lot of people know already that he's already very agile, and to see him do his thing in person was amazing. Danielle and Emma came in and trained hard as well. Jared didn't want them to be badasses, he wanted them to be normal, everyday people, but they really put the work in, defining their technique and their actions.

"Emma picked up the choreography really well. I was taught from the beginning of my career to always make your actors look good, no matter what, because they're the ones that everyone is there to see. If you make them look good, if you train hard, it benefits everyone."

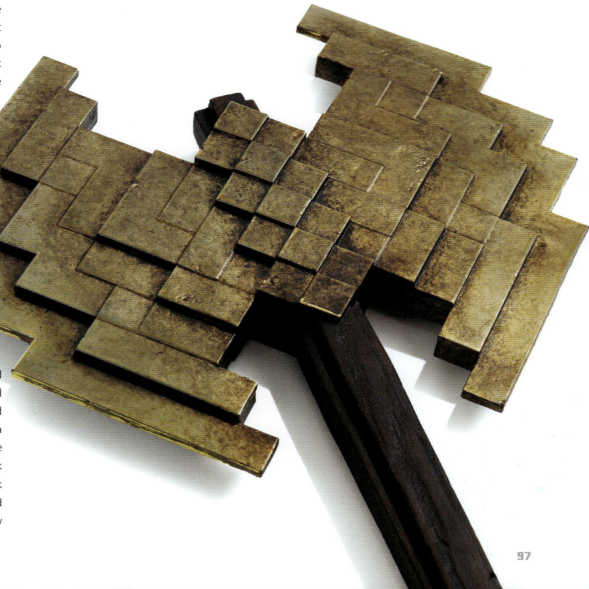

BELOW While not as durable as its iron counterpart, the gold axe is known for its speed, ability to disable shields, and its usefulness as a melee weapon. And unlike in game, this gold axe has two heads!

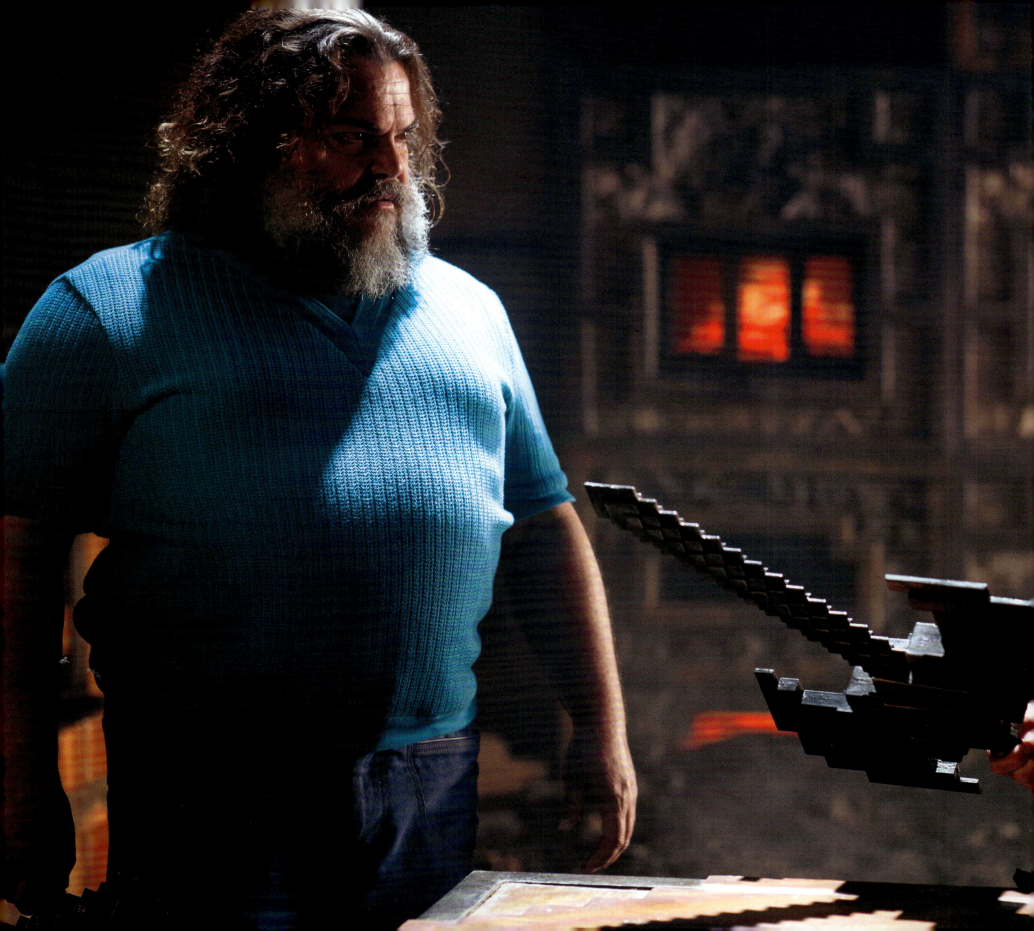

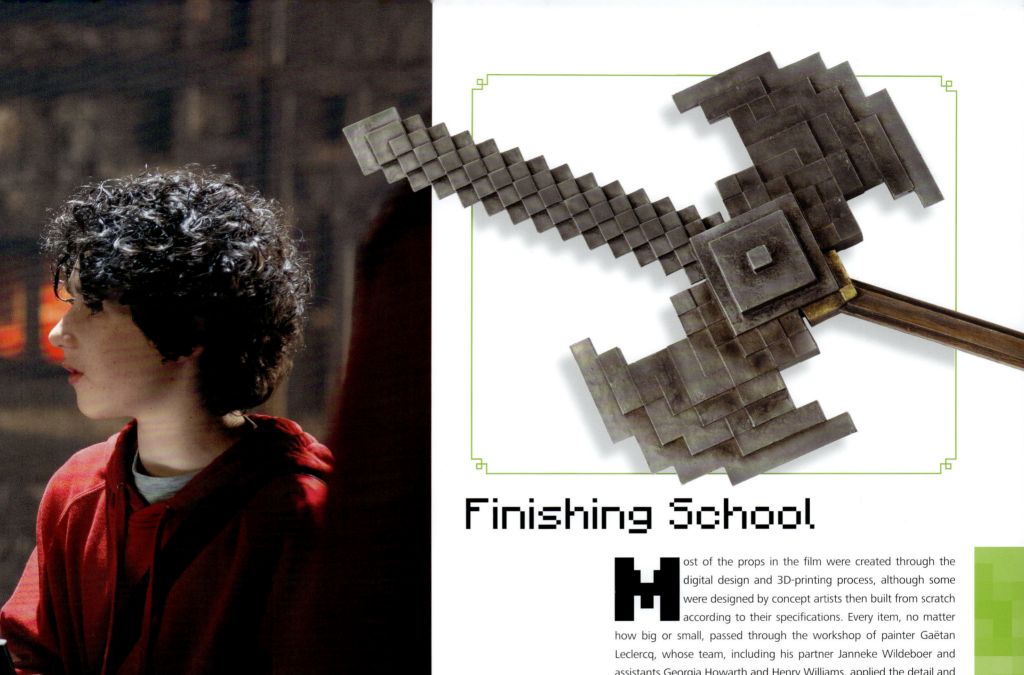

Finishing School

Most of the props in the film were created through the digital design and 3D-printing process, although some were designed by concept artists then built from scratch according to their specifications. Every item, no matter how big or small, passed through the workshop of painter Gaëtan Leclercq, whose team, including his partner Janneke Wildeboer and assistants Georgia Howarth and Henry Williams, applied the detail and finishing touches that ensured that every item was ready for the big screen. "I think the most difficult process was creating the swords. Everything that had to be metallic," says Leclercq. "Not only because they wanted a brand-new sword—Polly did a few designs, and there were a lot of meetings about it. The first ones were too bulky. They made sense in the game, but when you brought them to the real world, it felt like you were holding a toy. And I think that was the early process of weapons. It looked cheap, like something you bought from the supermarket. Too plastic, too bulky.

"They asked me to come in and give it a real metallic finish. And

OPPOSITE Two weapons in one! Steve looks on as Henry combines an axe and sword into a truly epic weapon.

ABOVE This weapon combines two of *Minecraft*'s standard weapons into a versatile addition to Henry's armory.

2. BUILDING BLOCKS 99

we realized that the metal was too reflective, and the way it reflected made it look black when it was filmed. It was reflecting the light in different ways that didn't make it look like a sword. It looked like a stick. And that was the longest process. On this film, we had a lot of stuff we had to make and paint, and then it would go through the scanning process. They would scan it and then they could use it [as a render] in the background or wherever it was needed in the film. From the practical side, actors like to hold something that looks like a weapon or an apple. It's the preference of the actors, most of the time. There's a lot of stuff that you need to build so that digital artists can study it, see how the light reflects off of it, practical applications like that. You can use digital tools to approximate that, but whenever possible they like to have a physical object that they can study.

"I would say pretty much everything that an actor is holding, every prop, has been built so that it can be held, then can be scanned and replicated if need be. That makes me happy, because that means that my job will still go on; they will still need painters. They may need us for different purposes and applications, but I'm happy to continue to do this kind of work. It might change in the future, but we'll see.

"There are a lot of digital artists, and because I was trained by old painters, the art of restoration painting, it's hard to keep that alive," Leclercq observes. "You can use these skills in different ways, different industries. On each production, I try to get an assistant, somebody who is just fresh in the business, to teach them what I've learned, so that goes on."

All of Leclercq's skills, from the traditional to the state-of-the-art, were put to the test when it came time to craft one of the rarest and most treasured items in *Minecraft*, the diamond sword. "The diamond sword was a highlight. We spent a lot of research time to make that look really cool. And I really liked the square palette with square brushes that we made. It's one of the bittersweet things about this job, that you get to hold these great props during production but then you know those things will go into storage after filming is complete. That diamond sword was pretty epic."

OPPOSITE (Concept art) The standard armory contains many weapons, but will any of them be enough to stop Malgosha and her piglin army?

BELOW Rare in gameplay and in the Overworld, the diamond sword represents the near pinnacle of innovation and technology.

2. BUILDING BLOCKS 101

BELOW Like its sword counterpart, the diamond axe is one of the most treasured and valuable items in the Overworld.

OPPOSITE CENTER Diamonds are an inventor's best friend.

OPPOSITE RIGHT Only the diamond helmet and the accompanying diamond chestplate can protect Steve during his final battle — or can they?

> "I'm not going to say whether or not I have a diamond sword in my closet right now."

Prop master Matt Cornelius and props designer Polly Walker had to bring all their knowledge and expertise to their own crafting table to bring the diamond sword to life, since its unique properties within the world of *Minecraft* did not necessarily lend themselves to a practical weapon in the real world. "That was such an interesting prop to make," says Cornelius. "It's meant to be translucent, and we did a lot of tests in the workshop to find the right resins to use to get the right translucency and the right fractal look. There were aspects that we knew, from the paint finish, and the different models that we had to build—we had to make a carbon armature that was clear, virtually invisible, because we needed a lightweight version of the diamond sword."

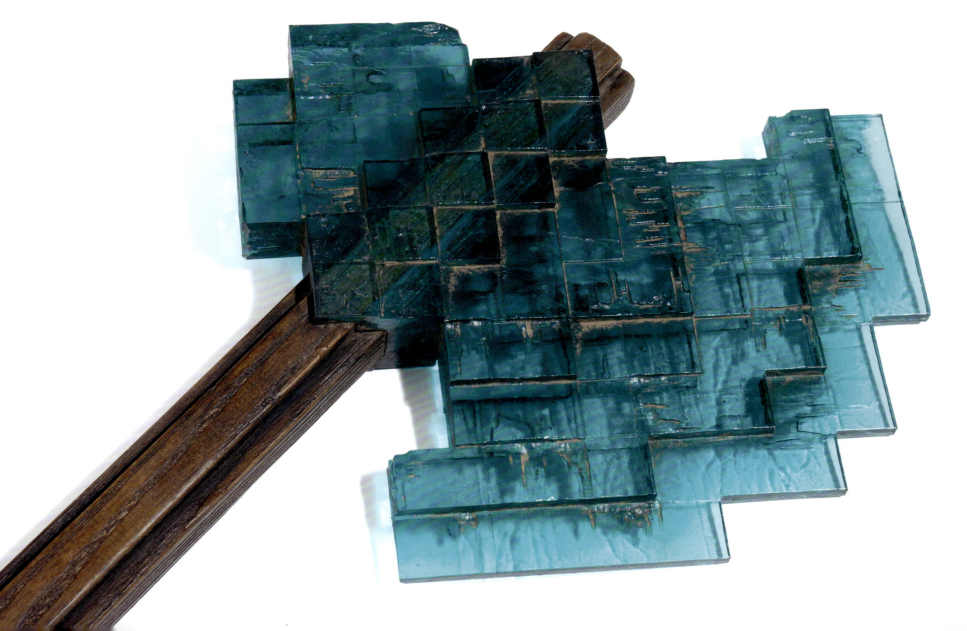

"Many of the colors in the sword were already there in the prop itself, in the cast, so Gaëtan's job was to bring as much of the glow as possible to the external surface. It required a lot of subtlety, but he and Janneke have an amazing skill set and the ability to make anything look like anything. I know that Jared and everyone at Warner Bros. were impressed with the quality of our work. We had such an outstanding team. The level of care, the reality that we brought to the props was next level."

That level of craftsmanship and the sheer awesomeness of the *Minecraft* props was appreciated by everyone on set, including the stars of the film. "The props department, they did this amazing work with every pickaxe, every sword, the diamond armor!" Jack Black notes. "The lapis lazuli! Every detail. The square loaves of bread. The square apples.

"And they noticed that some of these incredible things started disappearing. And they had to call a meeting for the whole crew. 'EVERYONE ON THE CREW! It has come to our attention that some people have been taking some of the props! Now that's not legal! No one can steal candles, apples, or any other items from this set! Is that understood! Let's be professional!'

"Anyway, everything on the set was kind of like a treasure, because it was so cool to look at, and everyone wanted to take home a little piece, of course. But I just took that as a sign that we were making a really cool movie. Everyone wanted to take home a treasure.

"Did I take home a treasure? I'm not going to say whether or not I have a diamond sword in my closet right now. That's not important, and I can't confirm nor deny!

"A pickaxe might have gone missing . . . I don't know!"

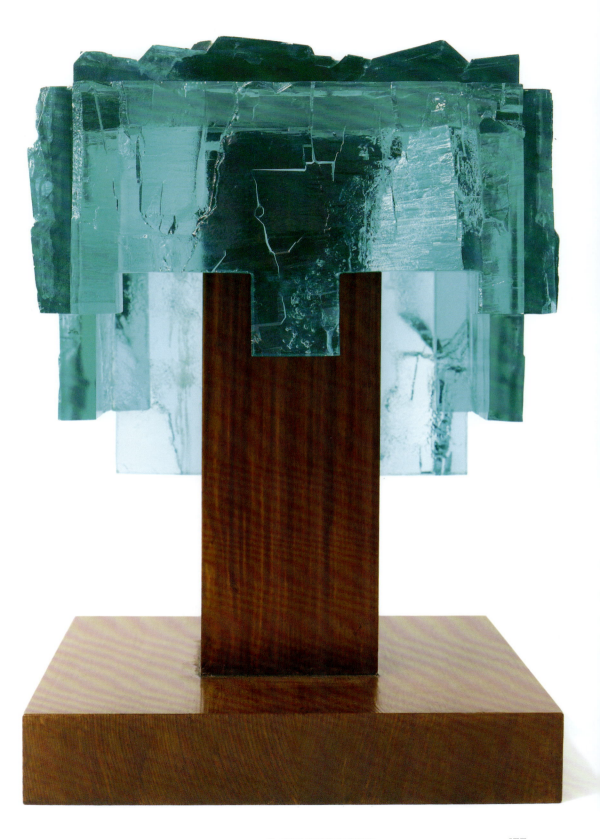

2. BUILDING BLOCKS 103

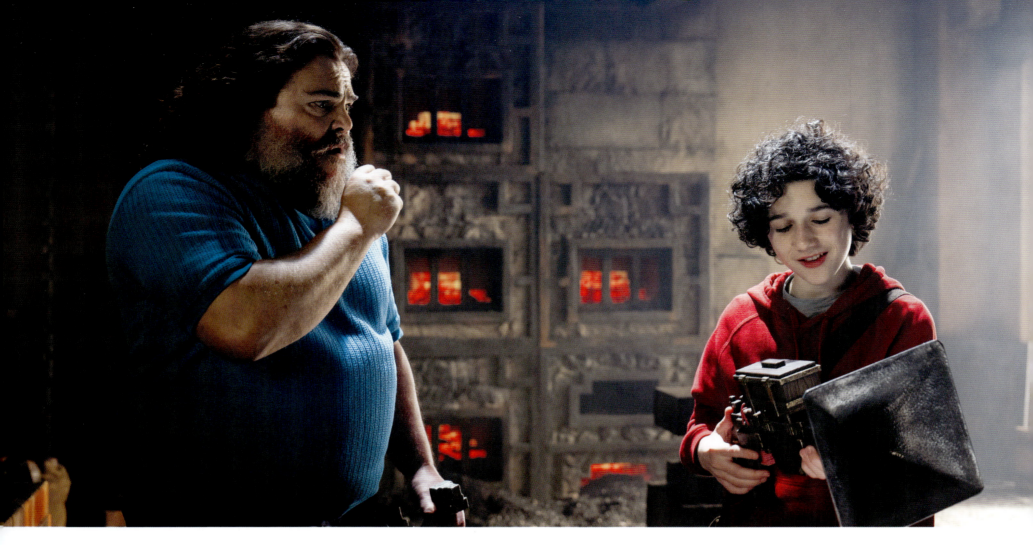

There Will Be Spud

Creativity in *Minecraft* is not without its limitations. You can't make something from nothing, for one thing, and some of the fundamental building blocks of the game are incompatible with one another. But what happens when the real world collides with the virtual world, and some distinctly non-*Minecraft* elements are introduced into the Overworld?

Director Jared Hess had some very specific ideas about just how this integration would happen, and he worked very closely with the props department and design teams to ensure that what appeared onscreen would match—and far surpass—the concepts that he wanted to bring to life onscreen. "Jared is so amazing," says prop master Matt Cornelius. "His vision, if we approached him to get some ideas and concepts that we could develop, he always came back with something amazing. We'd often take things on ourselves to keep things moving, then we'd take those ideas to him and he'd offer his take on what was working well and what could go in different, stranger directions. He knew what he wanted, and it was up to our design and fabrication team to take that input and deliver on his vision."

As anyone who has watched Hess's 2004 classic film *Napoleon Dynamite* can tell you, tater tots are an essential part of every adventure hero's diet. Delicious, nutritious, compact, and portable, every kid—especially kids who grew up in the Midwest like Hess—is familiar with the tiny spuds, which are a staple of school lunches and family barbecues. And almost every one of those kids knows that these bite-sized spuds have a secondary function as nature's perfect projectile. Light, aerodynamic, and the perfect size and shape to launch from one end of the dining room to the other . . . or to repel an army of marauding piglins.

ABOVE Even Steve, an experienced crafter, is impressed with Henry's ingenuity.

104 A MINECRAFT MOVIE: FROM BLOCK TO BIG SCREEN

Real world meets Overworld on Henry's crafting table as he turns his creativity loose and builds a tater tot launcher to protect his friends from the strange new world around them. This bizarre new device pushed the film's director and visual artists into uncharted territory as well.

"Can't get away from tots! I feel like most of my biological makeup is made from potatoes," says Hess. "We were just trying to think of a fun projectile, something Henry could bring from the real world that would be on his person, that later he could use as a projectile from a little launcher. Initially we were going to call it the spud gun and build little potato cannons, but we thought he wouldn't be carrying a full potato, but maybe he's got a loose tater tot rolling around in his hoodie, and he can put that on the crafting table along with an eraser, a battery, and some other stuff. And then see what would come of it. Small things that you could put into the inventory, onto a crafting table, then see how it would come together."

Bringing Hess's vision to life would be props designer Polly Walker, who found that wholly original creation a nice change of pace after she had spent several weeks adapting established Mojang tools and weapons. "Jared met with us every week or two, where we'd make a presentation, and he'd give us feedback on what we'd designed. That's something that I really valued that I hadn't gotten on a lot of other jobs, with the director coming in and actually chatting person to person," says Walker. "Quite often I send something off to the designer or art director and then through all these channels. But on this production, it was really cool to actually have him stand there and explain things, and he's very animated and very funny. 'Oh, we need something like this, and the action is going to be like this, *pow ka-pow foom foom foom*!' And I'd say, 'Oh, yeah, we can do that!'

"The tater tot launcher that he described to us, he said it's not like a gun, and when it launches, it goes '*THOOOP*!' So you kind of think about that when you're designing, the sound that it makes, and what goes into it. I designed that, and it's very interesting, because it's out of the *Minecraft* world, made from real-world stuff. There were a few conventions that could be broken with that design. It sort of flares out, and some of the on-grid rules got more flexible as the production

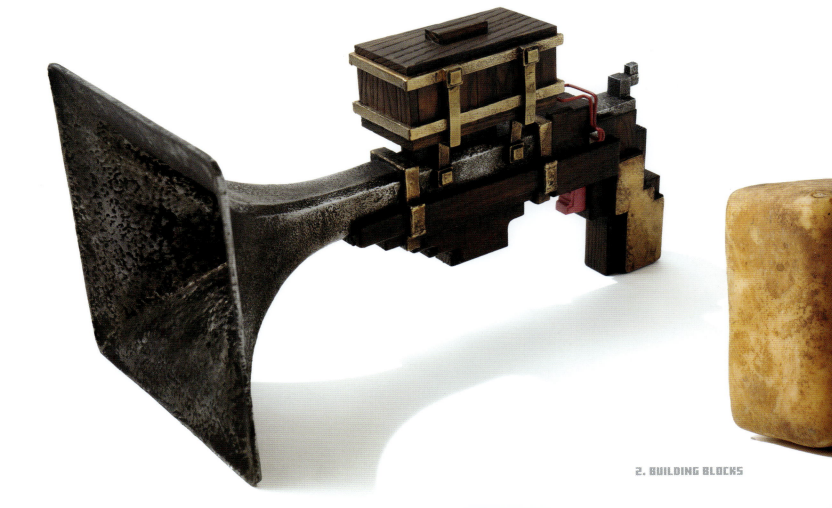

BELOW Henry's tot launcher turns an everyday potato into a spud-tastic projectile.

moved on, so there are a few more curves in there than in other *Minecraft* objects. Oh, we're allowed to do that? Well, that changes things a bit.

"It's still very square and *Minecraft*-y, but there are little bits, where Henry uses an eraser and a paper clip and a battery, and if you look at the design you can see these wires and clips and a battery you can see the end of, the trigger is like a rubber trigger, the same color as the eraser, and I incorporated all that. It's very wacky, but awesome fun to work on."

To ensure that even these uniquely non-*Minecraft* elements captured the feel and the spirit of the game, Mojang's senior leaders and designers were often on set and were never more than a text message away from the New Zealand–based design team. "On our end, one of our greatest resources is Markus 'Junkboy' Toivonen," says Torfi Frans Ólafsson. "He's the OG art director of *Minecraft*; he's been with Mojang since 2010. Markus and I made sure to push things in the right direction. But there were debates. Some initially felt that weapons and bows should be normal and not pixelated, that they should feel like a regular bow and a regular sword within the universe. But we thought, looking at them together, the regular weapons and the blocky universe didn't jibe as well. The weapons are iconic, and there's an expectation for it to look and feel a certain way."

While the elements needed to feel part of the *Minecraft* world, at it's core, *Minecraft* is about letting creators create, and Jens Bergensten realized the importance of stepping back and letting the filmmakers do what they do best. "One thing I learned about making a movie is that if you get too strict about following the rules and the play of the game, it's not actually very fun," says Bergensten. "It's a very convoluted story. One of the memes people have made about the teaser trailer comes from Jason Momoa crafting the buckchuckets, and he has just poured a bunch of items on the crafting table, and that's a much funnier way of doing that than saying that it has to be strictly on the grid. Because that makes sense in the game, but there's nothing in the physical world that clarifies why that's necessary, so getting stuck on that is just going to slow down the storytelling.

"That said, I think sometimes Jared has prioritized a funny moment over doing something the *Minecraft* way. It's a very deliberate and intentional game, and some things are slow and silent, and can take a long time, so sometimes I wish that certain things in the movie could have been slowed down a little bit or been a little more introspective."

Much like playing *Minecraft* online with your friends, however, Mojang knew that this project would require a lot of give and take. But if they struck the right balance with their creative partners, the possibilities were limitless. "I knew that our art team would be involved in some capacity, and that my creative director, Junkboy, would be involved from the get-go," says Johan Aronsson, lead creative in the franchise creative team at Mojang. And this work further refined the earlier conceptual thinking about the movie. "As he got involved, doing his

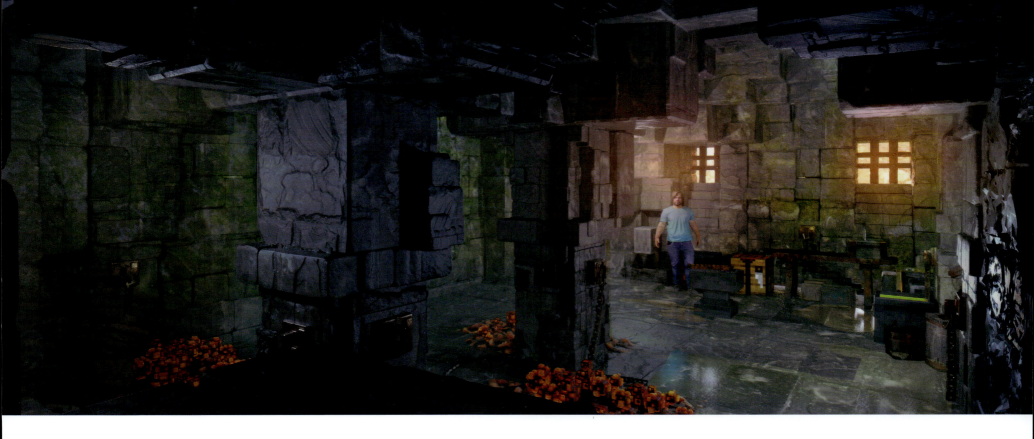

role, he would source things from us, different art directors and game designers, to define the look of the movie. A broad-stroke thought of what a *Minecraft* movie could begin to look like, feel like.

"Me and Junk sat in a room for a while to discuss this with Wētā. How from the beginning, you start with breaking a block. What happens when the block breaks? The block turns into item form, this little floating, weird thing in the air, and then you can pick it up and then you store it. But when you hack away at it, it just disappears, and then it gets assembled again. Then when you place it, it returns to the block form. Thinking about that, we had a little workshop around how that would happen, and how that would transition into these different items. When you build something out of something, it would have that logical structure between them.

"Everything that would have a round interpretation in real life was fun and challenging. Because of obvious reasons. Do you make it round or do you make it pixelated or blockified? And we decided to take that step by step. In the game, you have things that are entities, like mobs, that are kind of block-shaped as their base. But then you have items that don't have a block state. And those items only exist in the game as an extruded sprite. And those things would be like eggs, potions, the things that exist in 2D only. How do you make them feel *Minecraft*y?

"It was hard to find the logic because *Minecraft* isn't always logical. Some things are just what they are. We've done similar transitions before, like in *Minecraft Dungeons*, we were making the potion into an object, and we made that basically a square vial, and I think we tried to translate that in a similar way in the movie. Because that just felt natural," Aronsson continues. "We discussed the mechanics. How do you break something. Does it chip away, like a normal rock would? Or is it more like the game animation, where it cracks and breaks down in stages before it explodes? I remember we talked about the pixel being like the smallest molecule. And we didn't quite do that, because you need it to feel more real.

"Do we need to explain everything? Or can some parts just be vaguely mysterious? There's something nice about not dispelling the magic when we can avoid it. Because people have their interpretations, and that's one of the nice things about *Minecraft*. Some of the mystery is still there, because it's your reality, and you've decided how and why this is what it is."

ABOVE (Concept art) Despite spending years in the Overworld, Steve learns that there are surprises around every corner.

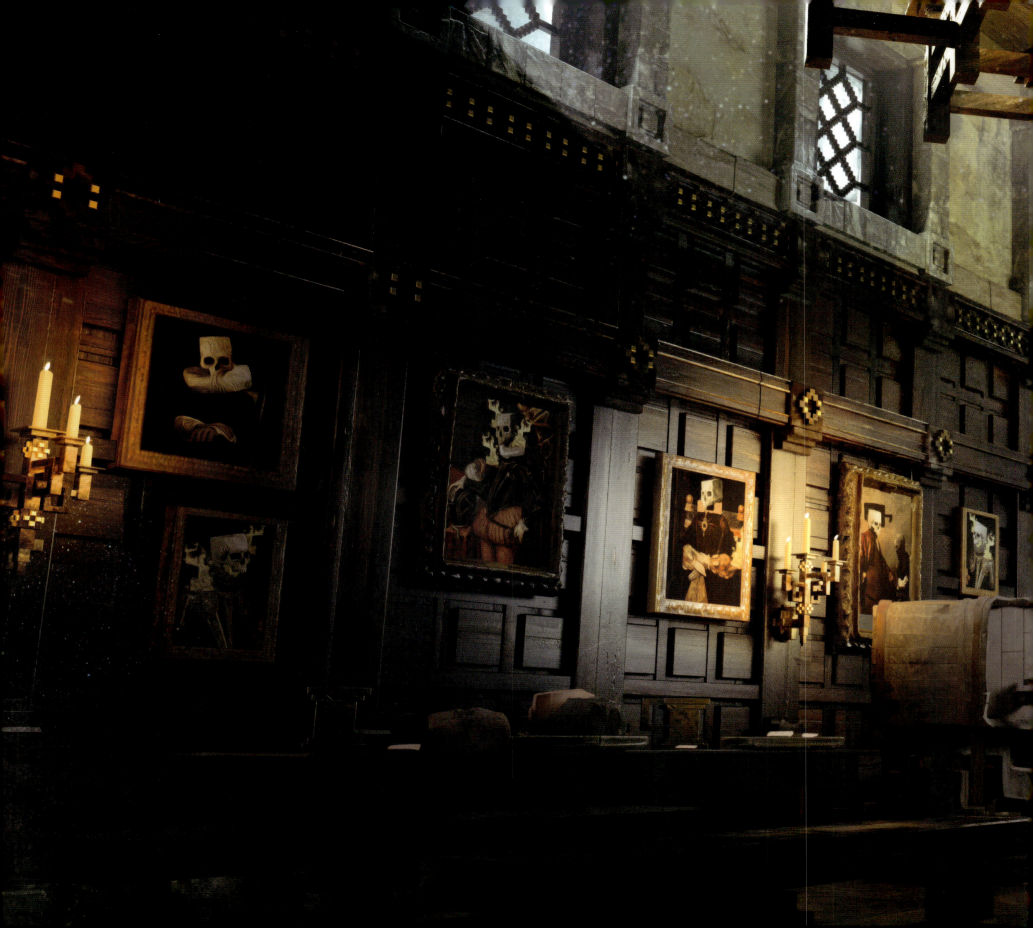

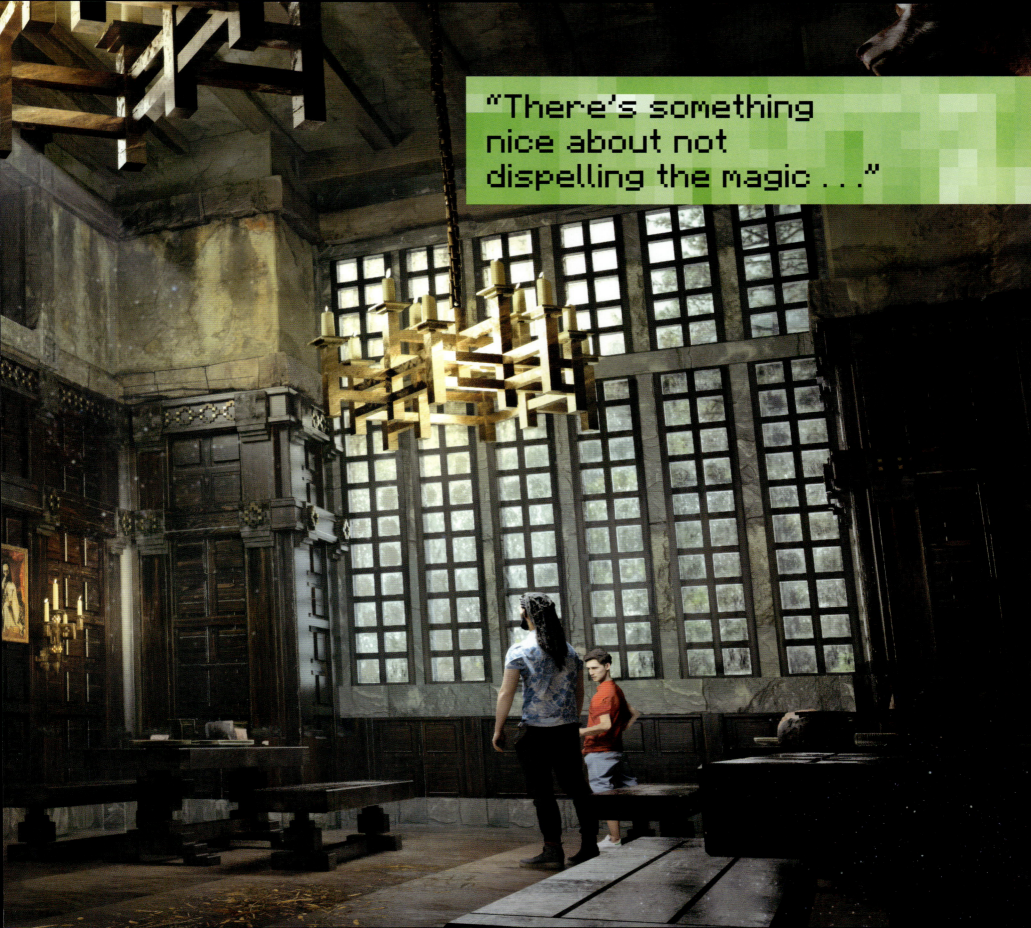

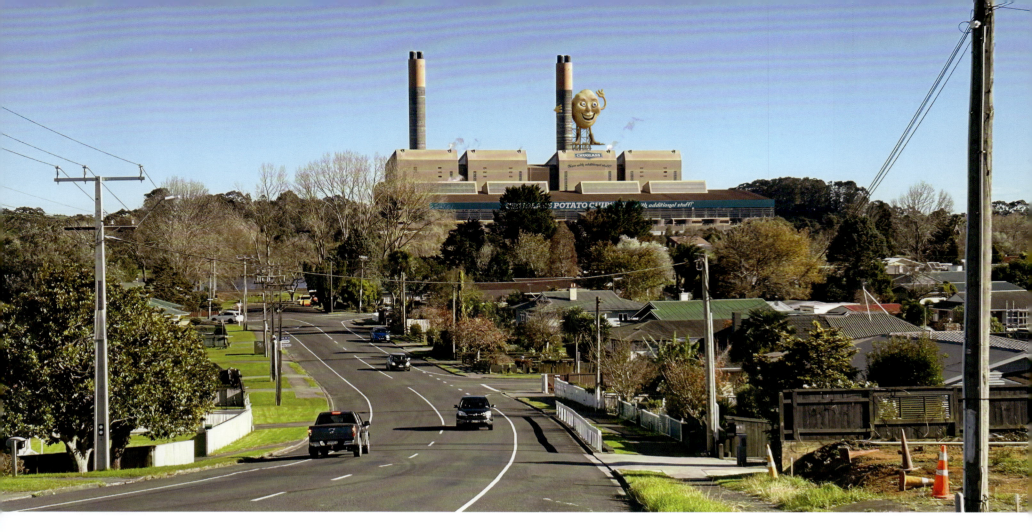

Welcome to Chuglass!

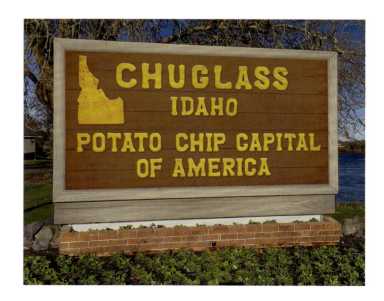

ABOVE The Chuglass Potato Chip Factory dominates the landscape of the small Idaho town.

Before their journey to the Overworld, Henry and Natalie journey to a land that may be even stranger than the biomes of the *Minecraft* world, a bizarre, almost supernatural realm unlike any they've ever seen or experienced before: Idaho.

Looking for a fresh start and an opportunity to rebuild their lives after the tragic loss of their mother, Henry and Natalie make their new home in Chuglass, Idaho, a quirky town known as the Potato Chip Capital of America, home to the 1989 Gamer of the Year Garrett "The Garbage Man" Garrison, a struggling public school system, and a population that makes the real world seem just as weird and mysterious as the *Minecraft* world—if not weirder.

"The fictional town of Chuglass, Idaho. We wanted a new place," says director Jared Hess, who grew up in the Midwest and who sets most of his films in America's heartland. "They move

there when Natalie gets a job handling social media for a potato chip factory. And we had so many iterations of this. We found an amazing building in New Zealand—and it's wild how much New Zealand looks like rural Idaho. So many beautiful farmlands, and it all just kind of worked. We loved the idea that when we meet our characters, they're all from this smaller place, and then they end up going on this journey to this massive, unbelievable world. It's a small town, so I guess I gravitate to what I know. When you're from a small place, you dream big. You dream of big adventures, for sure. When you meet these characters in the beginning of the film, they're all struggling at life in their own unique ways, and this adventure ups everybody's game. It's all about finding your creative superpower."

It was also about finding middle America, or a reasonable facsimile of it, on a tiny island more than seven thousand miles away from Idaho. "A lot of the real-world setting came down to location scouting, and we found some really good spots for that," says Mojang's lead creative Johan Aronsson. "We talked about how Garrett's place would look, finding the right level of dirtiness. But it's

LEFT AND BELOW "Potatoes + Oil = Happiness!" isn't necessarily the greatest advertising slogan, which explains why the team at Chuglass hired Natalie to reinvent their branding and their social media presence.

BELOW Henry and Natalie's new home in Chuglass—and just about every building in town—is just a potato's throw from the chip factory.

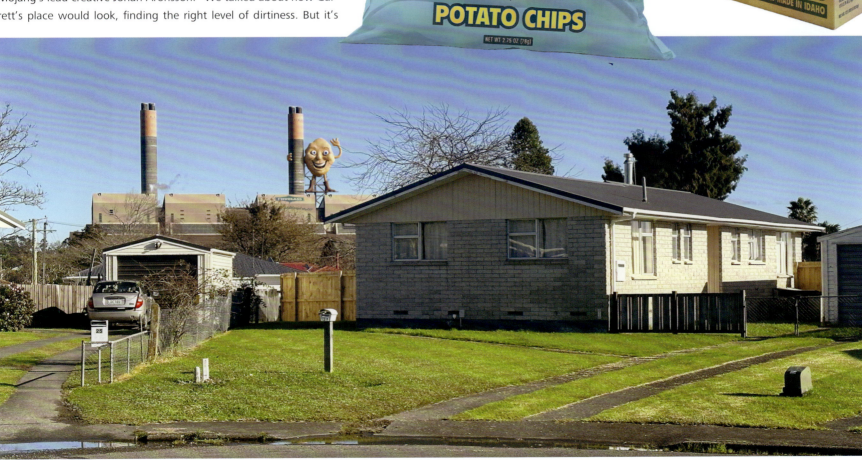

2. BUILDING BLOCKS 111

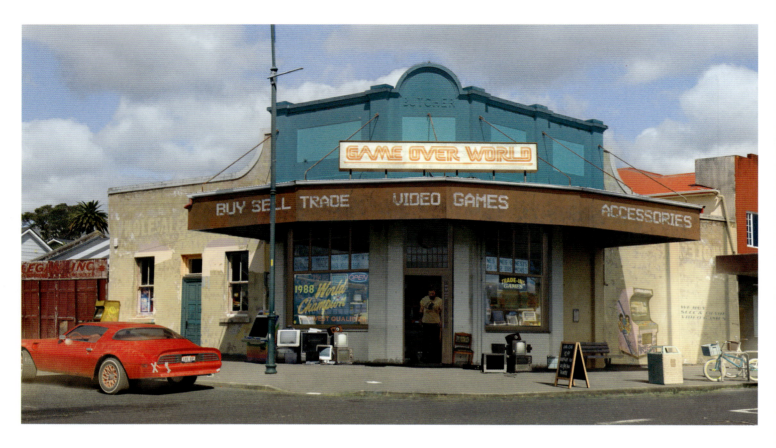

also his kingdom, if you will, so he would keep it tidy, and be kind of gentle with all of his machines and everything, so there's that balance. And the town of Chuglass itself, there's that '80s vibe to everything, which is almost—you go into an American town in the Midwest somewhere, and this is what you get.

"We talked about the living room space in the family's home, where the kids live. It just struck me how that's like the living room of the average American household, and I've seen that room so many times. It's very core, if you will. But for the most of it, it was location first, then finding the right spots, the right tone, and the right feel."

Bringing Chuglass to New Zealand allowed the production to take full advantage of the talented filmmakers who lived Down Under, as well as their knowledge of the geography and the landscape of Auckland and its neighboring towns. "Just within commutable range, about an hour's drive from the set, there's a small town that's been bypassed by the motorway," notes Grant Major. "A town that's had its day, several decades ago. But there's an old power station there, with two big chimneys. And we turned that into Idaho's finest potato chip factory, supplying potato chips to America! We were kind of lucky that the town was built for the power station, for the people who worked there, and it developed kind of like a suburb, which is quite hard to find in New Zealand, an American-looking suburb with large houses and no fences and large sections, and we just happened to stumble upon that town, with the power station right behind the houses. So it had this really nice graphic relationship. We're very fortunate to have found it.

"The Game Over World shop, Garrett's shop, we built the interior on the set, but the exterior is an old butcher shop in another town, just north of Auckland. [It's] just very nice to be able to find something with character for that. The school, we looked around a lot of schools in Auckland, and we found one that looked very much like

ABOVE Welcome to Game Over World, the headquarters of Garrett "The Garbage Man" Garrison. It's your one-stop shop for gaming lessons, video games, and personal advice . . . from 1989 and earlier.

OPPOSITE The 1989 World Champion has the sweetest ride in Chuglass, a red Pontiac Firebird. Hands off!

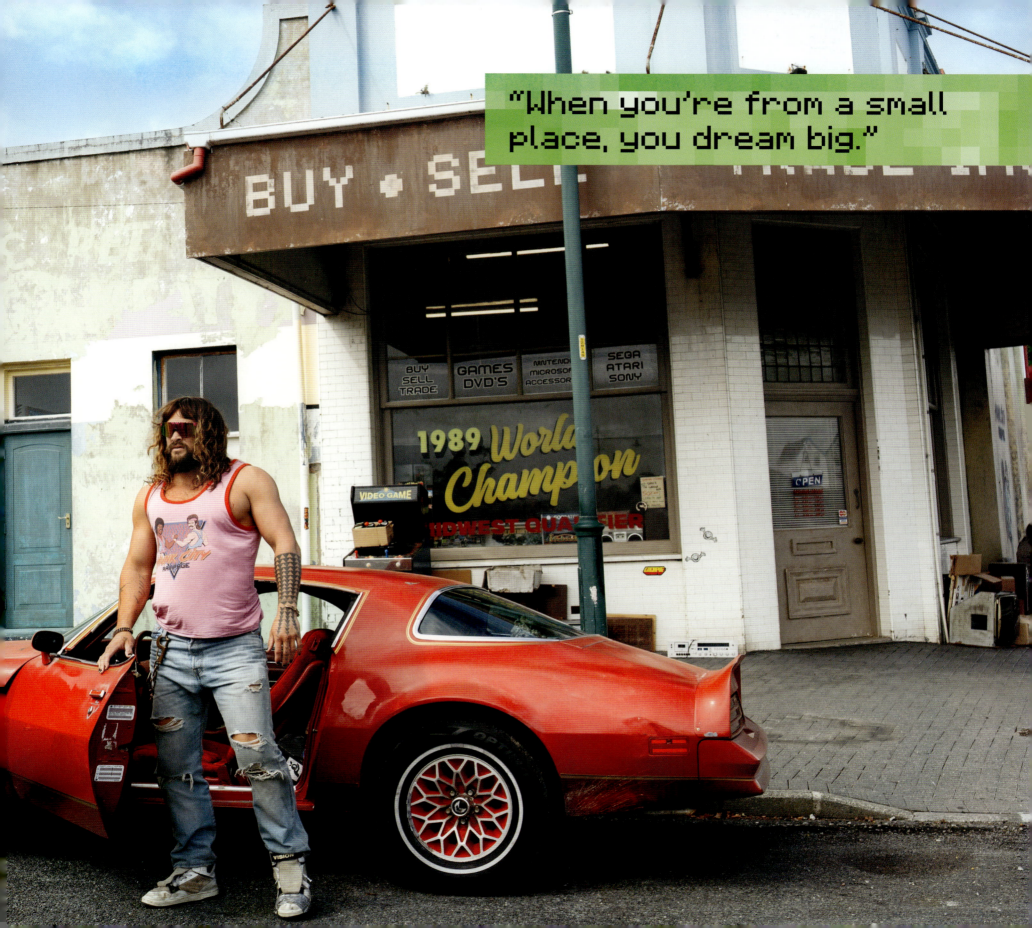

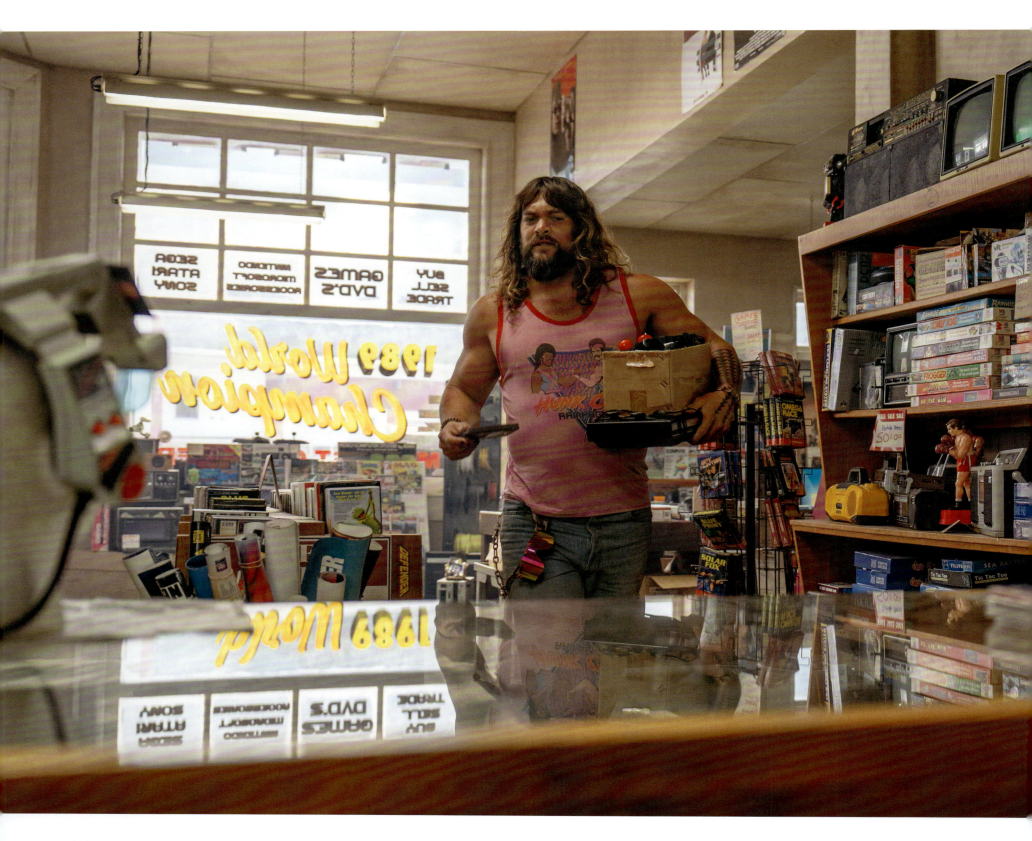

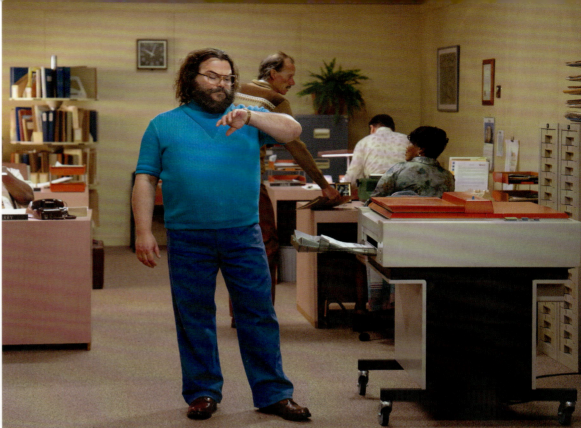

Napoleon Dynamite's school, oddly enough. It's very fun, that sort of character, that middle America vibe that New Zealand has parts of. Obviously, we're a long way from middle America, but finding elements that you can recognize, the things that make sense to an American audience, I think we did pretty well with it."

Outfitting the residents of this typical American town was the duty of costume designer Amanda Neale, who had considerably more experience dressing inhabitants of Middle-earth than townsfolk in the Midwest. "Chuglass, that's a made-up town in Idaho. So it was important to create context," says Neale. "What is Chuglass? Where is Chuglass? We created a high school uniform, and tourist T-shirts and sweatshirts that showed how proud everyone was of their town.

"Even the potato chip factory, that scene is hilarious, brilliant. We played a lot with references to convey all of that, all of that detail, but with a little bit of humor. We put graphics into costumes wherever we could."

As someone with little gaming experience, Neale didn't think of herself as an obvious choice as the lead costume designer for a video game movie, but she appreciated the opportunity to take on a new challenge unlike any that she'd encountered before. "I'm a hands-on designer, starting at the very beginning with budget and research. I work on a Miro board, so all of my research goes onto that. And

OPPOSITE Garrett adds to his impressive inventory at Game Over World, a time capsule of classic arcade games and memorabilia.

ABOVE Steve wasn't cut out for the nine-to-five office job he held before entering the Overworld.

RIGHT The Chuglass High School varsity jackets are an essential part of the local Idaho teenager's wardrobe.

OPPOSITE ABOVE Welcome to Chuglass High School! New students should report to vice principal Marlene's office for orientation!

OPPOSITE, BELOW LEFT And here is Mr. Gunchie's classroom! Due to budget cuts, he's adding art instruction to his gym-class duties, but let's all make the best of it, okay?

OPPOSITE, BELOW RIGHT Many young lives will be changed here in vice principal Marlene's office. She would like to remind you that you shouldn't listen to any media reports that call Chuglass High School the worst school in the state. Worst in the county, fine, but worst in the state? Come on.

I had two different illustrators working in different parts of the country. One working on the villagers and all of the Mojang characters, and another working on the real-world illustrations. I'd work on the Mojang characters in the morning and the real-world characters in the evening, making sure that they were working in conjunction with each other. Because with all the visuals and the graphics, illustrating so many different iterations of where we can go with each character, I would feed them reference and research, then they would do an outline and present it, and we'd figure out where we needed to go based on Jared's notes."

Four residents of Chuglass, lifelong residents Garrett and Dawn and transplants Henry and Natalie, would appear in both Chuglass and the Overworld, two visually distinctive realms that couldn't be further apart in terms of cinematography. "I think that the biggest challenge, from the costume-making point of view, was making sure that the real world held enough interest and detail as the Overworld. The world that Grant Major and his team built was incredible. The real world and the nuance and color couldn't get lost," says Neale. "Jared was keen to keep a simple palette there, but both worlds required a lot of work and research. We shot this film in Auckland, New Zealand, in two seasons, and we had to track which season it would be in Idaho, what does Idaho look like, and deep-diving into that physicality, what does modern-day Idaho look like? Because we're foreigners to it. We had to make sure that was a convincing element of the backdrop. Making sure that it was comfortable, and at least we were shooting in the summer and didn't have to layer the characters. We decided that it was set during a generic fall season. A few practical elements to consider with the design process."

A MINECRAFT MOVIE: FROM BLOCK TO BIG SCREEN

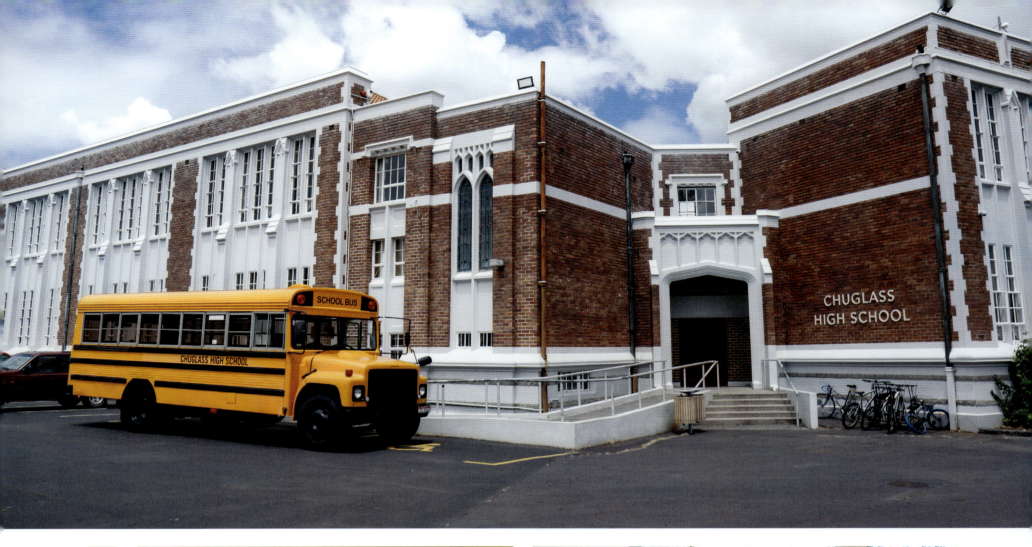

2. BUILDING BLOCKS

Garbage Time

Once Amanda Neale signed onto the film, she began a deep dive into the world of *Minecraft*, studying the environment, the palette, and the characters that would inform all of her costuming decisions. "When we started our research, it was so broad. We studied all the essential *Minecraft* skins. We looked at the Java Edition, so we could be kind of purist in our research, and not be complicated by every other kind of skin on the market," says Neale. "I guess that's the other thing that I really enjoyed about these characters, who were designed fifteen years ago. These characters are kind of genderless and they live in an egalitarian society, and they're in this very, very cool, wholesome way of living.

"We had some influencers come in, and they said they would kill a certain villager, and I said, why would you do that? It's such a beautiful game, why do you want to do that? But they said that after seeing their costumes, they'll treat them with more respect. So that was funny.

"The other thing, with some creative license, that Jared made, from a budget point of view, we could only create fifteen skins. And because Midport is brown, he also wanted to introduce other biomes, to add some more color into that village life. So, we introduced the snowy tundra, desert, and the wandering trader, who's pretty awesome. Then there's the understanding of who can go into the different biomes and making them all seem sensible. And I love

BELOW Actors suit up to portray a desert villager and a plains villager. Their onscreen faces were later added by the VFX department.

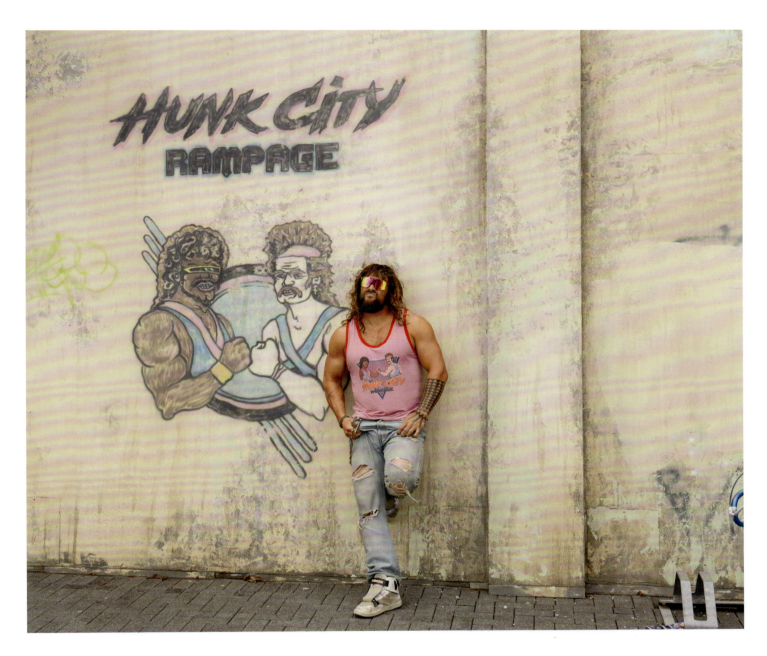

the fact that there's an employed network, and everyone has a specific job and role in that village. It's pretty cool."

When it came time to dress one of the most remarkable citizens of Chuglass, Neale looked no further than Jason Momoa's own closet for inspiration. "Jason Momoa is an absolute clotheshorse and is very particular in what he wears," says Neale. "He was obsessed with his Vision Street Wear style, and we were able to tap his personal collection for that. He brought to his character his bracelet and his chains, and all his accessories that he established on day one of shoot, so we had to scramble to kind of mimic and double them for his stunt doubles and make soft versions for that. He was very involved in his accessories.

"He really wanted to wear his Pit Viper sunglasses, so we got a whole variety of those and picked out which ones he wanted to wear, and he ended up wearing them throughout the whole movie. But yes, my initial brief with Jason, with information that came through Jared, was that Jason wanted to wear a tasseled denim jacket. And well, having just come off a show called *Sweet Tooth*, and being

ABOVE Garrett prepares to play the Hunk City Rampage arcade game on his home turf, Game Over World.

obsessed with tassels myself, that was an easy thing to deliver."

Although a standard denim jacket, even one adorned with tassels, would be a bold fashion statement on the streets of Chuglass, a typical jean jacket will just fade into the background in a world overrun with piglins, zombies, and skeletons. "When we created the denim and put it next to the ensemble cast that we were creating, the denim got a little lost, and I was concerned it would get lost in the vibrancy of the Overworld, where Garrett spends 80 percent of the movie," Neale observes. "So I had to create another set of costumes for him, and I played around with this pink leather. We tried so many different colors, but the hot pink seemed to hold its own, and matched beautifully with Steve's turquoise, and was really strong in the Overworld. And Jared was obsessed with the pink sheep in *Minecraft*, so it did lean into that color relationship. I don't know where he was at the time, doing publicity for *Dune*, I think, and we sent it to him, and he tried it on, and he loved it.

"The thing about the jacket, though, is it's a stunt movie, so we had to think about movability and comfort, and because of the scheduling, we pretty much fitted him the day before shooting, and that was terrifying. Making sure the jacket fitted, that it was aged appropriately, and knowing that everything would get blown out because of the lighting and having to adjust and compensate for that," she continues.

One element of Garrett's costume, an aspect that viewers may not even notice, took up a surprising amount of Neale's time, but

120 A MINECRAFT MOVIE: FROM BLOCK TO BIG SCREEN

the detail-oriented designer never leaves any costuming element to chance. "The graphic T-shirt is what took us the longest time. Jared wanted a ringer singlet, it's iconically '80s. His character is stuck in this bygone era, where he was a one-player icon, and that's where he got stuck, and wanted to remain in his glory days. So we stuck with the '80s aesthetic, which is handy for us because we loved it, but it really fed into the nuances of his character. A middle-aged guy who's still living in the faded glory of his '80s success, and that's why his design is entrenched in that period. It helps tell the story of where Garrett was, and how he's moved on through time. The T-shirt, we, I guess, had to make sure it was funny, iconic, and had independent life.

"And Garrett with his T-shirt, with so many layers, and that ended up being kind of a *Beauty and the Beast* reference. This misunderstood man with multiple layers, who was empathetic to Henry's character, and he guides him through the story. And that particular graphic also feeds into some narcissism, too, which is about the Garrett character. Putting a graphic on a Jason Momoa chest, it had to be detailed, it had to be deliberate, it had to be part of his character. Because it kind of disappeared as well? So hopefully we've done the right thing there. We spent a lot of time exploring and looking at lots of options that we could put on front of his T-shirt."

BELOW Whoa, dude! Characters from Garrett's favorite video game, Hunk City Rampage, are angling for a fight!

2. BUILDING BLOCKS

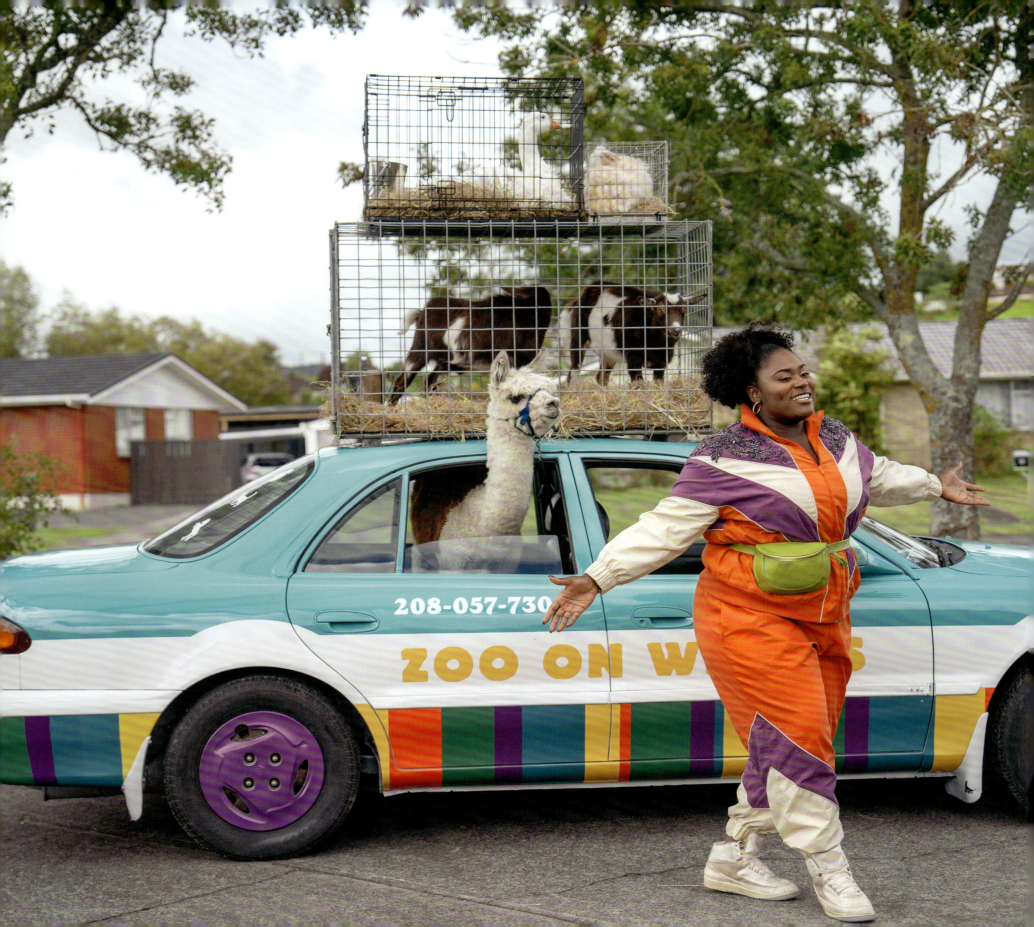

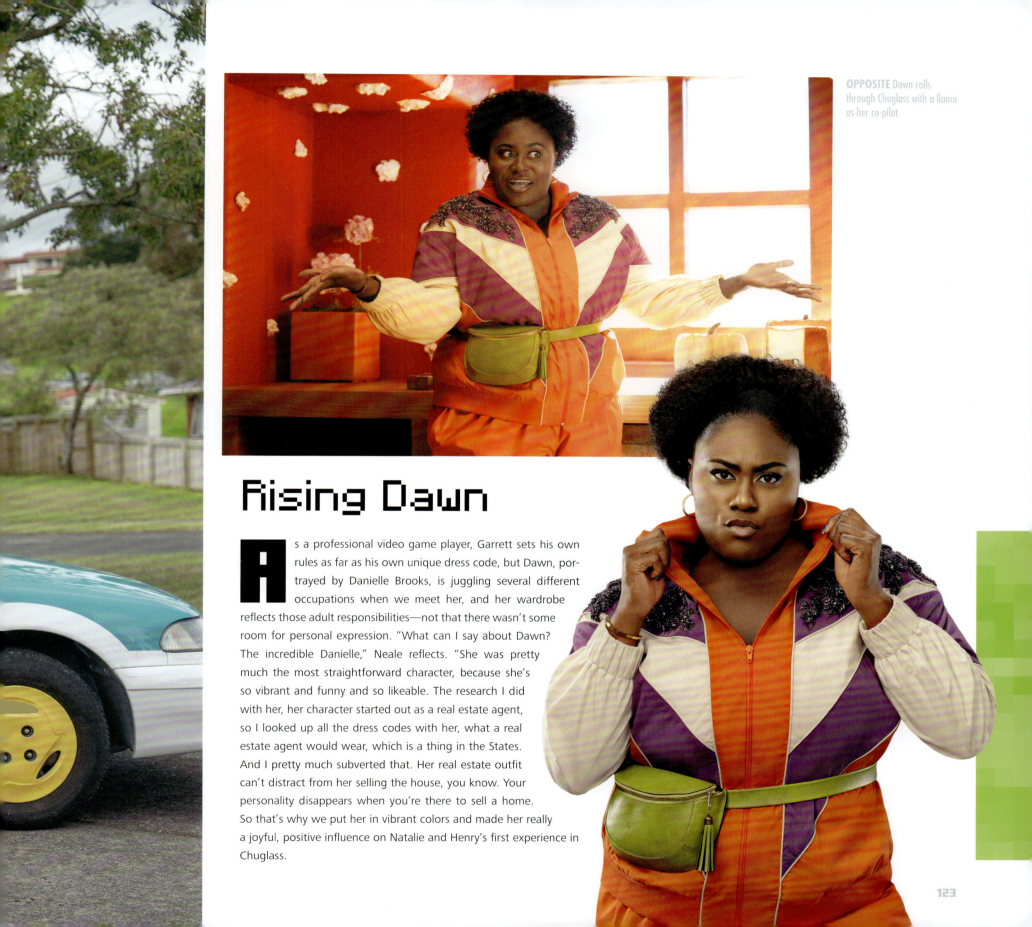

OPPOSITE Dawn rolls through Chuglass with a llama as her co-pilot.

Rising Dawn

As a professional video game player, Garrett sets his own rules as far as his own unique dress code, but Dawn, portrayed by Danielle Brooks, is juggling several different occupations when we meet her, and her wardrobe reflects those adult responsibilities—not that there wasn't some room for personal expression. "What can I say about Dawn? The incredible Danielle," Neale reflects. "She was pretty much the most straightforward character, because she's so vibrant and funny and so likeable. The research I did with her, her character started out as a real estate agent, so I looked up all the dress codes with her, what a real estate agent would wear, which is a thing in the States. And I pretty much subverted that. Her real estate outfit can't distract from her selling the house, you know. Your personality disappears when you're there to sell a home. So that's why we put her in vibrant colors and made her really a joyful, positive influence on Natalie and Henry's first experience in Chuglass.

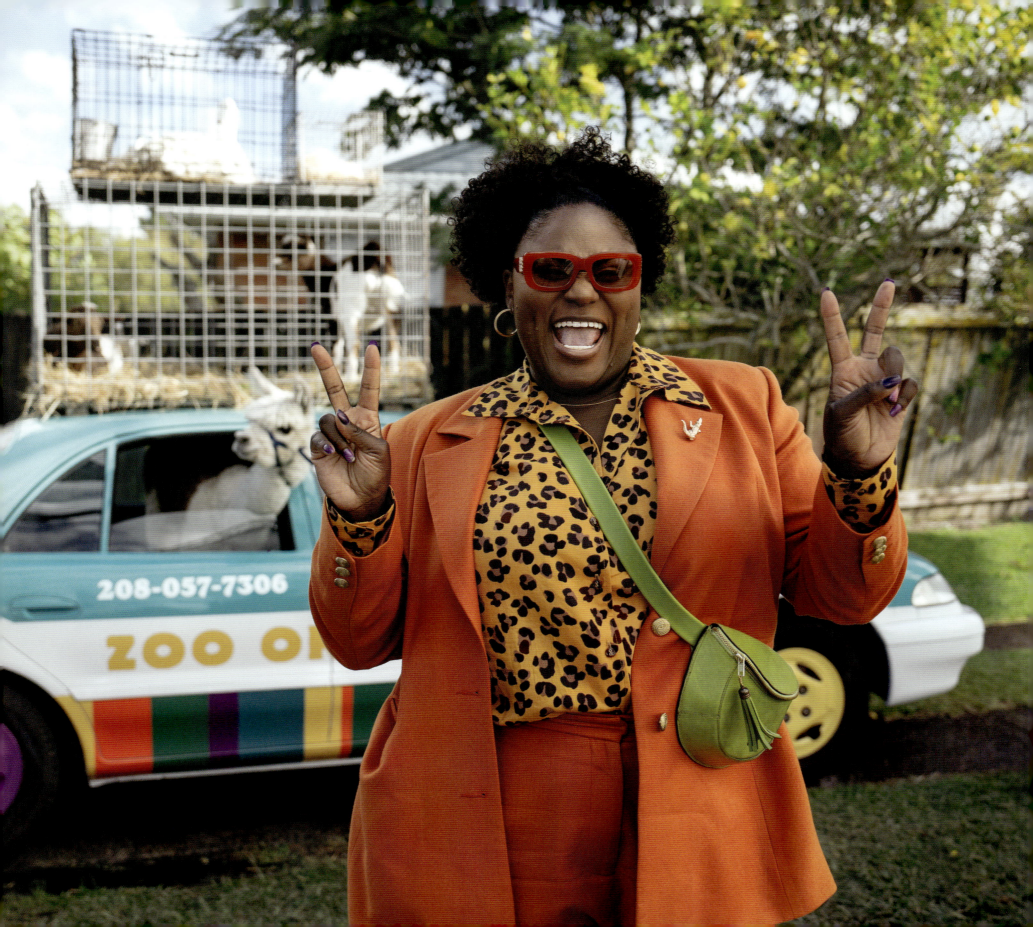

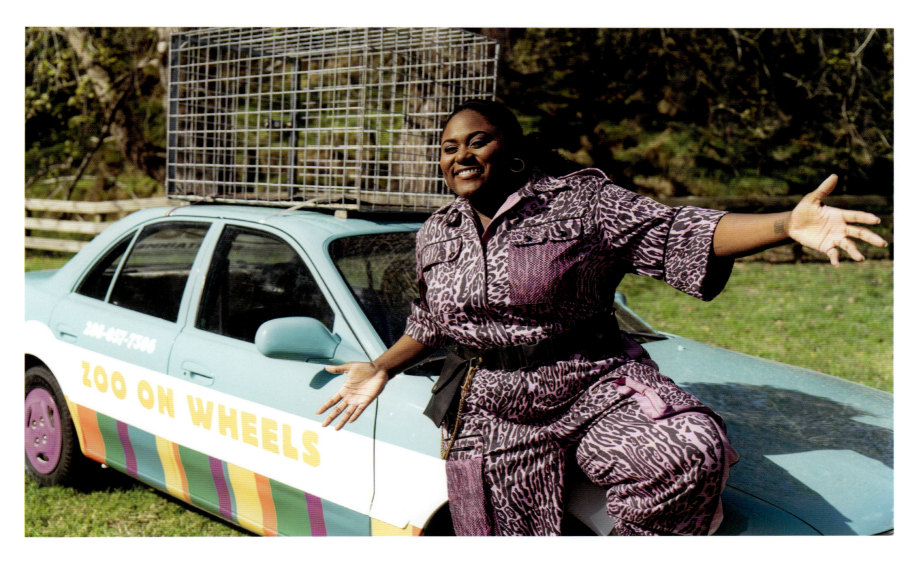

"After an initial conversation with Jared about Dawn being out of her 'real estate' look for when she goes into the Overworld, Jared wanted Dawn to be casual and wear something like a tracksuit. I saw this was an opportunity to have fun with Dawn, to bring some boldness and sass to her character."

Dawn's character changed significantly as the plot of the movie developed, but her sense of style evolved and adapted as her backstory and motivations became clearer to the filmmakers. "Working from an early iteration of the script, Dawn's character had a side business making and selling essential oils," says Neale. "Her lime green bum bag [fanny pack], which our department made, was originally a prop for her to carry her essential oils. We decided to keep the bum bag despite it no longer playing in the script.

"And Dawn's color palette was originally created from her business interests in essential oils and aromatherapy. With this understanding, we explored many different shades of natural healing colors and landed on lavender and amber. With these selected color choices, we explored different color intensities and tone, and after much color sampling, we ended up with the burnt orange and violet.

"What's interesting in this color story for Dawn was the color combinations and its personal connection to Danielle Brooks. When I first presented the Dawn costume concepts to Danielle, she was so excited, she and her team felt this costume was representative of the culmination of her career to date, from [Netflix series] *Orange Is the New Black* to [stage and film productions of] *The Color Purple*, something I didn't even consider in the initial stages of this process."

OPPOSITE Even when she's in real estate mode, Dawn's always ready to let her fun side show.

ABOVE No matter how many professional setbacks come her way, Dawn's always got a smile on her face and a song in her heart.

2. BUILDING BLOCKS 125

Sibling Revelry

Fortunately for Amanda Neale, one of the characters who had the most screen time, Henry, had the easiest wardrobe to design. Neale looked to one of her favorite movies, another tale of a young boy whose life is changed forever by a chance encounter with the extraordinary. "Our young character, Henry, is in a hoodie, which we changed so many times, but it ultimately came back to Elliott's hoodie from *E.T.*," says Neale. "That's iconic, and it's a very simple costume, but that's what Jared wanted. A nod to the '80s color palette, and a reference to that character."

Those hoodies went through a lot of wear and tear over the course

RIGHT Natalie dresses for success on her first day on the job at the Chuglass Potato Chip Factory.

"... but it ultimately came back to Elliott's hoodie from *E.T.*"

of filming, and each one had to stand up to a full day's worth of action under the intense lighting of a film soundstage. "Henry had eighteen sweatshirts," Neale continues. "To even dye those . . . we went through fifty meters of sweatshirting just getting the right red. Everything has been overdyed and treated to make sure we've got just the right red palette for that really bright world."

For Natalie, Neale turned to another beloved Steven Spielberg film from the 1980s. "Then there's Natalie and her cool cardigan, with colors drawn from *The Goonies*. Emma Myers, who plays Natalie, is such an incredibly strong young actor. But on the page, she's a young woman who's grieving the loss of her mother and being supportive of her younger brother, who she's trying to understand. And she's got these really grownup responsibilities that she's carrying. Trying to convey that in costume is really quite tricky.

2. BUILDING BLOCKS 127

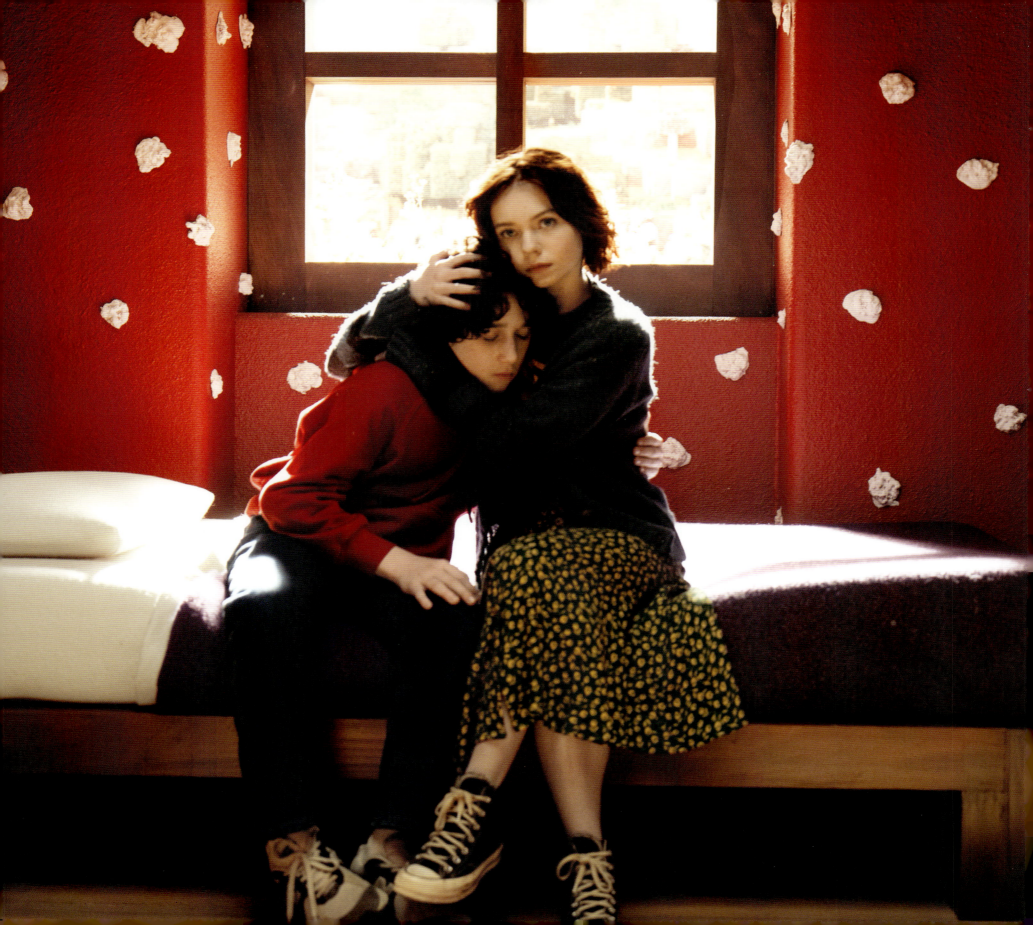

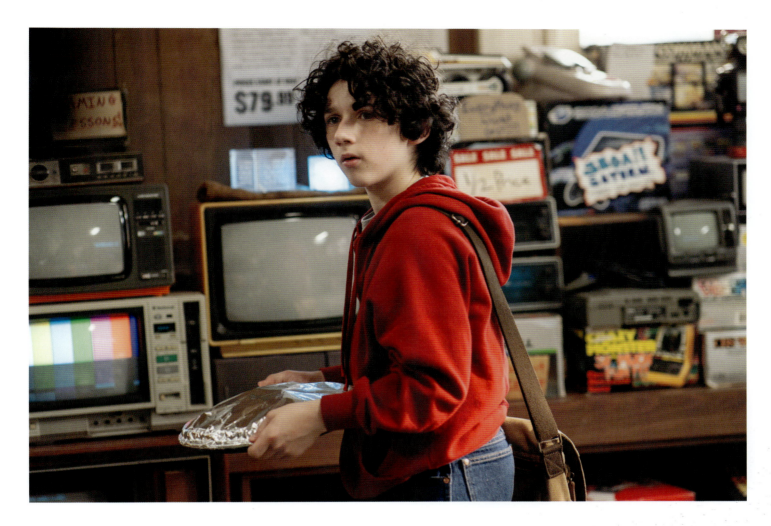

"Also making sure that around these colorful characters like Dawn and Garrett and Steve, very strong, colorful characters, making sure that she didn't disappear but also held her own weight. That was the trickiest character to convey, keeping her simple and understated. But when the camera turned to her, she was such an impressive young actor, who brought so much strength to that character that I didn't really have to worry about the costume in the end, since she just brought it in her performance.

"From a design point of view, we had to be careful about not overdesigning her. She's not a Lara Croft character. When she goes into those battle scenes, you're not expecting what she can deliver. And hopefully that's conveyed in the film. Putting her in a T-shirt, a cardigan, and a maxi-skirt was kind of unpredictable, but we tested the movement with that outfit with her stunt double, to make sure that she wouldn't have limitations with her physical performance. Hopefully it all ties together. An ensemble cast like that, it's a little tricky making sure that all the colors sit together, but they're all such individual characters, with the backdrop of the *Minecraft* world . . . it was tricky. But it's supposed to look effortless, and hopefully that's what we've done."

As with Garrett, Neale spent a considerable amount of time developing a signature graphic for Natalie's T-shirt, one that subtly conveyed the backstory and hidden depths of her character. "Natalie out of our *Minecraft* characters was the most uncomfortable on the page in the Overworld. I thought it would be interesting to explore different shapes with each of the characters," says Neale. "Natalie's circular yellow graphic was a way of exploring the idea that she felt out of place in the square-dominant environment of the Overworld, but the circle also represented a setting sun, a symbol of new beginnings for her character. The other characters have their own shapes, as well. Garrett has triangle detail on his gloves, and Dawn has chevron patterns on her tracksuit."

OPPOSITE Natalie and Henry are starting a new life in a new city, and it's one of the hardest challenges that the siblings have ever faced.

ABOVE Henry visits Game Over World on the way to school, with his mom's famous tater tot breakfast pizza in hand.

2. BUILDING BLOCKS 129

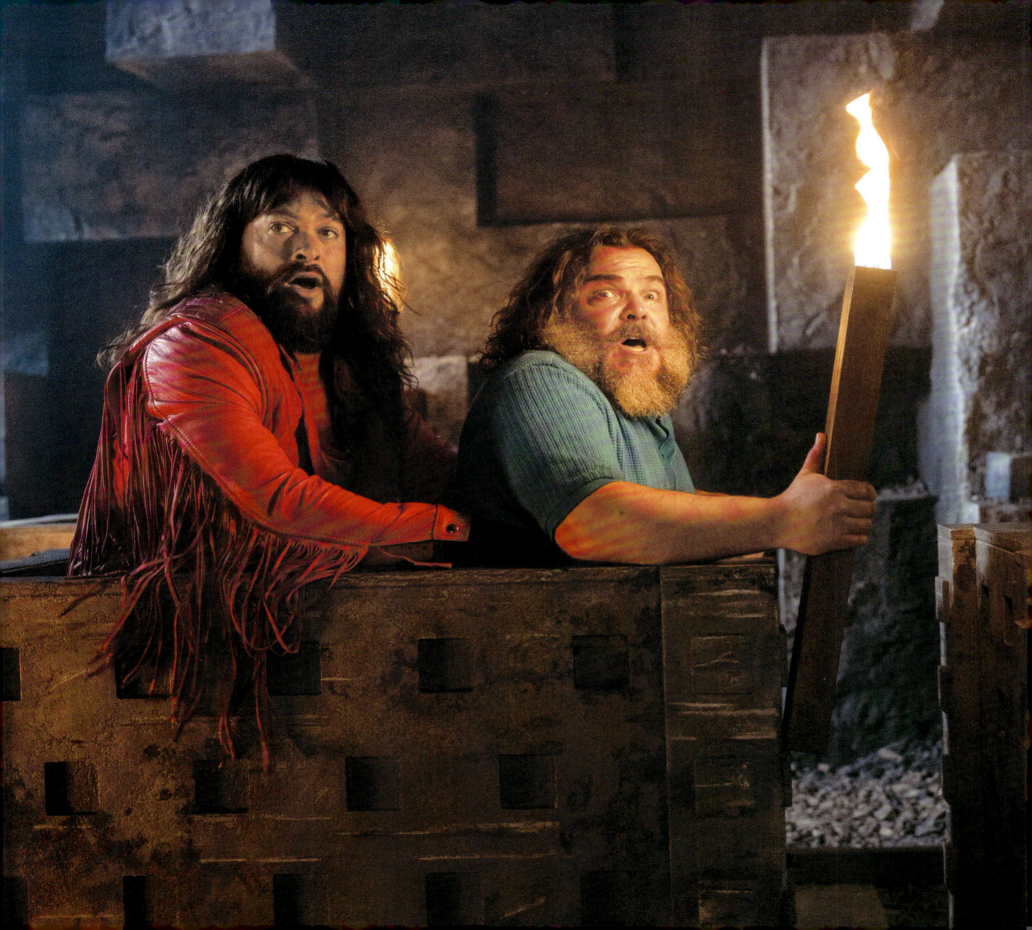

Heroic Fashion

Garrett, Dawn, Henry, and Natalie were invented whole cloth, so to speak, but what about the game's most iconic character, and one of the most famous video game characters in the entire world? "Of course the big thing with Steve, who is so iconic, is how can we convey the information that I have for this character based on the iconography that exists? It was terrifying," admits Neale. "It was creating an iconic character while being true to his color palette and making sure that every element of the design is true to the *Minecraft* world. I've never used color like I have on this project. The Overworld is so vibrant and primary. How do I have characters that sit comfortably in that world, that don't get lost in that world, that hold their personalities?

"The way the movie was lit just blew out so much detail, something we found out with our camera tests. We had to add a lot of texture so that we could respond to that. The last thing I wanted was just a turquoise T-shirt and denim jeans. The most important note I got from Torfi [Ólafsson] early on was that [the movie version of] Steve goes into the game in the late '70s, early '80s, so how do we convey that element?

"Which, given their age, I'm not sure a lot of players know. So giving him that '70s aesthetic, when he went into the Overworld, we kept the triangular V-neck for his T-shirt, but embellished it a bit to give a point of interest. Then gave it '70s pocketing and pocket detail and added some leather. Just trying to add a little bit of detail to, essentially, a box-standard costume. So that was my intention there. Texture, color, shape, and the nuance of the '70s detail. So that was that character."

The turquoise T-shirt wasn't the only iconic *Minecraft* outfit that Steve would wear in the film. After an extended break during the production, the film's script underwent a major revision that brought a fan-favorite upgrade into the mix. "The diamond armor was a new element in the script when we came back after the [Writers Guild and SAG-AFTRA] strike. We'd had about two weeks' prep to shoot, and it was pretty much a new script. So the diamond armor appeared, and we were like, 'Oh my god, this is so iconic. How do we translate this pixelated image of Steve and do it justice?'

"Honoring the iconography of the diamond armor and translating it into a real-world garment was very labor-intensive and also quite nerve-wracking. Nerve-wracking in the sense that we wanted to get it right and wanted people to say that we translated it really well, exactly how they'd have imagined it, if not superseded their expectations," says Neale. "But also for Jack Black, having to wear it and move in it. We used a water-clear urethane that we dyed. It had to be light, with no flexibility; it had to convey the material of a diamond, so we put foil behind the urethane.

"Oh my gosh, the process itself, building that costume, was incredibly detailed, and then getting signed off from Mojang that they were happy with it, and then getting Jack Black to put it on, especially for the stunt scenes, it was pretty intense. They were the hurdles that we had to jump; the functionality of it, but also making sure that we honored the game, and what the enthusiasts expect."

Neale and her colleagues also honored the spirit of *Minecraft* by finding innovative solutions to seemingly impossible problems, according to Mojang's Torfi Frans Ólafsson. "The diamond armor presented so many unique challenges," he observes. "Once we were on set shooting the final battle, stunt coordinator Jon Valera, costumer Amanda Neale, and VFX supervisor Dan Lemmon had a problem. Jack couldn't do his stunts wearing the diamond armor, and VFX weren't able to add it in post. There was talk of him not wearing it at all. But I felt we had to show it. We had to get that hero shot of him wearing it. But they said, 'He can't wear it during the battle. Not the chestpiece.'

"So, I suggested that in his first jump, after he falls flat on the floor that Malgosha comes and smashes it, leaving him vulnerable. Jared liked the idea so that's what happens in the movie. We see it in

OPPOSITE Garrett and Steve buddy up as they prepare for a daring minecart escape!

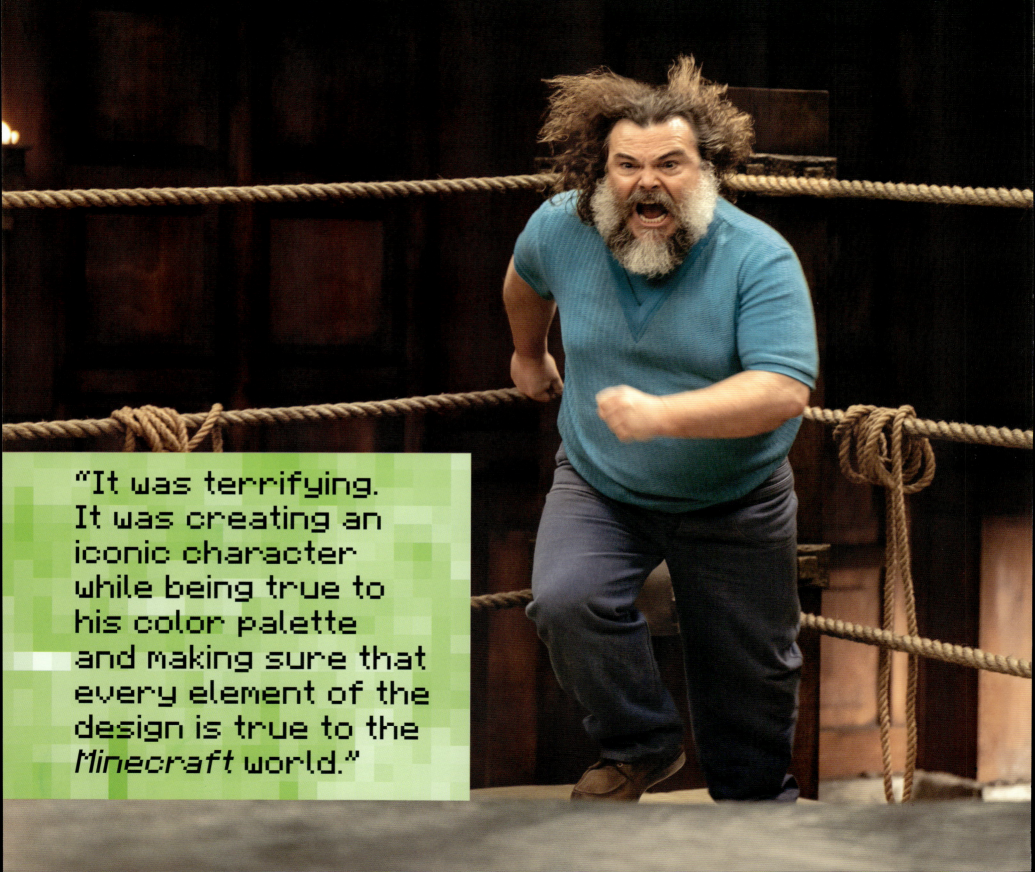

"It was terrifying. It was creating an iconic character while being true to his color palette and making sure that every element of the design is true to the *Minecraft* world."

all its glory, but at the start of the fight, the chestpiece is smashed by Malgosha's staff and Steve spends the rest of the battle just wearing the helmet and boots, making him look more vulnerable and upping the stakes. So it worked for the storytelling. An example of a compromise made on the day of [the] shoot!"

All in all, Amanda Neale supervised a team of nearly forty designers, fabricators, and technicians, all working in unison to create the unique wardrobe for the film, to ensure that the actors were as comfortable as possible, and to keep all of these outfits intact throughout the rigorous production. "I always visit the set early on to establish the characters and their costumes, but we had a team of thirty-eight and a big on-set team that had our workshop just up the road to make any on-set repairs or adjustments," says Neale. "We went through seven pattern-cutters just in creating the [Chuglass] high school uniforms, tailoring Dawn's suits . . . Jason Momoa and his stunt double, we created about twelve of those jackets, a lot of repeats for all those costumes. No time for any darning myself, but I was there to establish everything, and had a very impressive, hard-working team with me. . . . I was fast and furious."

RIGHT Every element of each actor's costume is tagged and filed by the wardrobe department.

OPPOSITE With the fate of the entire world at stake, Steve charges into action to protect his new friends.

2. BUILDING BLOCKS 133

3. MOB MENTALITY

BELOW Steve's first and best friend in the Overworld is his loyal wolf companion, Dennis.

BOTTOM A typical Overworld forest may contain several different varieties of tree within a single field, like towering oak trees and colorful cherry trees.

The Overworld is a wonderful, expansive dimension consisting of many different biomes, and, as Henry and his friends discover upon their arrival, is home to an array of fantastic native life-forms unlike anything they've ever encountered before. Many of these mobile entities—known to *Minecraft* players as mobs—are friendly, or at least indifferent to visitors, but when night falls, the most dangerous mobs come out to bring chaos and terror to the Overworld.

"Aside from their introduction, the first thing that happens to our heroes when they enter the Overworld is the first night scene, where they're attacked by zombies and creepers and skeletons," says Mojang's Torfi Frans Ólafsson. "And that plays out like the first night scene when you're playing *Minecraft*, just after sunset. They have nothing, no tools or anything, and Henry builds a really primitive tower so they can stay indoors and defend themselves from the zombies. Then the next morning, they wake up and the sun comes up and they watch as all zombies catch on fire. Again, this is super well known, and it's been part of the game for fifteen years. By starting that way, we get all the players along with us on the journey. Then we can introduce new rules into the movie that aren't in the game."

It took a tremendous effort from the visual effects team, prop makers, and costuming department to bring these iconic characters to life. Villagers. Zombies. Creepers. Skeletons. Enderman. Piglins. Dennis. DENNIS?

As every *Minecraft* player knows, the Overworld is a scary place at night, especially when you're just starting out. Fortunately for Steve, he makes a new friend—a best friend—who helps him survive that first night in a strange land. Dennis, described by the narrator as "a fuzzy gray angel," saves Steve's life and just may save the Overworld and our world before all is said and done. "That may be the character that grew the most over the course of the production," says choreographer Alyx Duncan. As the script developed and Dennis's role grew and evolved, VFX supervisor Dan Lemmon told Duncan that because of the character's complexity and importance to the story, he wanted to try something special with Dennis that would really make him stand out from the other animated characters in the film.

"Dan told me we were going to need a Dennis proxy," Duncan recalls. "Dan said, 'We need a wolf head, kind of like a puppet,' and he asked if I could find someone to make it, and I looked to movies like *Labyrinth*, which was so very mixed media in its approach. Fortunately, I had just worked with this amazing puppeteer, Paul Lewis, who is not only a puppeteer but is also an absolute film geek, and he's made all sorts of amazing puppets and designs inspired by his favorite films. He has just this incredible level of craft, and he was up to the challenge when I told him about our needs. His job was to be a proxy, just provide the eyeline for the actors, especially Jack, to play to. He brought so much personality to what was essentially going to just be a stand-in shape.

"Paul was the puppeteer of the wolf-head proxy. He performed whenever there was an 'acting' interaction with one of the actors, mostly Jack or Danielle. Alex Leonhartsberger was the dancer, and he

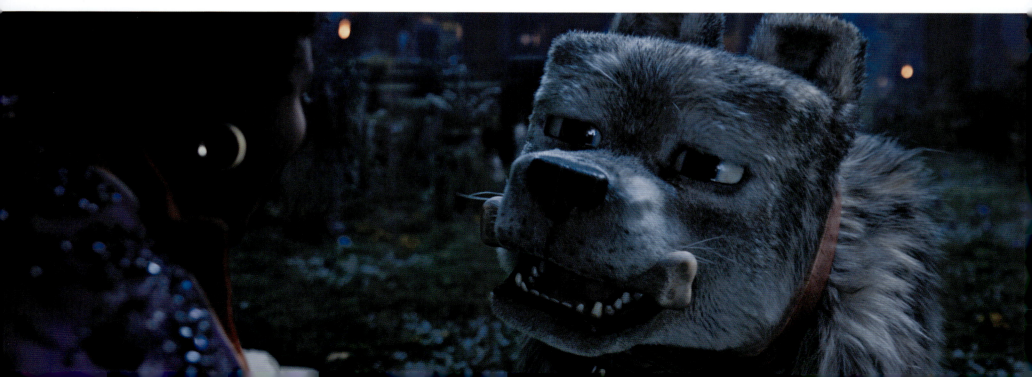

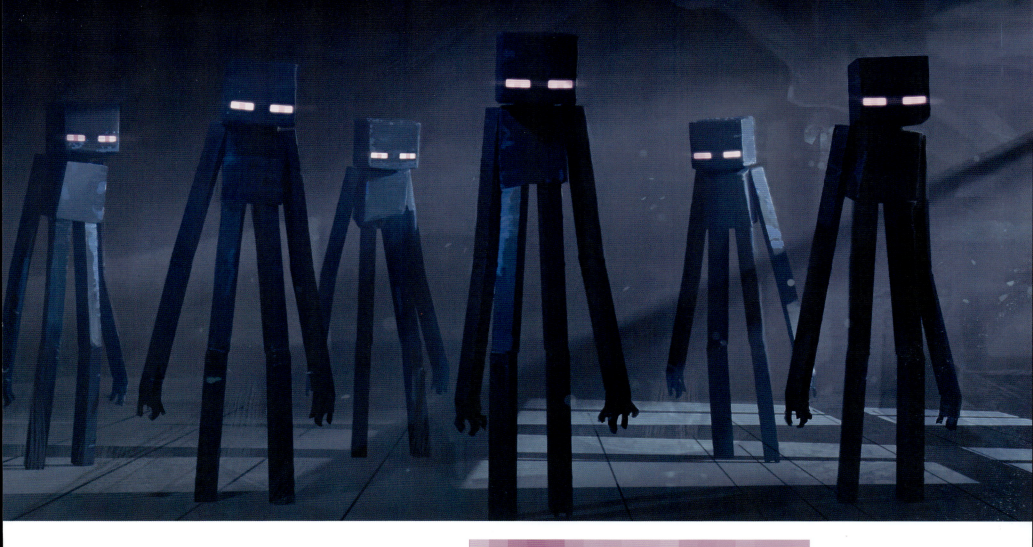

performed Dennis whenever there was dog- or wolflike locomotion action required. He's amazing at moving like a wolf, walking or galloping. So it was for any scenes when he was moving beside actors, or action-based sequences such as leaping through the portal being chased by piglins, or carrying the bag with the orb in it. Sometimes both would be on set for the day and swap out as needed for each shot."

Dennis protects Steve from the hostile mobs that populate the Overworld, iconic creatures known to everyone who has ever played *Minecraft*. But unlike the entities that players encounter in the game, these mobs would inhabit the same physical space as live, human actors, and the film's visual effects department would have to bring these two worlds together into a single, seamless environment. "The Overworld is uniquely, identifiably blocky, and the same is true of the creatures you encounter there, whether it's a sheep or a piglin or a creeper," says Torfi Frans Ólafsson. "We saw so many iterations

"But now we have a generation who played as children and are now adults, and that made it so much easier to tell the story."

ABOVE (Concept art)
One Enderman is trouble.
Six Endermen? Time to run!

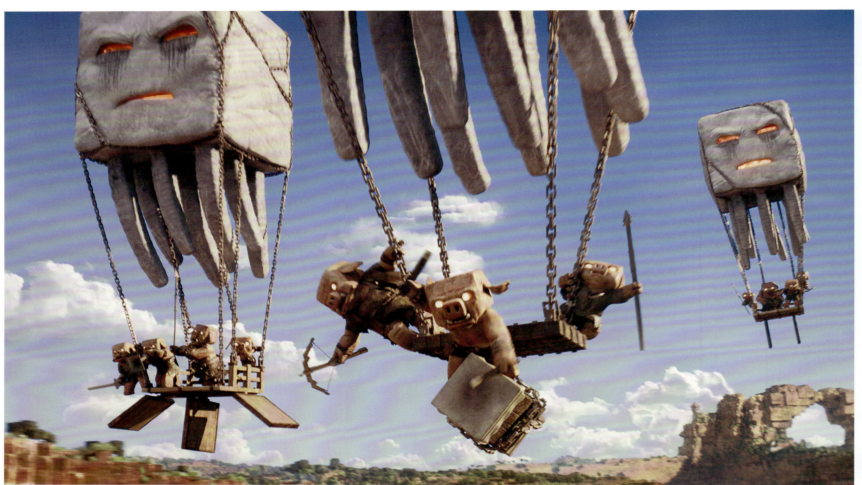
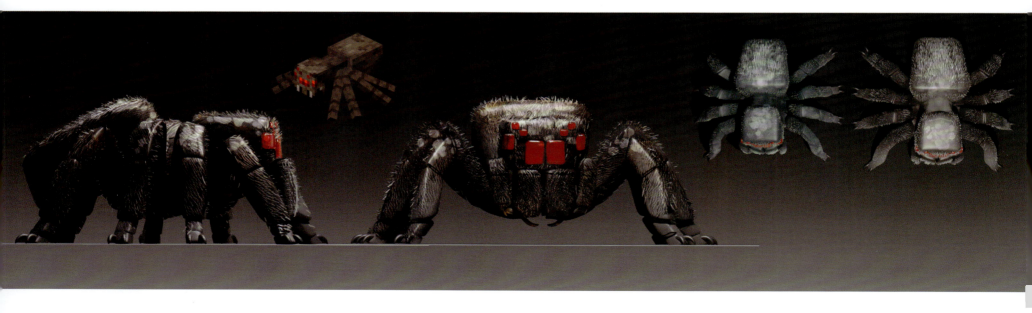

138 A MINECRAFT MOVIE: FROM BLOCK TO BIG SCREEN

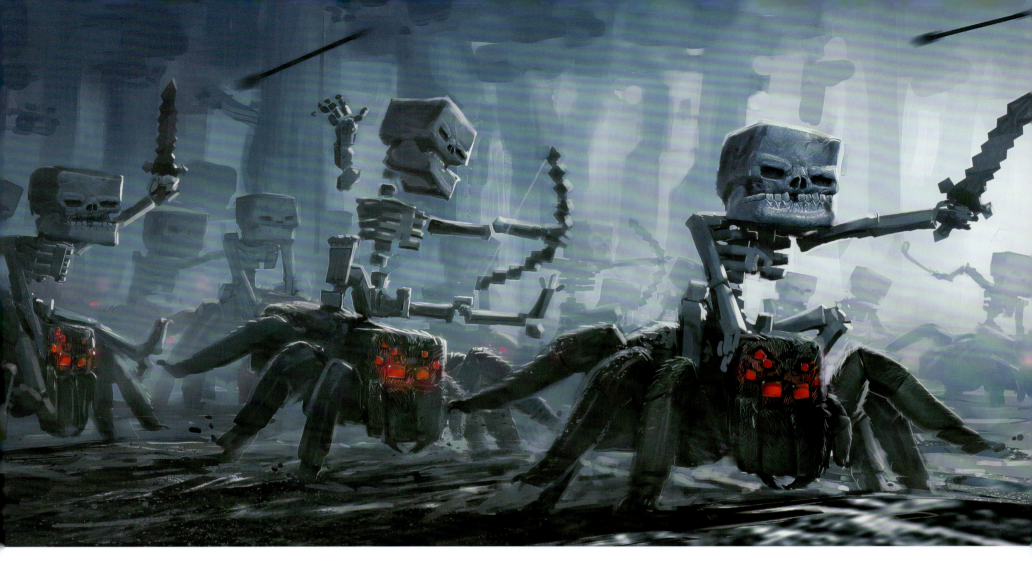

by concept artists of random zombies or random skeletons that lost that *Minecraft* look, and it just looked like *The Walking Dead* or *Dungeons & Dragons*. It looked like things that we've seen before.

"And it became truly magical when we decided to go stay super close to the blockiness, but make it all kinds of dirty and gritty and realistic. The thinking behind the mobs, keeping them blocky, what is it going to look like for an eight-year-old drawing these characters from the movie? What's the silhouette going to look like? And kind of reverse engineering from that. We wanted to start making everything blocky, like in the game.

"Those constraints, though, are what makes it *Minecraft*. In the game, nobody has elbows or knees. The low-fidelity is the beauty of the game. It is that way, of course, because it was easier to develop, but it turned out that it's easier to project yourself onto something that's low-fidelity instead of high-fidelity, kind of a Rorschach test."

And the concept art that passed Mojang's test was welcomed with open arms, according to Ólafsson. "It actually was really cool when Wētā Digital started doing all these creature designs, and suddenly these artists, they all knew exactly what they were doing. I looked at the designs and said, 'Yeah, that person grew up with *Minecraft*.'

"Before, in the older concept art, we had these Hollywood people, not to speak ill of them, but who didn't know about gaming or *Minecraft*, and they looked at the game designs and decided to try to fix them. But now we have a generation who played as children and are now adults, and that made it so much easier to tell the story.

"In that sense, I think the movie benefits a lot from coming out now, rather than five, seven, ten years ago. The concept artists are exactly the right age."

OPPOSITE ABOVE Ghasts provide the aerial firepower for the piglin army.

OPPOSITE BELOW (Concept art) The spiders in *A Minecraft Movie* have additional joints and a wider range of movement than their in-game counterparts like the standard spider and the cave spider.

ABOVE (Concept art) The skeleton jockeys ride into battle.

3. MOB MENTALITY 139

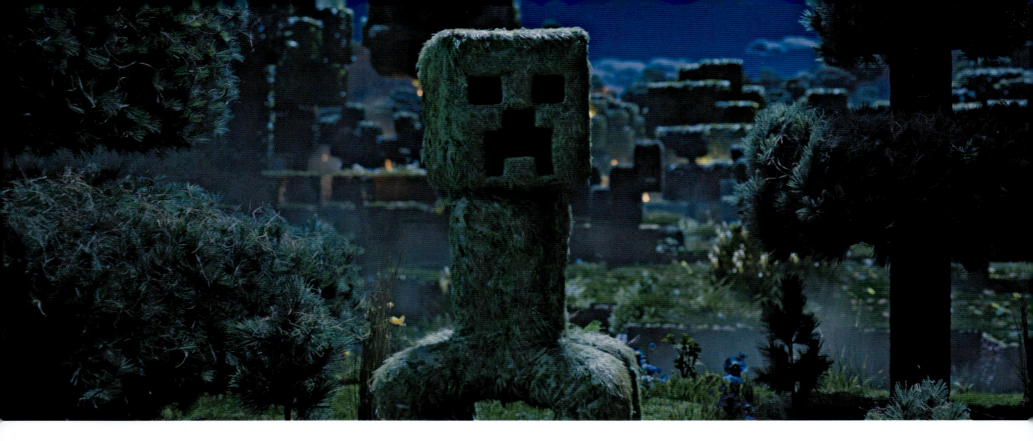

(Don't Fear) The Creeper

"In the early days, we took inspiration from other role-playing games, like *Dungeons & Dragons* and *Dungeon Master*, that's why the first monsters are zombies and skeletons and slimes and a dragon," says Mojang's chief creative officer Jens Bergensten. "But now we have the rule to try to invent unique fantasy creatures. That we build our own universe. We can take inspiration from other games but don't want to adapt real-life pop culture. We don't want to add vampires or werewolves or pirates."

Of all the original creations in *Minecraft*, one stands head and shoulders—wait, does it have shoulders?—above the rest, and adapting it for *A Minecraft Movie* would prove to be one of the biggest challenges facing the visual effects department. "The creeper is a really good example of a character that's iconic, one of the most iconic characters in the *Minecraft* world," says VFX supervisor Dan Lemmon. "It's almost the banner of *Minecraft*, since it's unique to the game, and so specific to the game. And a player's experience with the creeper is so visceral. You hear that 'sssssssss' sound and you go, 'Oh no! Run! Something's about to blow up.' When we started designing them, we asked the Mojang guys, 'What is this, anyway? Is it like a walking bush, or maybe a turtle?' And they said they didn't really know. Some people think it's covered with scales, some say it's covered with ivy.

"We looked at a few different concepts, some that made it look like a weird alien turtle. Some that made it look more like an enchanted bush. We asked, does it have TNT inside it? No, not really, but it gives you gunpowder when it dies, sometimes. It was fascinating to see how this character that was so iconic in the world of *Minecraft* was also so nebulous and undefined, and left to the imagination of the creators of the game."

And that iconic character, oddly enough, was never supposed to exist, according to Jens Bergensten. "Most of the time, when we add a new mob, it comes from a gameplay need. We either have a new location or reward, and want to put a new challenge in between, or it's about building atmosphere and making certain areas more scary or dangerous than others. One of the more popular or famous stories is about the creeper, one of the first mobs. It was actually supposed to be a pig, but due to a coding error, the length of the body was flipped with the height of the body. The team thought it looked really creepy as it was walking around, so the original developer of *Minecraft*, Notch [Markus Persson], decided to turn it into a

ABOVE Creepers were given a whole new dimension in *A Minecraft Movie*.

OPPOSITE ABOVE Night falls quickly and the zombies attack!

140 A MINECRAFT MOVIE: FROM BLOCK TO BIG SCREEN

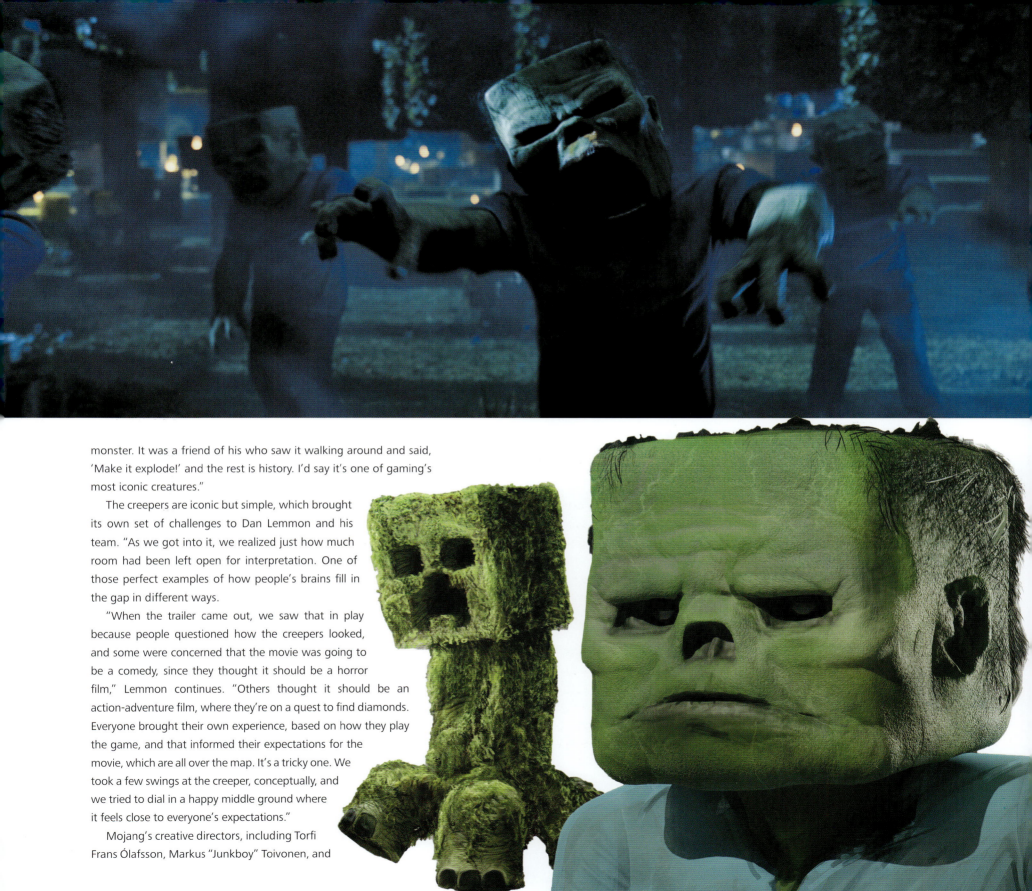

monster. It was a friend of his who saw it walking around and said, 'Make it explode!' and the rest is history. I'd say it's one of gaming's most iconic creatures."

The creepers are iconic but simple, which brought its own set of challenges to Dan Lemmon and his team. "As we got into it, we realized just how much room had been left open for interpretation. One of those perfect examples of how people's brains fill in the gap in different ways.

"When the trailer came out, we saw that in play because people questioned how the creepers looked, and some were concerned that the movie was going to be a comedy, since they thought it should be a horror film," Lemmon continues. "Others thought it should be an action-adventure film, where they're on a quest to find diamonds. Everyone brought their own experience, based on how they play the game, and that informed their expectations for the movie, which are all over the map. It's a tricky one. We took a few swings at the creeper, conceptually, and we tried to dial in a happy middle ground where it feels close to everyone's expectations."

Mojang's creative directors, including Torfi Frans Ólafsson, Markus "Junkboy" Toivonen, and

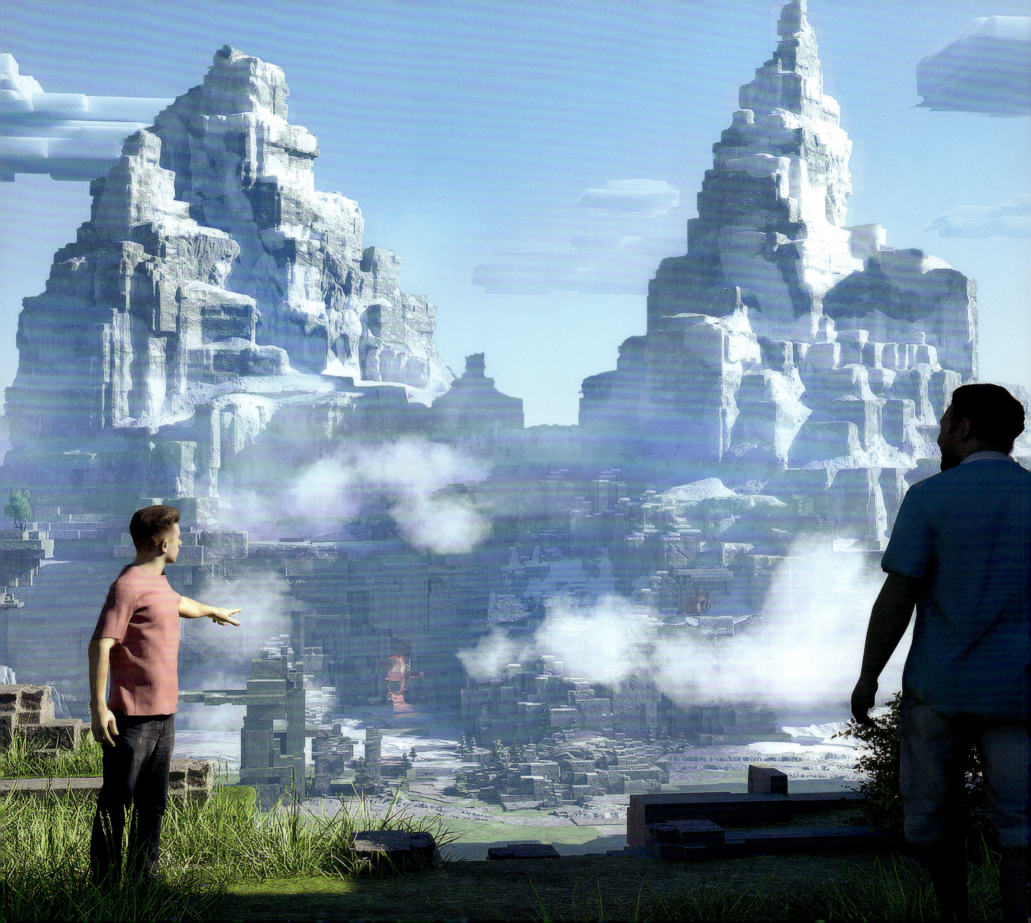

> "... but when we got to the chicken jockey, they just stopped and said, 'THAT is amazing.'"

Johan Aronsson, worked closely with Lemmon to find that happy middle ground. "We had a little gathering with Junkboy where he set up a workshop to figure out, fundamentally, what the creeper would be," says Aronsson. "And everyone wanted to do their interpretation, including what it's made of. Is it green because it's camouflage? Is it veins? Is it green, for whatever reason? But you get this feeling when you play the game that it's creeping up on you, so it has to be stealthy. It has to be soft. So we were looking into . . . maybe it is camouflage, because it needs to be stealthy, so it can get close to you and blow up? Same thing went for most of the mobs. What is the fundamental mechanic for what each of these things does in-game? That was the essence of what we tried to figure out.

"And when it came to figuring out how they would interact with real people, I think it was the same there. We wanted to stay very true to how it would work in the game. It was very important to stay true to their behavior. But in the movie, it was a challenge, because you have to allow them to express certain emotions as well. We don't have rigged faces in the game, obviously, but when you have the characters next to a person and they don't express, you're losing quite a lot of communication. Obviously, some entities can use their limbs to communicate; others can't. Like pigs. How do you give them a sad face? Some liberties had to be taken because it is live-action.

"But then you have the creeper, and mobs like it, which are more fantastical. We still don't know what the creeper is made of, but we tried to find something that kept a balance between that mysterious vibe but that didn't dispel anything you've seen in the game. It's one interpretation, which is something we tried to do with most things."

The mobs aren't all dark and scary, though, and the team made sure to balance out the creepers with some of the funnier, stranger inhabitants of the Overworld, too, notes Warner Bros. executive producer Cate Adams. "Our team isn't necessarily a 'Fellowship of Dingdongs,' as Jared Hess called the team, but we do have all these nerds who said, 'Let's play together and let's do the best we can!' It's going to be wacky, but it's going to be fun. Like when everyone came together and made what was certainly our favorite mob, the chicken jockey.

"That image . . . we were going through our design packets with the producers, and getting comments and making adjustments, 'the moss is too furry,' 'these characters are too scary,' 'the piglins are interesting . . .' but when we got to the chicken jockey, they just stopped and said, 'THAT is amazing.'"

OPPOSITE (Concept art) Mountains dominate the landscape as Henry, Garrett, and Steve survey the world around them.

BELOW Watch out—chicken jockeys are more dangerous than they look!

3. MOB MENTALITY

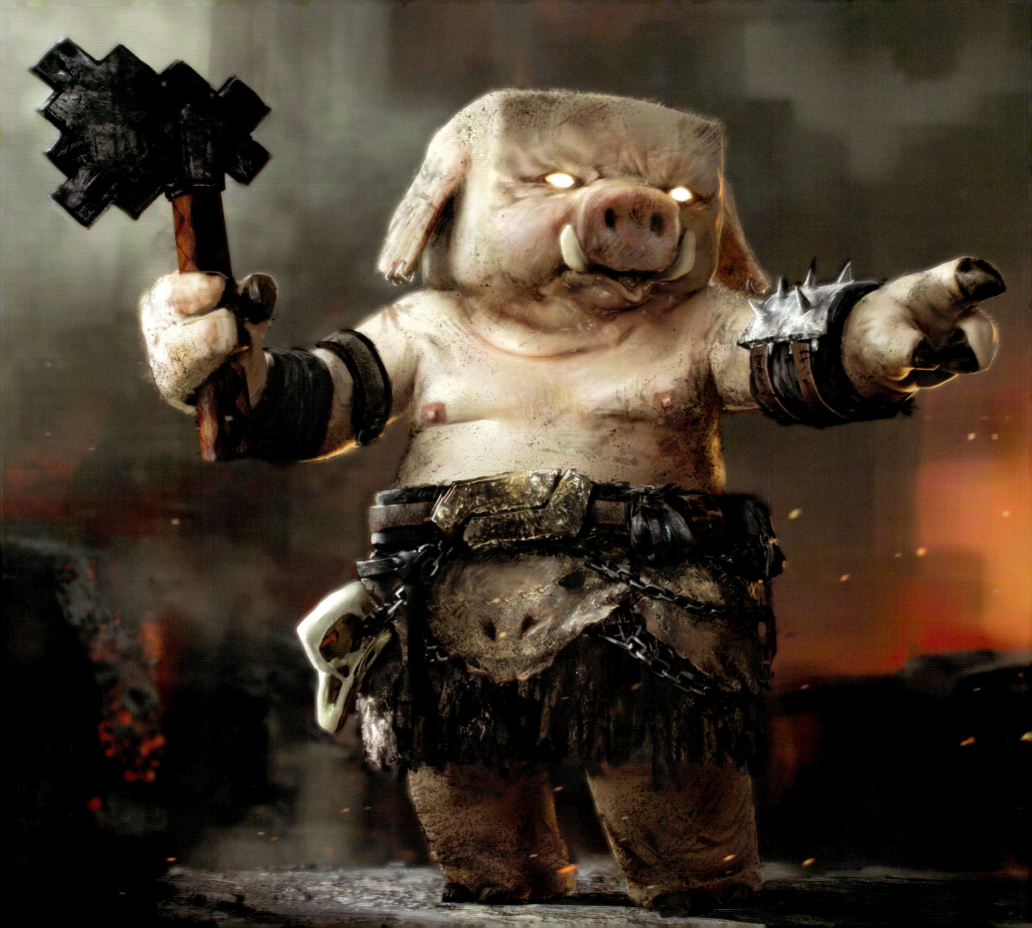

Night Moves

A *Minecraft Movie* utilizes a combination of human actors, motion capture, and computer animation to bring the Overworld to life, but to accomplish that, the filmmakers had to ask questions that no one had ever asked before. How are the movements of a skeleton different from those of a zombie? How does a villager move from one place to another? Just what is it that separates pigs from piglins?

To find the answers to those questions, the producers turned to New Zealand–based filmmaker and choreographer Alyx Duncan. Her body of work consists primarily of live theater and small independent films, so she was surprised when Jared Hess asked her to join his team on *A Minecraft Movie*.

"I had some basic familiarity with the game and had an image of it when I was approached to work on *Minecraft*, and early on, I was provided with a list of characters that we'd be developing, where I knew we'd have to develop a set of rules for each character to work with," says Duncan. "But in the first read of the script, I saw there was a whole universe here. I had to do a deep dive to really learn the game and know what I wanted to discuss in my first meeting with Jared. Are you after a set of geometric rules that apply to the characters, the shapes and the boxiness of the game, or do you want to bring out the qualities of what it is to be a villager in terms of personality, or a piglin? How does this work?

"It was a really lovely conversation between myself, Jared, and Torfi. And it's my role, really, to define what the rules of the movement are. I have to look at what are the rules of the game, and what is the culture of each of these beings in the game. How do they interact with each other and the other elements of the game. And then I've got the elements of backstory that Torfi brought, how some of these characters like the henchmen—the vindicators—hearing things that I would never think in terms of how the game was built, and the ideas that they had when they were deciding what these characters were, were able to influence and inform my decisions about their movement. This whole backstory of *Minecraft*ness."

Character animation within the game world is limited by the way the characters are rigged and by the gameplay itself, which restricts the agility and movement of *Minecraft*'s signature mobs. To bring them to life using a combination of cutting-edge mo-cap technology

OPPOSITE (Concept art)
A piglin warrior prepares for battle.

BELOW (Concept art)
Members of the piglin army await orders from their queen, Malgosha.

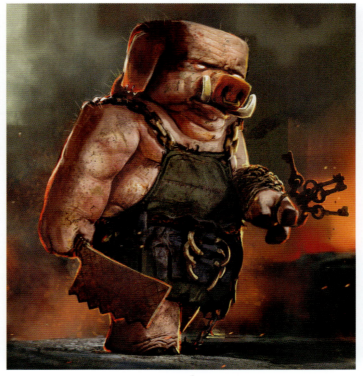
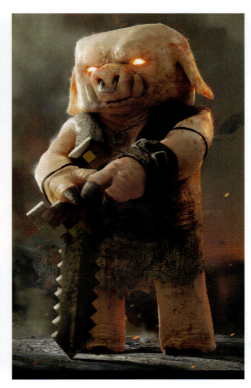

3. MOB MENTALITY

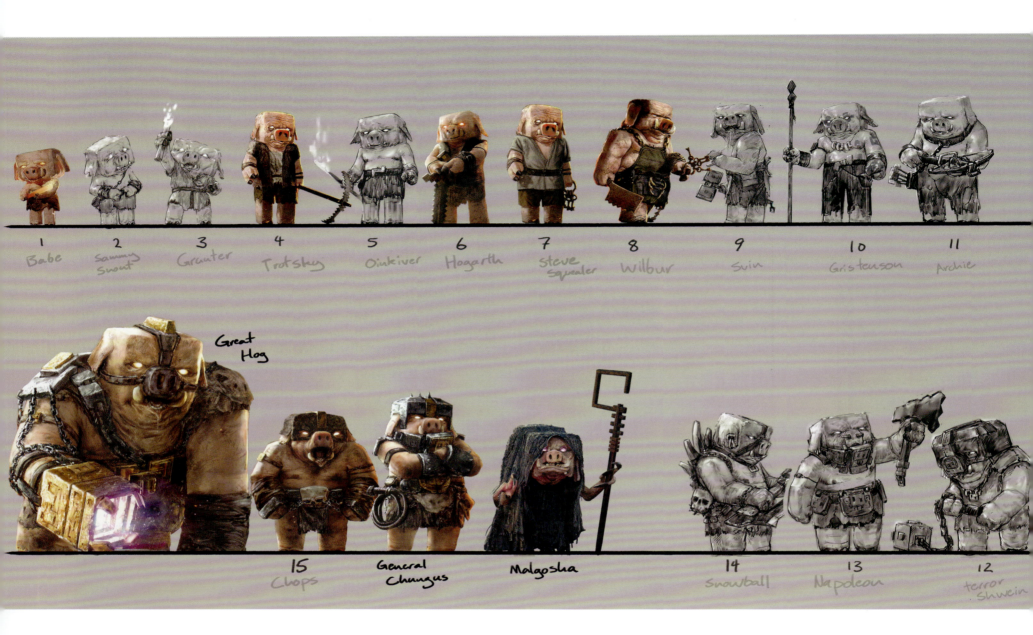

and "faux-cap" technology, which uses on-set stand-ins whose parts will be played by wholly animated characters, required Duncan to take a deep dive into each mob's appearance, philosophy, and motivations . . . all of which were much more complex than she had previously thought. "Prior to my first meeting with Jared, I thought everything was going to be incredibly boxy, which was my assumption from watching it," says Duncan. "And he said, 'No, no, no, I want it to have this organic quality. I want the piglins to have this . . . piggy quality.'

"And I thought that was great, and that informed my own research on things like how do pigs move? What are the ways of pigs? I looked at lots of videos of pigs, pigs rutting, and pigs fighting, and all of that. And I established these rules. Pigs' heads are sort of big, and attached to their body, and they don't have much side-to-side movement with their heads. It's not completely locked, but it's close. Their biggest sense is their sense of smell. They don't have great eyesight, but their nose works very well. So every decision about the movement of the piglins comes primarily from that sense of smell, first. They sniff, then move. Sniff, move."

Duncan studied each of the hostile mobs and developed a range of motion and a philosophy that would inform each group, providing each with its own unique vocabulary of movement that Duncan would teach the performers who would be portraying them onscreen.

"The zombies are slower but are lethal. How do they move? They don't see very

OPPOSITE (Concept art) Dozens of unique piglin characters are introduced in *A Minecraft Movie*.

RIGHT (Concept art) Hold it right there—the vindicator wants to axe you something!

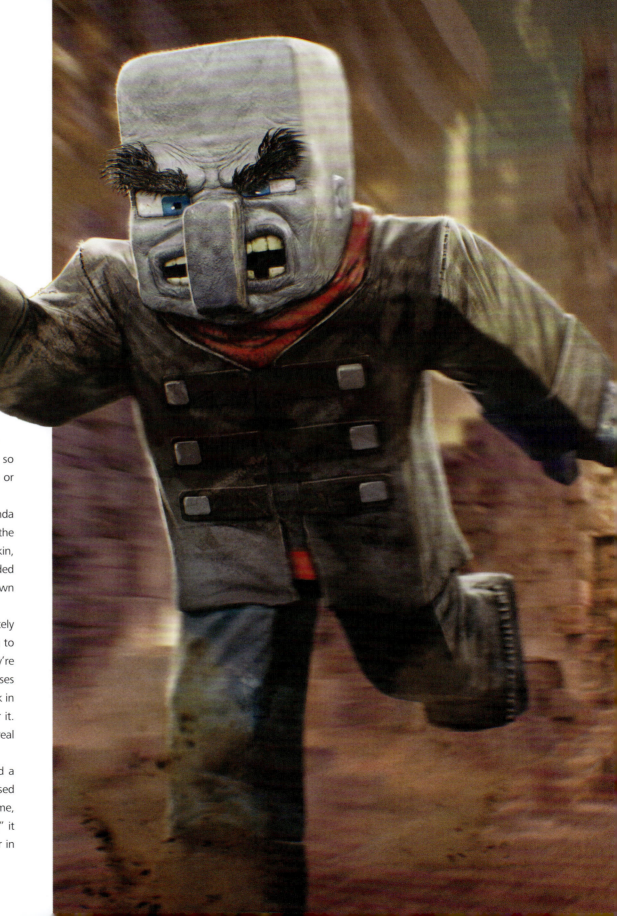

well, but they can hear. Their hands come up and they hear something and then their body moves, so there's always this sort of delay, a delayed response to things. Anything zombie I watched and studied. Jared had me watch [Ray Harryhausen's] *Jason and the Argonauts* to get ideas for the skeletons. Michael Jackson's 'Thriller.' And we watched videos together so that everyone was on the same page. Are the legs out to the side or parallel? What are the rules?"

Whereas Duncan choreographed the zombies' movements, Amanda Neale addressed their physical appearance. Because zombies in the game strangely seem to wear the same clothes as the Steve player skin, Neale's team created a zombified Steve costume. "We aged it, shredded it, covered it in mold and moss. Then VFX had to break all of that down and translate it into the digital medium."

Despite their mutual undead status, the skeletons had a completely different range of motion and skill set than the zombies, according to Duncan. "The skeletons, they have the bow and arrows, and they're really good shooters. So they have strong eyesight, and their senses are very visual. They've got these spindly necks, and when they lock in on something, the head turns first, and then they turn and go for it. Through that conversation, work with the senses, that led to some real specificity in the movement.

"With the vindicators, they're sort of like villagers, but evil and a lot faster. And Torfi told me this lovely backstory that they had based them on Jack Nicholson's performance in *The Shining*." In the game, if you use a nametag on a vindicator to give it the name "Johnny," it will become hyper-aggressive, a reference to Nicholson's character in

BELOW The evoker's magical presence spells trouble for everyone around them.

OPPOSITE ABOVE Jason Momoa and the stunt performers pose for the camera! The VFX team will render Garrett's on-screen opponent using computer graphics and motion capture technology.

OPPOSITE BELOW Garrett holds his stone axe in a defensive position as he stands ready to protect his friends.

> "Having those rules and that structure, which is *Minecraft*, really adhering to how *Minecraft* is imagined, that really opened up all of the possibilities within that."

the film. "That kind of information is so helpful for me, because I can take video of Jack Nicholson in *The Shining* and we can all watch it and discuss his movements and what elements of his performance we can adapt for the character movement."

Duncan worked closely with Jared Hess throughout the production, and she also coordinated all her efforts with costume designer Amanda Neale and VFX supervisor Dan Lemmon to bring the mobs to life. And as any *Minecraft* player can tell you, everything is better when you play with friends. "It was a really beautiful process, the coordination of the props department, finding out how they really worked, and the coordination with Amanda's department, and then with Dan and his team, to sort of filter through what they ultimately needed. It was such a lovely [experience], the language of this film, moving between a virtual realm and a physical realm, I really appreciated the open door of Dan's postproduction.

"I think that is a cool thing in New Zealand, once you've done a few films. It is a big landmass, but it's such a small country, with so few people here. And it is a place that, being an island, it has the culture where you don't make enemies? It's a place where you're always going to work with everybody again, and to be able to lean on the talents and experience and skills of everybody, you become a big family," Duncan continues. "Film is such an incredibly collaborative medium. On a film like *Minecraft* that isn't animation, it isn't live-action, it's really somewhere in between; there are so many different angles that need to be considered, and I love that culture with the film crews here. We're all looking at the same problem from different angles. Even things like when we're on set, the sets are so beautifully articulated, and I think that does come through in the scenes that I've seen.

"You know how they say restrictions benefit creativity? Having those rules and that structure, which is *Minecraft*, really adhering to how *Minecraft* is imagined, that really opened up all of the possibilities within that."

Stunt coordinator Jon Valera had to examine those possibilities while plotting the action sequences, especially those involving the film's nonhuman characters. "Because I've been with Jason Momoa as his coordinator for quite some time, and started training with him on *Conan the Barbarian*, we maintained a friendship for all these years, and he usually calls me for all of the projects that he does. When he told me about *Minecraft*, to be honest, I'd never played *Minecraft*. But Jason wanted me to be a part of it, so he put me in touch with Cale Boyter. I was honest, told him I didn't know anything about it, but Cale's a big ball of energy, and he sold me on it. He said, 'We want this to be kind of stupid and weird,' and a lot of stunt coordinators like to do things that are stupid and weird, so that was an easy sell.

"I was super excited to do something a little out of my comfort zone, since this was my first comedy where I'd be directing the action scenes. It's not very often that you get to design stunts for kids entertainment or comedy," says Valera. "Usually when you direct action scenes, you go for bone-crunching, intense action, shots that look like they hurt. Especially with the last few productions I'd been working on, with the heavy action and the violence factor. This one was obviously comedic action, and some of the characters involved weren't human, so some of the action has to be unnatural. What works for a human isn't going to look right for a piglin or an animated character. Luckily, I have kids, and I know what makes them laugh. It helps. Sometimes when I watch cartoons or animated shows with them, I see what makes them laugh, and I study that.

"As a stunt coordinator, I have to study movement. Not just violent action, but the way people move and react, how the body moves, and

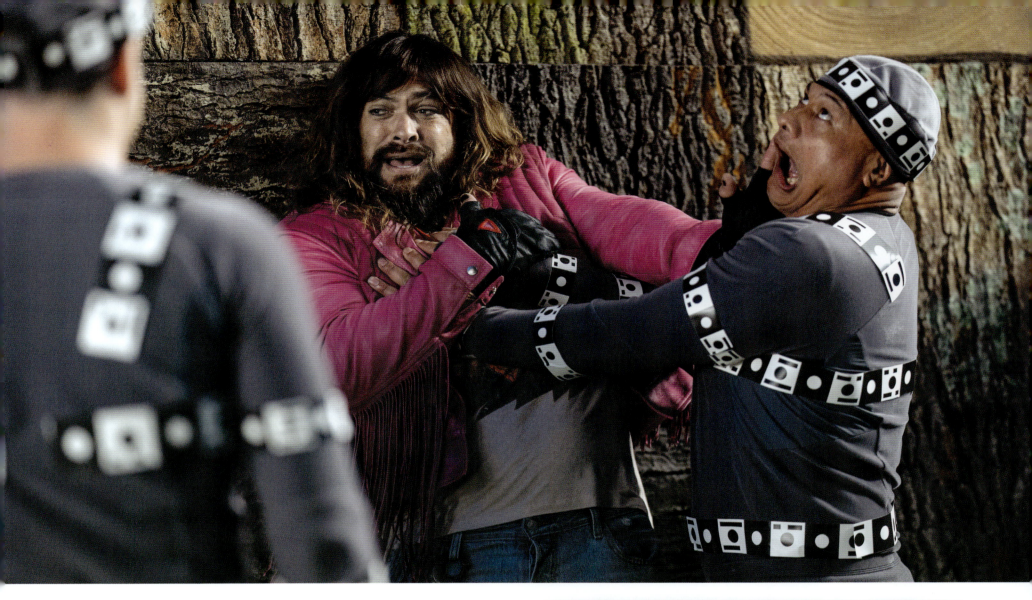

not just people. Animals have their own unique ways of moving, too. As a choreographer coming up, we're taught to study all kinds of movement. I tried to keep my head in that space of what would make my kids laugh. Jared Hess has that young mind, too, and in early meetings with him we really got onto the same page. His creativity really drove those ideas.

"We watched gameplay on YouTube, and Jared sent me film clips explaining how the nonhuman characters like the piglins, zombies, and skeletons would move. And we created a hybrid movement because a human character and a blocky *Minecraft* character are going to react to action in different ways. If a piglin falls flat on its face, maybe it's almost like a suction cup that would stick on the ground. We had a stuntman working as a piglin, and we used a frontwire so that we could slam him into a wall, and his face reacted like a suction cup so that he stuck to the wall then just slid down. My team and I always like to have fun with it and do sound design, and that helps sell the ideas for the action."

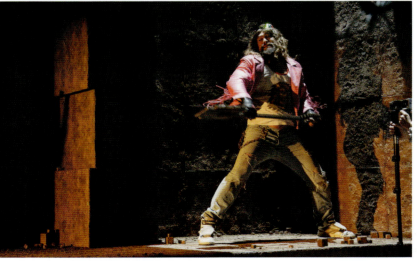

3. MOB MENTALITY 149

The Village Green Preservation Society

Although the Overworld may seem hostile, there are also friendly, blocky faces who are ready to help Henry and his friends with their journey. The villagers are task-oriented mobs who live and work in the small towns that populate the Overworld, and *Minecraft* players know them as valuable trading partners and allies who can provide goods and special items that can't be created on the crafting table.

Some of the mobs and background characters featured in *A Minecraft Movie* are entirely animated, but the villagers share so much screen time with the human cast that the VFX department felt they required a more tactile approach. "Dan Lemmon decided that it would be easier to translate the VFX characters if they had physical costumes, so we did that and used face replacement [animation] for those characters," says costume designer Amanda Neale. "The village was a totally different world. You know, we changed our fabric twice, because it kept blowing out. We traded it out for a very heavy hemp

RIGHT The librarian, cleric, and butcher dress according to their respective roles in the village, with appropriate aprons, robes, and accessories.

OPPOSITE (Concept art) Three baby villagers are staying up past bedtime under the watchful eyes of the iron golem.

fabric. We went through so many color samples for Jared Hess, since he's very particular about color. And we had to make sure it set properly in the Midport Village, which was essentially neutral tones as well.

"The other thing is that we only wanted to use natural fibers, because that's what *Minecraft* trades in. It's wools, it's seeds, it's natural materials. It's all woven on a loom, and that's the other element we wanted to convey. Everything was human-made and fabricated, hand-built from natural materials. That was a key element for us. And everything was, apart from their underbodies. The square-boned forms underneath, that was foam and Lycra and all kinds of tweaking to give us the box shape for their costumes and making sure there was breathability and functionality. They could be taken off quite easily, because you could only spend so much time in these costumes before they'd overheat, there were a lot of considerations in play.

"It's so interesting, because the villagers' costumes, as terrifying as it was to make sure that we were honoring the entire *Minecraft* community and the beloved symbols that these people have known, to identify, that was the biggest concern. That we worked in conjunction with Wētā and had notes from Mojang that we were getting it right.

"For us, because we had such a short time frame to build these costumes and these characters, we also had to factor in rehearsal times. The physical shape of the villagers, for these performers, they had to be about five-two, five-three? So everyone ended up being a diminutive dancer so they could all move and all be about the same height. We incorporated movement rehearsals into each of the fittings, where they could try on the shoes, and everyone could move and learn to walk, and then we'd sign off on a particular movement. And they could get used to being in that shape. So the performers themselves were such a key part of the process, defining the movement and visual traits of these villagers."

3. MOB MENTALITY 151

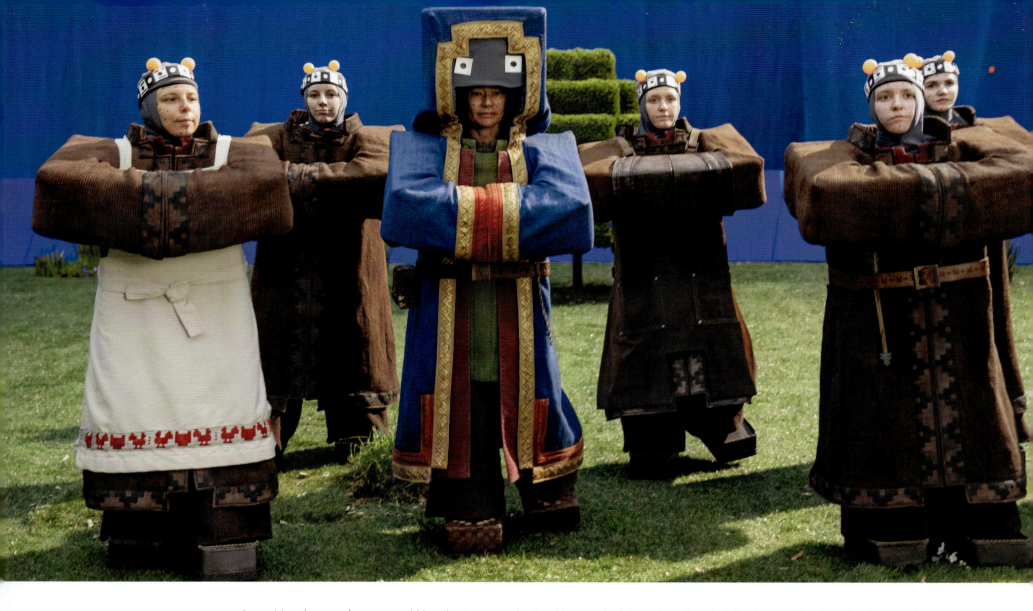

ABOVE A butcher and four plains villagers prepare for business with a wandering trader.

OPPOSITE ABOVE The costume workshop features a full complement of villager outfits.

OPPOSITE BELOW Bringing the villagers' distinctive faces into a 3D world required many designs and revisions over the course of production.

Supervising those performers would be Alyx Duncan, who taught an entire village of five-footers how to act and move like Midport villagers. "It was a really interesting thing in terms of casting, I guess, to work out the principles that were important for these characters. Throughout the film, there was faux-cap, people literally in suits that were suited characters with a motion-capture head, for the villagers, or faux-cap, people standing in for piglins or doing the action of the zombies but would later be recreated by animators to replicate the actions of those actors on the set," says Duncan.

"The casting, what was important, for the villagers, because they were literally going to be suited humans, they needed to adhere to the rules established in the game. The villagers all had to be exactly the same height. And so we had this quite stringent task of finding people between five-foot and five-foot-three. We then had three tiers, three heighted groups for the suits, then we always had people the exact same height together, so we had this uniform quality. It turns out that it's quite hard to find that many people in New Zealand who are all the same height and are all trained dancers, who could perform this very uniform action. It was a very interesting process.

"We also established the culture of these characters within this village, with that limited range of movement. They've all got their hands locked together, so what do they do when they meet each other? What is the range of movement that they have? We had to work closely with Amanda Neale in the costume department to make sure that, ergonomically, these suits could endure these long shoot days."

That hard work on behalf of the cast and crew paid off, however, and resulted in a visual world unlike any captured on film before. "It

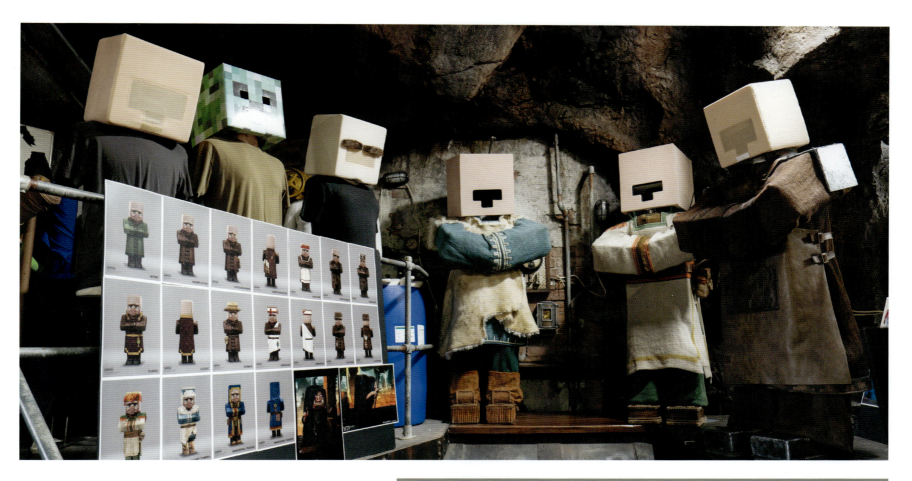

was honestly incredible," says Warner Bros. executive producer Cate Adams. "Watching the art team and the props department, they must have had so much fun building the swords and pickaxes and inventing new things like the tot launcher, and the buckchuckets, which were kind of a mistake but also really fun. It was just kind of a treat to walk on set and see every detail and design. And then the costume department with the villagers, who had to come up with all of these individual designs, since they all have different jobs. How do we make all of the villagers feel fun and interesting?

"In some ways it reminded me quite a bit of *The Lord of the Rings* and the town of Hobbiton, where you see Hobbiton and every single Hobbit has their own job. Here, every single villager has their own job, and the accoutrements to go with it, like the hats and what they're using for their tools. It's amusing to see that in the background, but really charming."

But not charming enough for one wayward villager who makes his way into the real world, apparently. What kind of nitwit would do that?

3. MOB MENTALITY 153

Villager concepts of various types and for many different biomes were created.

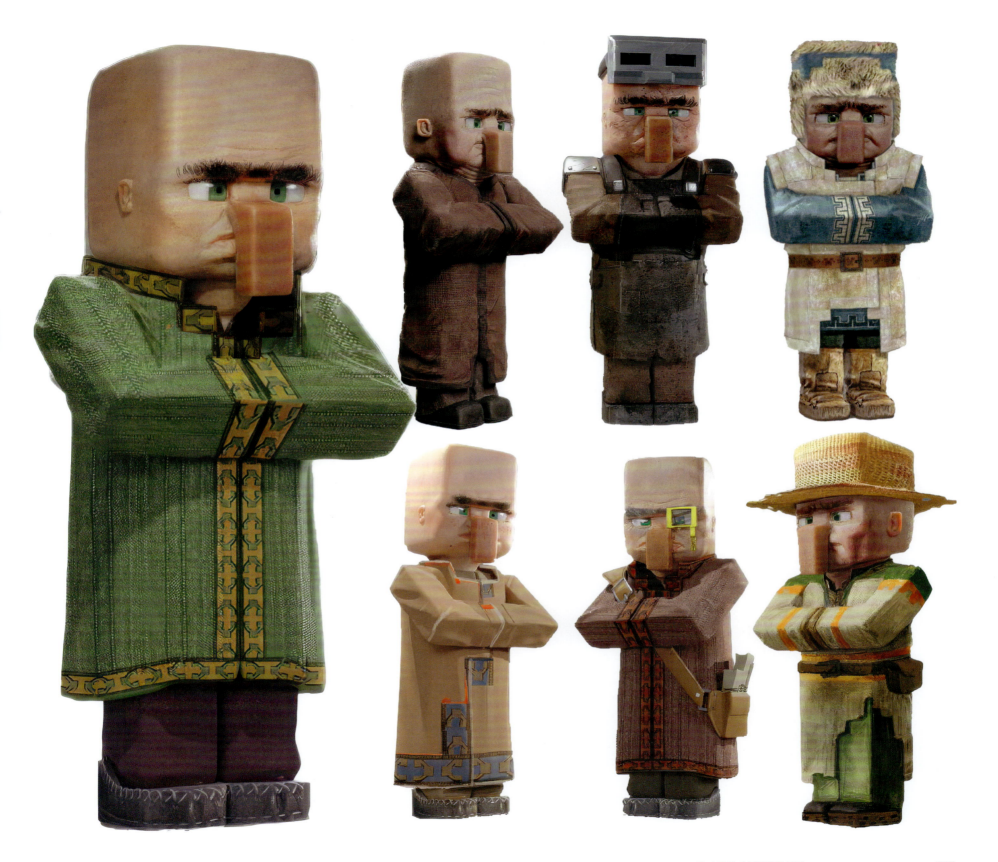

3. MOB MENTALITY　155

Survival Mode

"We always knew that we wanted it to be Survival mode." Jens Bergensten, *Minecraft*'s chief creative officer, knew from the outset that as much as everyone loves Creative mode, the *Minecraft* movie would require an element of danger to bring the audience onboard for Henry's Overworld adventure. "There were discussions about what happens if a character dies. Warner Bros. said that there had to be stakes. If there aren't stakes, then nothing matters. And I think that is the perspective of someone who hasn't played the games. When you play *Super Mario* and you have three lives, it's not like there aren't stakes. You don't want to lose any lives. There's always something at stake.

"In the new *Jumanji* movie, they have three lives, but in the story, they're very quick to remove those extra lives as quickly as possible to get to the 'stakes.' So there were a lot of discussions about death and dealing with death in the script. We went back and forth on versions, but in the current script, no one dies. There is a joke about it being Hardcore, but no one dies in the script."

Throughout much of the film's development, the story's Big Bad was initially never in doubt. "I was a junior executive on this ten years ago, when it first started here, at the very beginning," Warner Bros. executive producer Cate Adams recalls. "We knew from the start that we wanted it to be a live-action movie. We also really wanted to offer something that you didn't think you were already getting. People were already creating videos in the *Minecraft* world, whether it was them playing *Minecraft* or creating video content in *Minecraft*. With that 8-bit resolution, we felt, 'You can already get this.'

"So we wanted to create something that could feel bigger and more expansive, to offer something that you couldn't get. What if you could go into the *Minecraft* world? Wouldn't that be supercool if you were a kid? And there were varying takes. We were on a path with a different director and had a lot of prep work done in terms of visual design. The plot was different, because we leaned more into the Ender Dragon."

Although *Minecraft* is an open-ended, practically infinite sandbox game, those who prefer quest-oriented gameplay know that the ultimate goal is to find and defeat the Ender Dragon, the most legendary being in the *Minecraft* universe, the ultimate video game

OPPOSITE (Concept art) Steve enters the Earth Portal with Malgosha's soldiers in hot pursuit.

BELOW (Concept art) Henry and Natalie attempt to secure the Earth Crystal as a wolf spies on them.

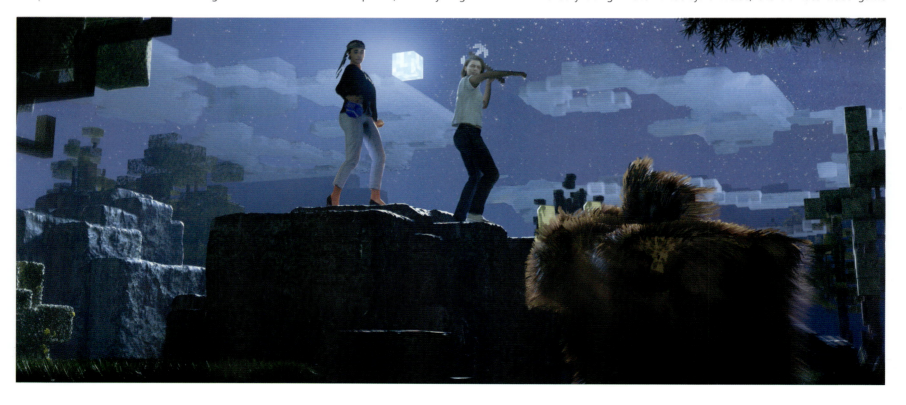

156 A MINECRAFT MOVIE: FROM BLOCK TO BIG SCREEN

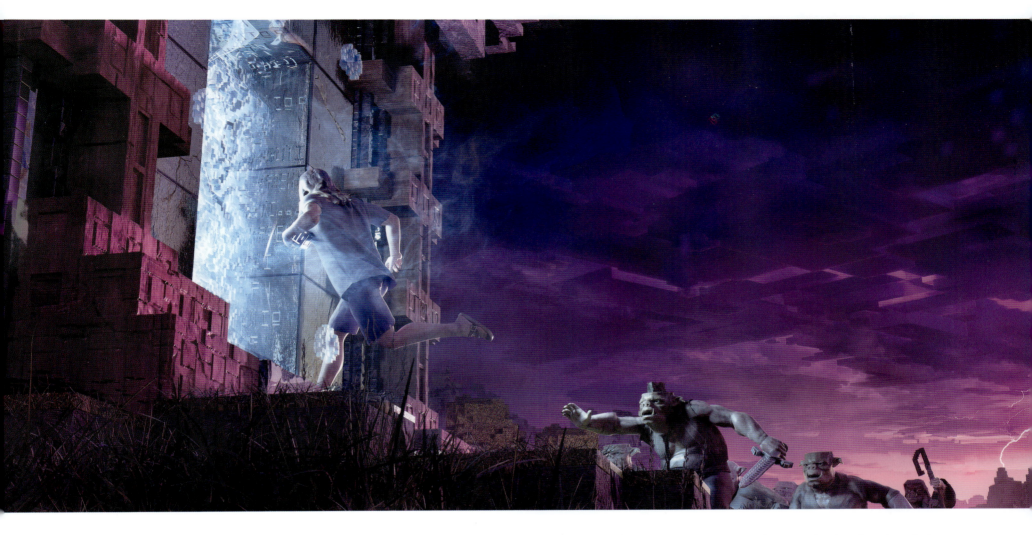

endboss. When it comes to raising the stakes and introducing the most dangerous foe imaginable, nothing tops a dragon.

Unfortunately for the production team creating *A Minecraft Movie*, every other movie studio on earth also knows that nothing tops a dragon. "We talked about the Ender Dragon a lot, but there are so many dragons in all of media," says Adams. "Disney films, *Game of Thrones, How to Train Your Dragon* . . . we've already seen dragons. Let's do something we can only get in a *Minecraft* movie, which is how we ended up with the piglins. There aren't piglins in any other IP [intellectual property]. And we just asked ourselves, 'How can we do something that you can only do in *Minecraft*?' . . . That was our guiding principle. Then it was a matter of finding the writers and producers and directors to do it."

"The Fellowship of the Nerds," according to Adams.

That creativity and ingenuity of that Fellowship allowed them to resolve all of the storytelling dilemmas that had come up over the course of production, according to Kayleen Walters, VP of Minecraft franchise development at Mojang Studios. "The big question was how do you tell a story about a game that doesn't really have a story? And what is that first story that you're going to tell? There was such a weight on everyone who tried to tell that story—you've got to have the Ender Dragon, you've got to visit all of the different biomes . . . Then there was this pushback, where they didn't want it to be what everyone was expecting.

"There was a lot of push and pull to determine what story we wanted to tell," Walters continues. "I came on to help the team so that we could keep pushing forward, making progress, and not go sideways with it. That's when Saxs Persson, who was then the co–chief creative officer at Mojang, came onto the production, and he made a vital connection for us." Mojang at the time had just started working on a new game, and it had a throughline based on a new mob, the piglin. "Saxs looked at that and asked, 'Why don't we tie it to the piglins instead of the Ender Dragon as your antagonist?' And that helped us shape the story in a different way, and we all kind of leaned into that. It didn't feel as definitive as if it were solely about our actors meeting the Ender Dragon."

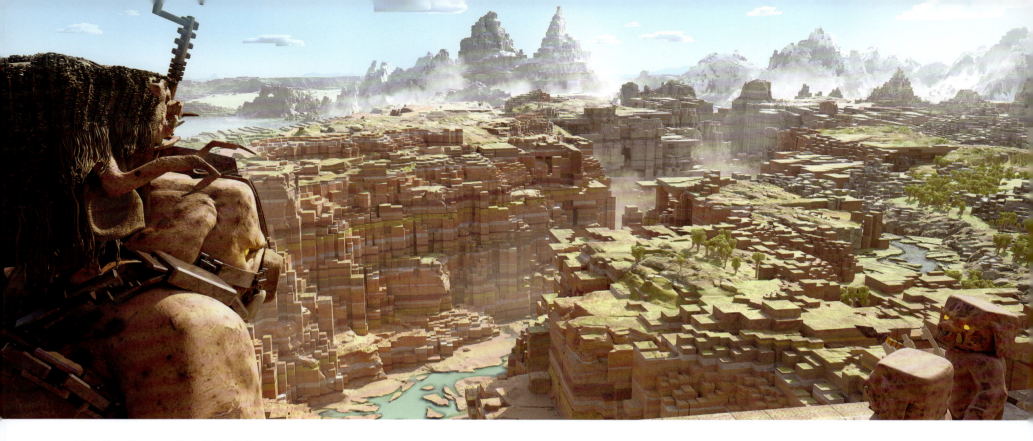

This Little Piggy

Mojang saw the storytelling potential in using the piglins as the film's antagonists and the opportunity to build on their own mythos, according to *Minecraft* chief creative officer Jens Bergensten. "Back in the day, when the Nether was first introduced, one of the inhabitants was a zombie pigman. And there has always been this question of who were the pigmen before they became zombies? And we had always planned to expand on that dimension, to introduce these creatures, whatever they were. And as we were thinking about that, that's when the development of *Minecraft Legends* started. It's a strategy game set in the *Minecraft* universe, and we needed some sort of protagonist," says Bergensten. "So the idea was that we would tell the stories about the pigmen. But we didn't really like the 'pigmen'; we wanted something easier to use for our fantasy-building and storytelling, so it was changed to piglins."

"In *Legends*, there is a narrative about the piglins invading the Overworld, and that story inspired Jared. He wanted to use that to tell the story for the movie. They are very central to the movie, and they are very fun."

The film's director agreed with that assessment. "Jared completely fell in love with the piglins," says *Minecraft* creative director Torfi Frans Ólafsson. "Just as he was coming on board, we had released an update to *Minecraft* called the Nether Update and had really added the piglins there. We'd only seen them zombified in the Nether prior to that. We did that to lay the groundwork for *Minecraft Dungeons* and *Minecraft Legends*, as part of tying together the mythology of the different games. But Jared saw in the piglins that he could make them be kind of the Minions of our movie. Funny little antagonists that could both be kind of cute and innocent, like the baby piglins running around, but could also be kind of terrifying, and scary. And what's most important to him, funny."

But the piglins had to walk before they could run, and adapting their movements from *Legends* to *A Minecraft Movie* was no small (pig's) feat. "There are limitations inherent in the character designs of *Minecraft*," notes Ólafsson. "Like non-bending elbows. In none of our trailers or consumer products are there bending elbows. And this has led to any number of debates. Some of the first notes we had from our animators were on the piglins, who were not allowed to have elbows or knees.

"They came back to us to say, 'We can't animate that; we can't do

ABOVE (Concept art) Malgosha and The Great Hog look out upon the Overworld as they prepare to launch her latest and greatest evil scheme.

OPPOSITE (Concept art) It's a trap! The piglins attack Midport Village and only Henry and his friends can stand against them.

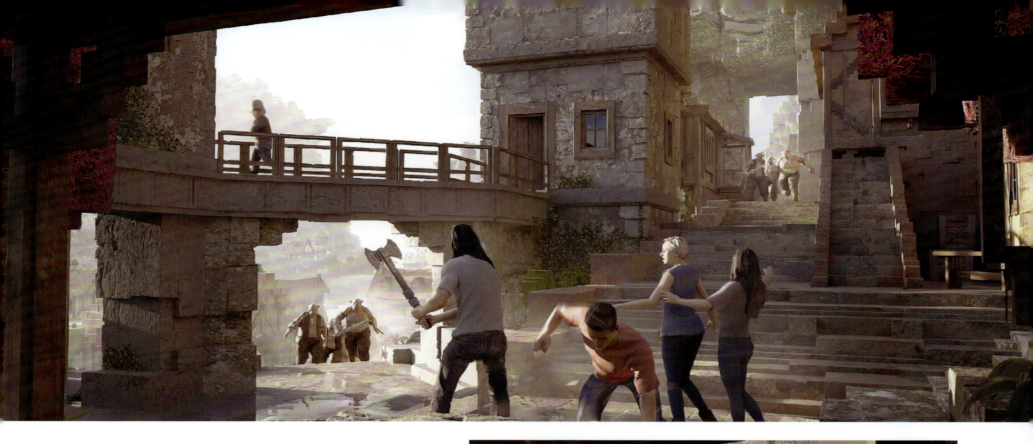

proper character animation like this.' And the compromise, when you look at them, is that they're sort of struggling, they're not very flexible, like bodybuilders. They couldn't do gymnastics—they're all chunky and stiff. You get a sense of blocky steps and movement, it's clear that they have really bad elbows and knees."

Dan Lemmon worked closely with Mojang and with choreographer Alyx Duncan to determine just how the piglins and the other mobs would move onscreen and interact with the film's human actors, and they ultimately came up with a solution that was true to the game but not completely beholden to what had come before. "That's been the process, from initial designs and set construction to asset construction and the characters," says Lemmon. "We've spent a lot of time with our piglins and our mobs and skeletons and creepers, the llamas . . . you look at some of those characters in the game, and there are no elbows. Often limbs will be one big, rectangular solid with no joints. Then we would look at something like the spiders, and we'd note that we can't make them move like spiders if they don't have joints. So we're going to joint the legs, but we'll keep things squared off so that they can articulate as they move through the space. We settled into a place that was a good compromise between something that honors the game and something that allows us to animate and to have these characters participate in the same world as the actors, like they belong together.

"It's one of these things where there is a healthy amount of

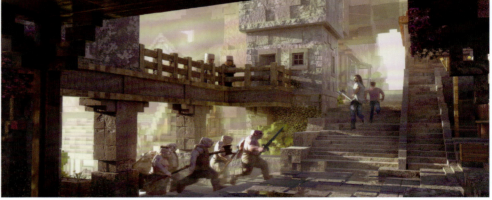

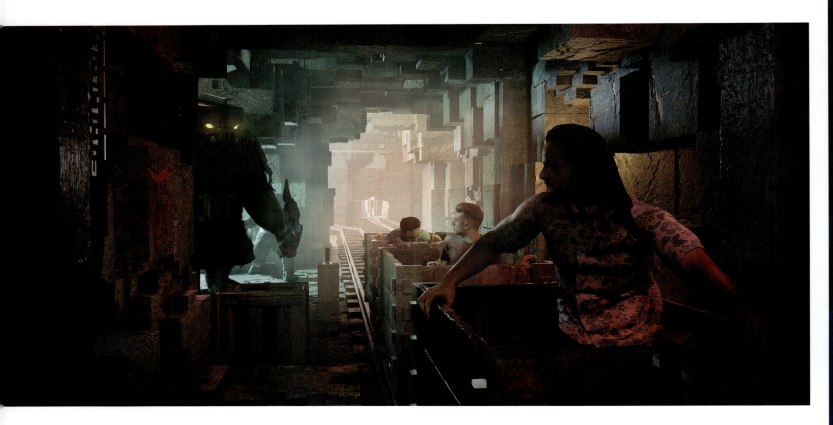

suspension of disbelief that has to be engaged in order to accept things like the piglins, in particular. If you saw one walking down the street, it would be massive, like a six-hundred-pound thing. They might be shorter than you, but their heads are twice as wide as my shoulders. You set up those rules and you try to obey them as closely as you can, to make sure it all fits together in the same space."

Unlike the creepers and other mobs that had to be completely identical to one another, the concept artists and VFX team were encouraged to run hog wild with the piglins and to provide each with their own distinctive appearance. "The piglins, we knew that we needed a horde, probably an army of them at the end of the movie, so we wanted a variety of sizes and body types so that they would feel just like a motley band of ragtag, improvised, sloppy characters," says Lemmon. "Wētā did a lot of the concept art for them and cast a wide net for those guys."

That diversity is what makes them so unique within the world of *Minecraft*, according to Mojang's Johan Aronsson. "The piglins I feel are insanely nice," he observes. "They have so much personality, so many different sizes. And some of that comes from *Legends*, which has a lot of different piglins, different versions of them, different ranks. And how they behave is part of their rank, almost. The lower-ranked piglins, for lack of a better word, are kind of stupid, impulsive. And they can be kind of cute and nice, but they can also be kind of horrible. The further up you go in the ranks, the more brutal they get. It's been very exciting to see how that comes to life."

Warner Bros. executive producer Cate Adams agrees, and is certain that the piglins are going to win over a whole new audience after their star turn in *A Minecraft Movie*. "There's just a lot of humor in the design, like what they're wearing, in their armor, adorning them in gold now, which is a late addition, since they crave gold in the game. And getting to see just the fun of it play out in terms of their size, and the visual comedy elements," says Adams. "That was a big part of the design that Jared Hess carried through with all of our teams. You want to go to this movie and just enjoy it, and it's been fun getting to see them play with it."

ABOVE (Concept art) Garrett and his crew attempt a minecart escape, but The Great Hog is in hot pursuit.

OPPOSITE (Concept art) The Great Hog approaches! Malgosha's most powerful soldier is feared throughout the kingdom.

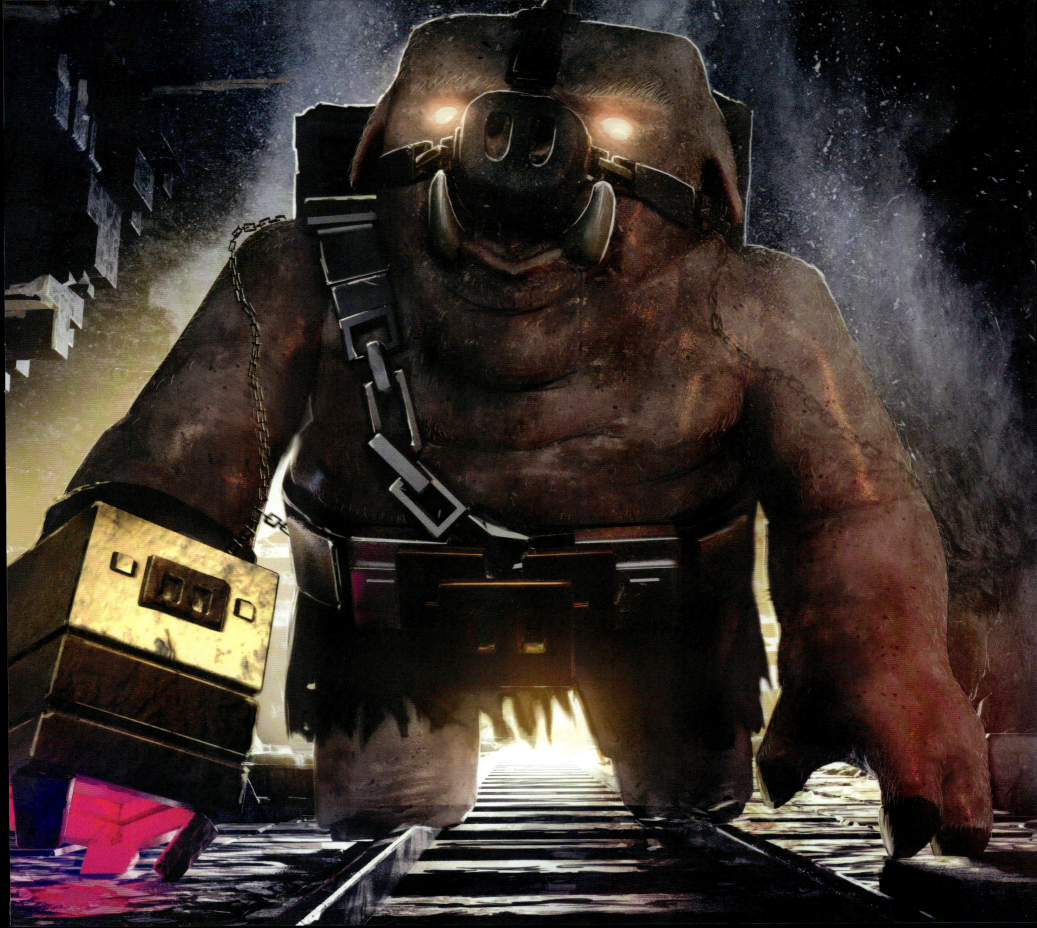

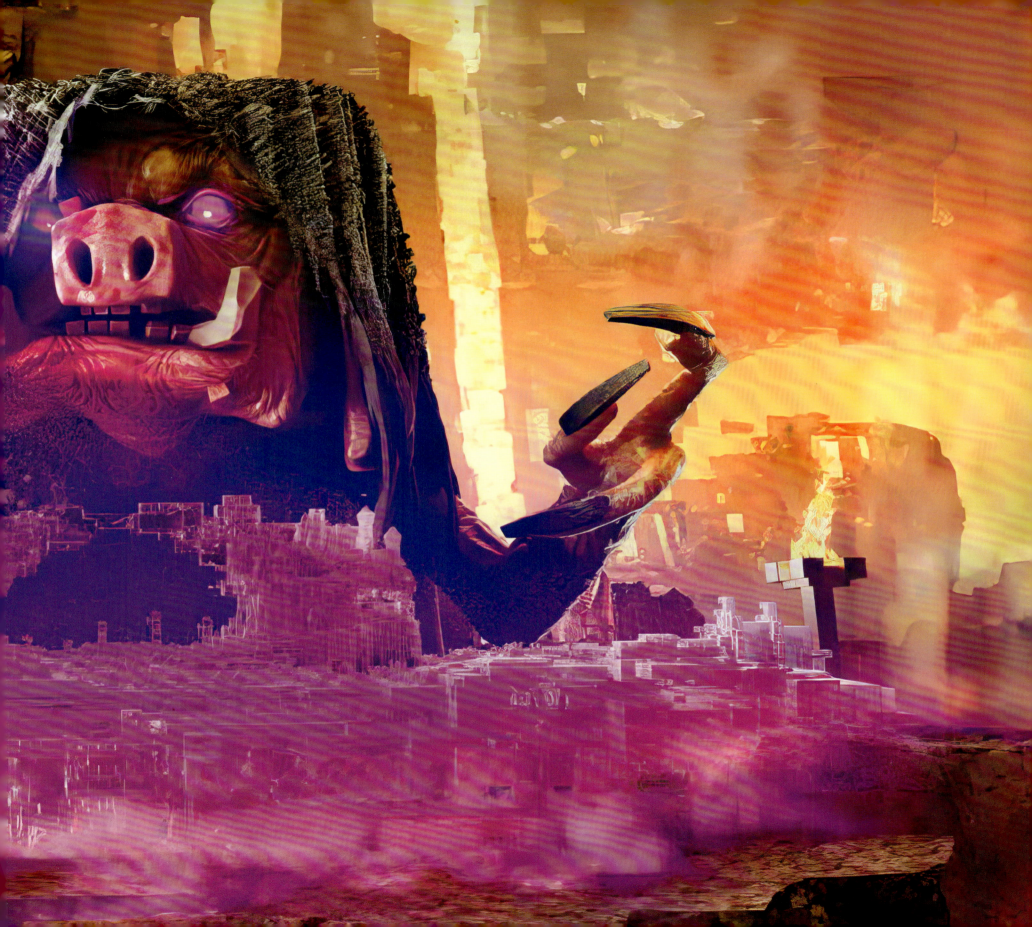

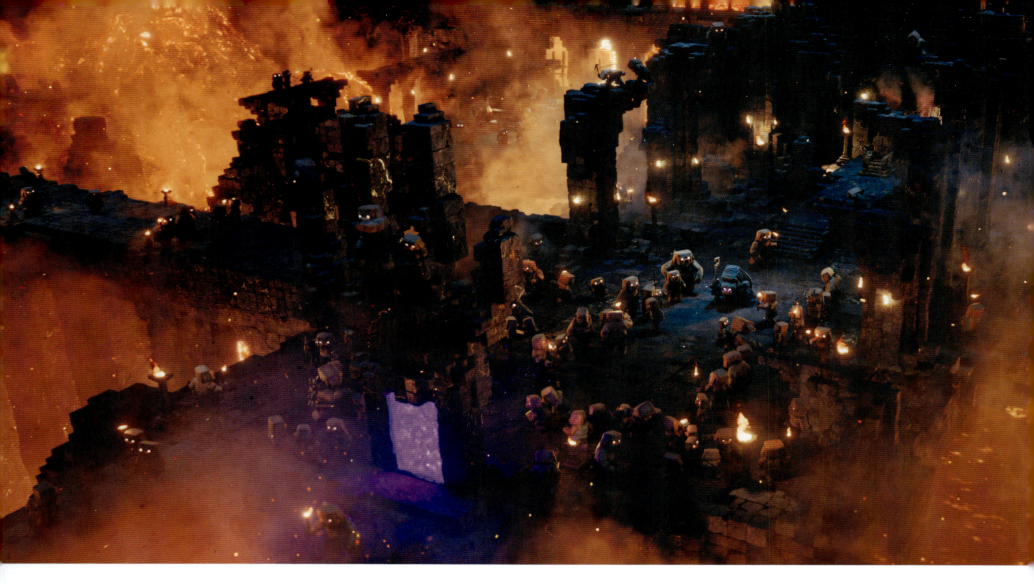

One to Rule Them All

One piglin undeniably reigns over the others. The Big Boss in *A Minecraft Movie* is the piglin leader, Malgosha, known and feared by all who inhabit the Overworld.

"Malgosha hates what the Overworld stands for, and she hates creativity," screenwriter Chris Galletta explains. "And there's a version where she's like Sauron, and you know that she's a force of evil, but you also learn that there's a backstory that's kind of like Stephen King's *Carrie*, where she got humiliated trying to make something, which is the risk of being creative. That you might get laughed at. And she took it really poorly and now she's evil. And now the only creativity that's allowed in the Nether is that you're allowed to make a painting of her or a bust of her, something like that.

"She's a fascist warlord, basically. She's silly, but it's also scary to imagine a world where you can't be creative at all, and everyone's chasing gold around. It's a recognizable world, I guess."

In direct contrast to Malgosha's origin story and personality, however, it took a considerable amount of creativity to bring her to life.

"For Malgosha, we had to make sure that she was of that same piglin language, but also somebody unique and special within that world, somebody that had that sort of evil boss vibe," says VFX supervisor Dan Lemmon. "She and The Great Hog were based on some characters in the *Minecraft Legends* game. Fans of those games will recognize a lot of those aspects. For Malgosha, the rich texture of her big, heavy cloak. Amanda Neale, our costume

ABOVE Malgosha's lair is a monument to the piglin queen.

OPPOSITE Cloaked in darkness, Malgosha wields more power than anyone in the entire *Minecraft* realm.

164 A MINECRAFT MOVIE: FROM BLOCK TO BIG SCREEN

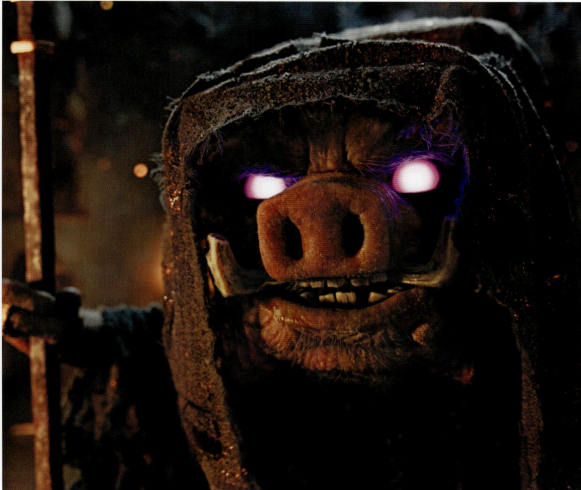

designer, designed the cloak and went to the trouble of distressing it and giving it all the kind of love and care that you would for a hero costume. Even though it never appears in the movie directly, we had it on a stand, on a Malgosha-shaped pedestal that we could wheel in and use it for reference, for scale, and for the actors to play against."

Amanda Neale and her costuming department worked closely with Lemmon's VFX team and the props department to develop the Malgosha proxy that would take the villain's place on set during the filming. Neal shares, "You spend the whole time walking around each department, looking at the accessories and soft props and figuring out what the graphic is for those, including leather stamps, and then you go to the textile department and look at the color samples and swatches, for the costumes and overdyeing for Malgosha, who was a very big build herself.

"She's the big pig in the Overworld, the antagonist in the script. We actually had to build a metal frame to hold her costume, since it was so heavy and so big. The mo-cap actor would have to go on with his gray mo-cap suit, and we had to have the costume as a visual reference for the visual effects department. Very busy production, with the different departments and signing off on things. And working with the extras, making sure that our background characters worked within our filming environments."

That team approach makes Malgosha one of the most complex characters to appear in *A Minecraft Movie*, but every member of the crew agrees that she was worth the effort. "I love the way Malgosha came together," says Dan Lemmon. "The character animation on her is so rich. And so fun. The facial expressions, her lip-synch, the facial articulation, the way we interpreted her muzzle, her big flappy jaw, the way that her expression is old and withered and mean. She's just a fun character, really fun to animate. Really fun to see her shine.

"Malgosha, we had a performer on set, Allan Henry. He had the same proportions as the character, which was good for establishing the eyeline with our actors. He developed a movement thing that worked well as a stand-in for Jack Black to interact with. He also is a talented performer in his own right, and he gave an audio

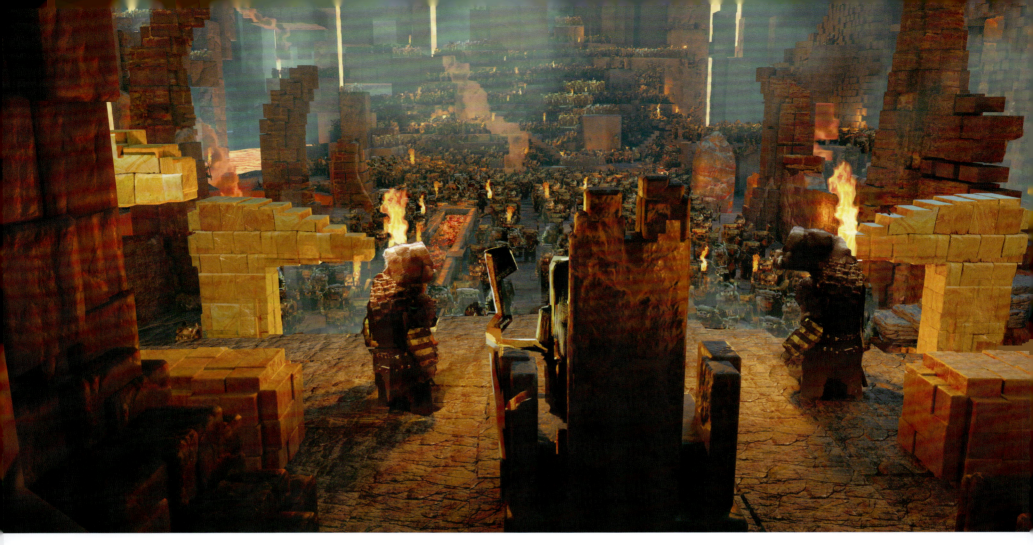

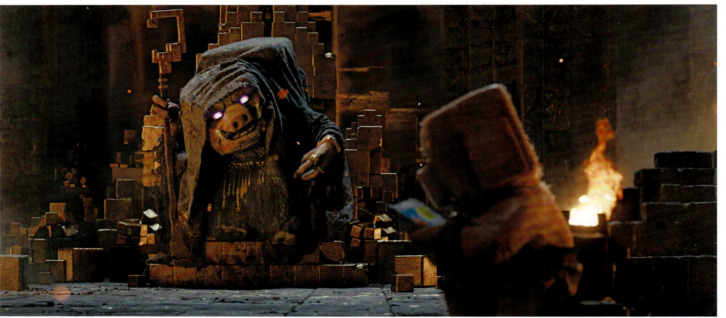

ABOVE AND RIGHT (Concept art) Malgosha surveys her piglin army from her golden throne.

OPPOSITE ABOVE (Concept art) Malgosha and her piglins charge into battle in a concept illustration highlighting each warrior's distinctive personality.

OPPOSITE BELOW The fate of two worlds rests upon the power of Malgosha's staff and the Orb of Dominance.

166 A MINECRAFT MOVIE: FROM BLOCK TO BIG SCREEN

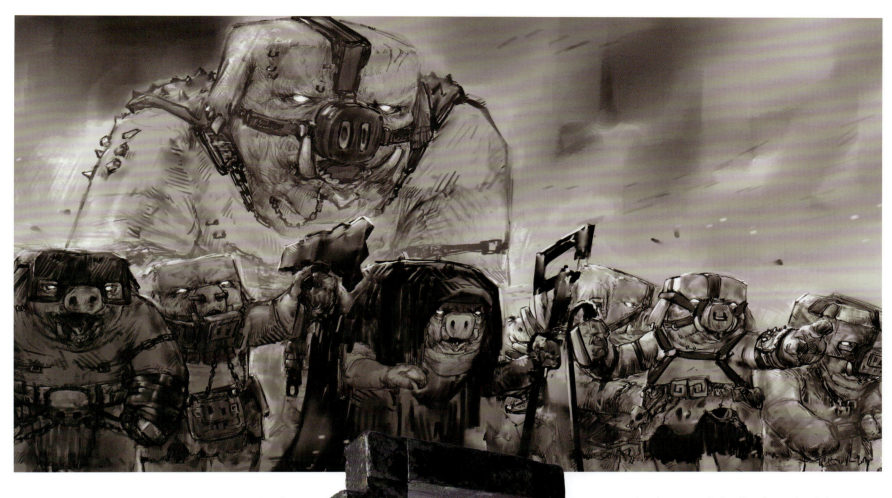

performance, and did dialogue that lived in the film for a long time while we were editing.

"They cast Rachel House to do the voice of Malgosha. Some of the lines, she effectively repeated what Allan had done on set, some things she embellished. There's been a lot of back and forth that way. We used Allan's body movement as a foundation, and sometimes we would deviate off of that a little bit, but that was the starting point. Always, we try to get the dialogue established before we get into the animation too deeply. It's not just dialogue, it's punctuating, it's gestures, hitting different words, the attitude, not just words but posture, and the total package. We did as much as we could but sometimes had to put things on hold while we waited for updated dialogue."

All in all, Lemmon worked for three years on *A Minecraft Movie*, from the earliest design discussions to rendering the final effects that will appear onscreen, coordinating efforts on every visual aspect of the film from the tiniest square blade of glass to the largest woodland mansion. "Finishing the film, it's a matter of seeing how far we can push things back toward a stylized, saturated video game space without it looking like a video game but still honoring the richness of the game and finding that balance," says Lemmon. "Getting all the different creative partners in the film to see the world the same way. You get into the details and realize that different people have almost polar opposite ideas how to achieve the right look. The simplicity of the game's visuals has actually made it harder to agree upon how to bring this to life, since there are so many different directions one can go. Trying to get everybody on the same page has been one of the big challenges."

3. MOB MENTALITY 167

4. PUTTING IT ALL TOGETHER

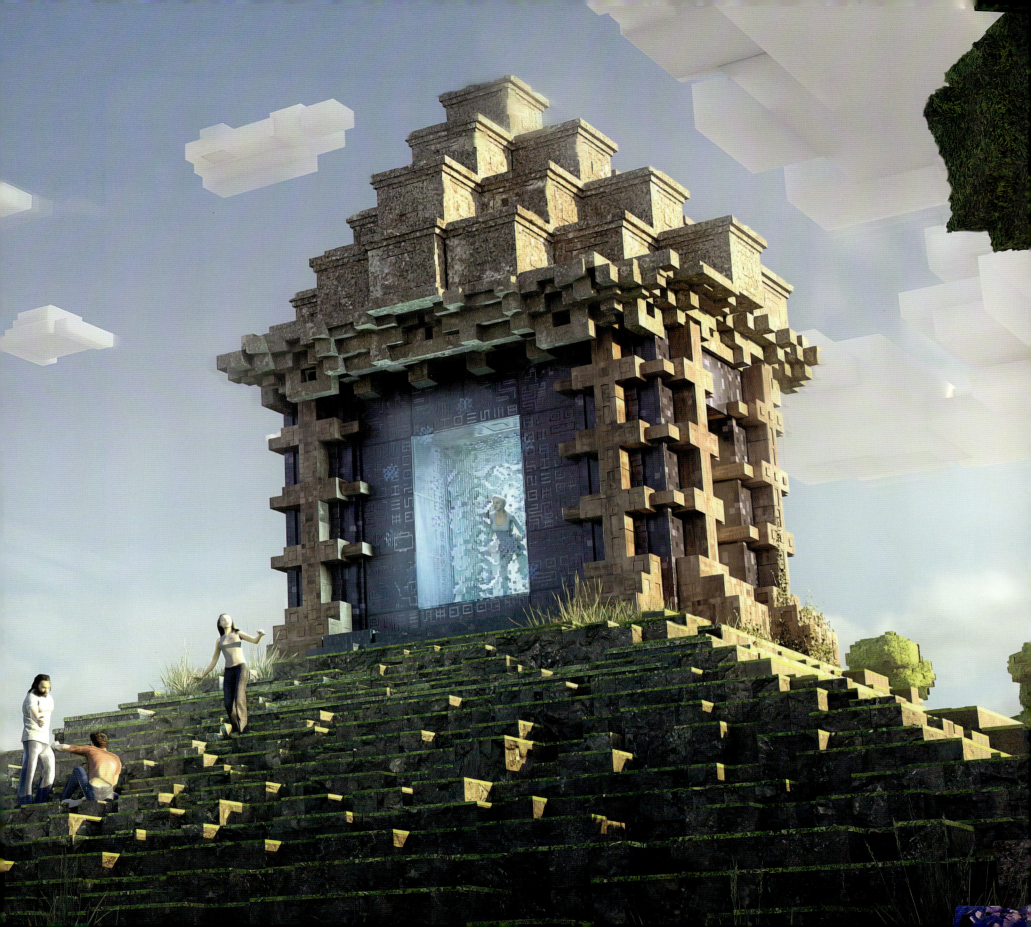

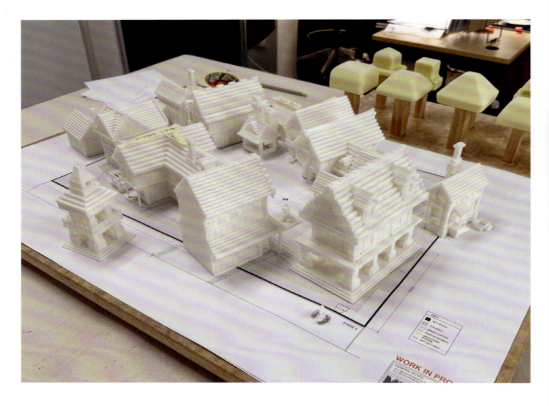

ABOVE Artists create a 3D-printed village to study each building from multiple angles before rendering them in the virtual world.

OPPOSITE ABOVE (Concept art) The bridge to the Woodland Mansion is the site of one of the most intense action sequences in *A Minecraft Movie*.

OPPOSITE BELOW A *Minecraft* crew can never have too many pickaxes and shovels.

More than a decade after it was first announced, after years of planning, building, tearing down and rebuilding, and then more planning, *A Minecraft Movie* became a reality thanks to the dedicated efforts of a talented core of creative personnel, from game developers and executive producers to screenwriters and actors to artists and musicians. A veritable village of inventive story-builders joining forces to do what they do best, in true *Minecraft* spirit.

The lessons that Mojang and their creative partners learned along the way resulted not only in a visual world that brings *Minecraft* to life in a way that had never been attempted before but also charted the course for destinations and journeys yet to come. "The *Minecraft* experience is almost like an impressionistic painting," says Mojang art director Johan Aronsson. "And that informed the logic and the sensibilities that we applied when creating this film. In every player's head, it's a different experience based on what they bring to the game. You're filling in the gaps and that makes it tricky, but that's also a fun part. We can do this now and it's one interpretation, and it's a nice interpretation, that lets you explore things that other people may never have thought about.

"And we're exploring how *Minecraft* can be interpreted into other games, and other types of entertainment. *Minecraft* at its core is so simple, and you can go so many different ways, and the way they picked almost follows the way players tend to want to enhance the way the game looks. *Minecraft* is so simple and open, but it's also super-immersive, and somehow realism is the first thing that comes to players' minds when they want to take it up a notch. So in that sense, I'm happy with the movie's direction and now I want to do a lot more.

"At the core of it, what we try to keep in mind is that we're telling one story here. For every game, over all the years, every player has their own story, and this is just another one of those stories. There is no canon, really, in that sense. We're making cool stuff, and this is one interpretation of it. And if you see it from that perspective, we've done a lot of cool things in this movie, a lot of cool choices, experimented a lot. And even, at some points, figuring out things where we could apply that logic elsewhere. Things that could go from the movie and could come back to the game, or even other products. And that's always a win."

> "In every player's head, it's a different experience based on what they bring to the game."

That team spirit was evident throughout the production, as each individual department had to work closely with every other department to complement one another's efforts and deliver the best, most complete vision of Minecraft to the screen. "There are a lot of partners on this film. A lot of strong, creative voices in the room," says VFX supervisor Dan Lemmon. "Ultimately, it all adds up to a film that's going to be well considered, in terms of the fan base, and the history and intent of the game. Having the Mojang people involved has been instrumental in making sure that we're creating something that the fans will connect with. Working in the movie environment with filmmakers has been its own unique challenge. It's visually such a different kind of film, a totally different kind of experience.

"The game is simple and abstract, but that simplicity hides a lot of complexity beneath the surface. Interpreting that simplicity into a real space has been one of the biggest challenges I've ever had making movies. Going from something so abstract, and so beloved, you know that every choice that you make is going to be scrutinized and questioned. Adapting that into something that fits into a cinematic world that people are going to embrace, hopefully, that's been the hardest thing."

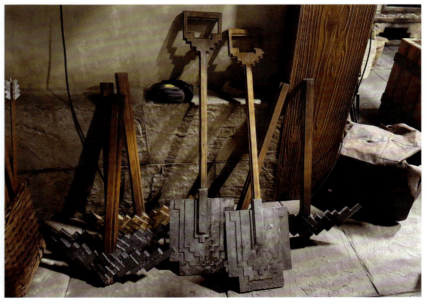

MINED STONE NATURAL STONE

Suspension of Disbelief

ABOVE This rendering shows the relative height of a stone block as depicted in the game when compared to an average adult. Those proportions were modified in *A Minecraft Movie* for practical considerations.

RIGHT The Earth Crystal possesses power beyond human — and piglin — comprehension.

The cinematic world established in *A Minecraft Movie* is rich and visually complex, a brightly colored mix of fantasy and reality, a crossover between the digital realm and the real world, a mash-up of animated elements and live action. Bringing these two visions together to create something new, something never seen or even imagined by *Minecraft* fans before, to synthesize something that is both real and unreal at once, was ultimately the biggest creative challenge to the filmmakers, but it was a challenge familiar to Dan Lemmon and his VFX team.

"One of the concepts that really struck me in storytelling is the notion of the suspension of disbelief, a term that was coined in the early nineteenth century by Samuel Taylor Coleridge," says Lemmon. "He had this notion that you could bring an audience along for the ride as long as you established and obeyed your rules, and as long as you had some kernel of truth to the story you were telling, an emotional truth. If you had that truth, then you would accept ghosts and ghouls and vampires and other things. A big part of my craft is about supercharging that suspension of disbelief. Taking something that might exist in other peoples' brains and putting it in a story in a way that would allow that story to seem much more plausible and believable.

Conversations with Cale Boyter and Jared Hess at the outset of that journey helped Lemmon determine that path that his own *Minecraft* adventure would take. "For me, the

real challenge is what is this place going to look like? The game is so low-fidelity, and to me, it's a little like looking at a Rorschach blot. There's so much abstraction that you can kind of see in it whatever you want, in a way. That's part of the charm, and maybe part of what people love about it," says Lemmon. "The aesthetic is so lo-fi, and so unobtrusive that it doesn't really put anybody off. It leaves a lot unsaid and leaves it to you and your suspension of disbelief to fill in the gaps.

"What we settled on early on is that we would lean into the blocky aesthetic, but we would finish it in a photorealistic way. So it's a physical, realistic world, but it just happens to be organized in this gridded, cubic kind of way. And the physics would be different. We leaned into all these aspects of the *Minecraft* game where you'd knock the bottom out of a tree, but the rest of the tree stays floating up above. Those kinds of absurdist physics, we'd keep, but the finish of these things would feel photographic. So we could make sets, we could make props, and we could make digital environments and extend things and enhance things, but they would all fit into this same physical environment and space.

"And we studied all of this to see how far we could push the grid, using natural shapes and occurrences to find ways that we could shape this world. Adding spirals and hexagonal shapes. It was quite interesting as a concept," he continues. "Then we started talking to Torfi and the folks at Mojang, and they said, 'You can't do that! You'll have a riot on your hands! You've got to stay on grid, everything has to be square, everything has to line up.'

"Figuring out what that means, keeping everything on grid while we're shooting, without squares and measuring tapes and making everything line up at all times . . . we kind of came up with some rules, that the basic structure of the world would stay on a grid, but things that are loose, they can be placed anywhere, they don't have to snap into that grid. But when we build things, in the *Minecraft* construction way, those things will stay aligned. The clouds in the sky are cubic; they'll be aligned with the earth and that grid. The process of figuring out what the world should look like, in a cinematic way, that honors the game but also feels like a movie. It's going to obey the rules that the fans are familiar with, but it should also feel like we used the game as our starting point and enhanced it, taken it steps further into bringing it into a photographic and cinematic space."

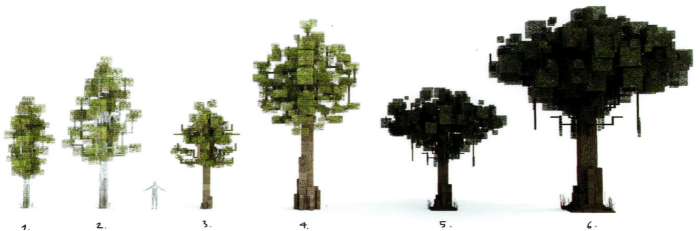

ABOVE The arctic biome is one of the most beautiful lands in the Overworld.

LEFT The designs in *A Minecraft Movie* reflect the diversity of forest life in the real world, with different varieties, sizes, and ages of trees taking root throughout the woods.

4. PUTTING IT ALL TOGETHER

Winging It

Havigating the cinematic space between fantasy and reality is especially difficult in modern filmmaking, and the crew had to strike just the right balance between digital and practical effects during production. Stunt coordinator Jon Valera knows that the stakes are high for *A Minecraft Movie*'s action scenes, especially the hair-raising flight sequence featuring Steve, Henry, and Garrett. "The elytra wingsuit sequence was the most challenging for us. Even though it was a full greenscreen environment, when you see Jack, Jason, and Sebastian flying around, they were strapped into these stunt rigs called tuning forks, which we use to simulate flying in front of a green screen. It's one of the most uncomfortable sequences for any actor," says Valera. "Jason has dealt with these a lot in the past, on *Aquaman*. Most of the stunt performers I know aren't big fans, but it's the easiest way to simulate flying without being in the air. The way the sequence is designed, Jack and Jason are flying together, with Jack riding on top of Jason," he laughs. "Basically straddling him.

"Designing that rig so Jack wasn't putting all of his weight on Jason, with Jack on four-point wires so he's not resting directly on Jason, that puts a lot of pressure on your back and your core, even if you're in a tuning fork all by yourself. When you see the sequence, it's a lot of Jack spinning around, going upside down, holding on to Jason, spinning around his body—it took months to plan that and plot it out so that we could keep our actors' faces and bodies in there as much as possible, instead of trying to cheat it too much.

"There were times that they weren't in the tuning fork and we

BELOW AND OPPOSITE Elytra are among the most beloved and most coveted items in *Minecraft*. Designers paid great attention to detail when adapting the wings for human use.

"There's not a price or time limit on creativity."

tried to make it as comfortable as possible while we filmed close-ups of their faces, and framed out the box. But everybody wants to see Jack and Jason look like they're actually flying, so as much as possible we got them into these shots, full-body. And Jared wanted to see the motion and their body performances, and for that we had to put them into those stunt rigs. But we tried to make them as comfortable as possible. Everybody knows if you're just sitting in a harness, that's one of the most uncomfortable things that even a stunt person can do.

"I know my team; they know me and how I work. I start about eight to twelve weeks ahead of the actors' arrival, working with the director to plan our stunts and make sure we're all on the same page," Valera continues. "Sometimes those early concepts will help you come up with other ideas and may inspire the director or the studio to add scenes or take things in a different direction. One idea sparks another, and that's the whole vibe of *Minecraft*. Just creating.

"There's not a price or time limit on creativity. When it comes to designing action, I like to go big with my ideas right off the bat. You can always tone things down if you need to, but I always start big."

4. PUTTING IT ALL TOGETHER 175

Block Party

In the true spirit of *Minecraft*, every player knows that rules are meant to be broken, and even Mojang's senior creative director of entertainment, Torfi Frans Ólafsson, knew when it was time to follow the rules and when it was time to step back and let the creators create. "In Creative mode, you can use any block you want, and you have infinite blocks and can throw them down superfast," says Ólafsson. "This movie is in Survival mode, in the sense that all the blocks and resources come from somewhere. That was kind of our principle. But as the movie progresses and we sometimes have to go from scene to scene quickly, that kind of got broken; there's a little bit that assumes that someone got some resources or assumes that someone spent more time gathering the blocks, but it was really important for us to show it in the first night scene where Henry knocks into a tree and gathers wood for building. Again, something that doesn't happen in the game, but it was important for us to be able to show that process, and to realize that he has to punch the tree to do that, and we had to set things up so that he at first did that by accident."

Ólafsson notes that using the Hoberman sphere idea, where objects can collapse and expand as needed, let the team create the perfect way to stay true to the world, while working with the needs of the story. He says, "At some point, you have to surrender to the fact that it's an adventure story, not a scientific simulation.

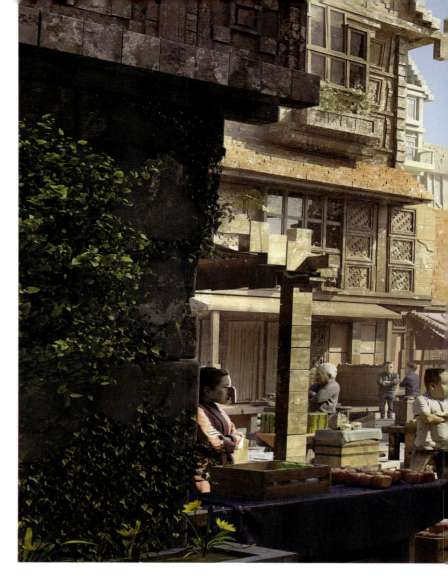

"I think Jared would agree, when dealing with a creative, wacky, and little bit surreal world, it's probably good to not take yourself too seriously. Some game adaptations take themselves too seriously. Whereas the gamers have a sense of humor, and they make fun of things, and make jokes, and do silly things in the game just to see if they're possible. And that sense of humor and tone was really important. If anything, I think other game movies told us that you're allowed to be funny, and you're allowed to be fun, but you have to respect the audience. To do all that, while breaking the rules, that's been the hardest part.

"But we tried to honor that. We have a bunch of Easter eggs and jokes, too, references to the game. We had to explain a lot of this to executives, who asked questions about how or why something happened in the story, but we did that for the gamers. In some cases, we pause the story or have an infographic show up or

BELOW These blocks are among the essential elements of the *Minecraft* world.

176 A MINECRAFT MOVIE: FROM BLOCK TO BIG SCREEN

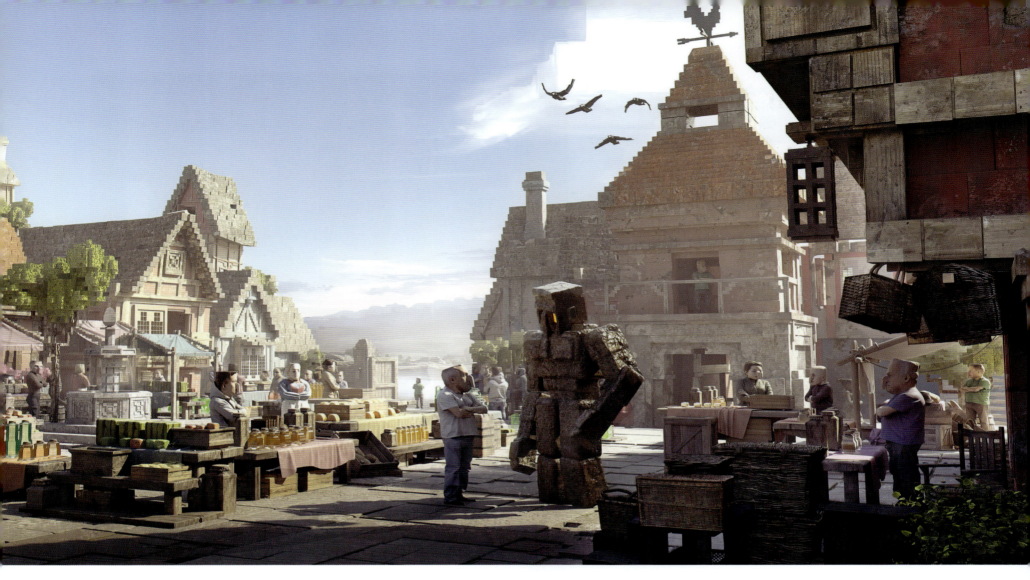

have one of the characters stop to explain it. But I think in world-building, if your world is consistent, and if you establish those rules early, and respect those rules throughout the movie, audiences accept different rules, physics, different mechanics. We had to keep it consistent.

"For example, there's an Ender pearl used in the last act in a way that's never been done in a *Minecraft* game. But we set that up where, earlier, Henry kills an Enderman and gets the Ender pearl, exactly like it happens in the game. But earlier in the scene, Garrett throws an Ender pearl, and Steve tells him that it will make him teleport. Garrett says no it won't, but he throws it, and he teleports. And that was a running principle for us: start familiar, and then expand. Honor the rules first, so the players and the fans know where we're coming from. We're not just making stuff up, not just being silly."

ABOVE (Concept art) Another peaceful day in the village marketplace.

LEFT The Ender pearl is one of the most coveted items in *Minecraft* and Steve only has one of them. No biggie.

4. PUTTING IT ALL TOGETHER 177

Hip to Be Square

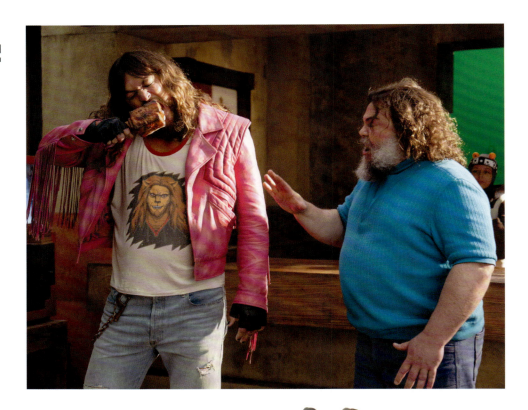

Then again, sometimes you do have to get a little silly, especially where *Minecraft* is involved. "So many props on this film were unlike anything I'd ever been asked to make before," says props designer Polly Walker. "I had a lot of fun with the chicken, the roast chicken and the pork chops, the *Minecraft* meat. The roast chicken, we had to design it, then someone had to eat it. How did we do that? Getting this weird square chicken going on that someone could actually eat was a combination of design and prop makers rigging it, and then making all this square food. We had prop chicken leg that had this insert of real meat in it, so that Jason Momoa's character could take it and bite into it.

"And then in the real world, we had Henry and Natalie's mom's precious pig mug. We kept getting notes from Jared, make it uglier. Then we did, and he'd reply, worse. Then we'd make it uglier, and he'd tell us, go even worse! We made this really ugly but pretty cricket pig mug that gets broken.

ABOVE Garrett tries to impress Steve by devouring a molten-hot serving of Steve's lava chicken.

RIGHT The prop department made sure that this square chicken was entirely edible for Garrett's big scene. The secret ingredient is lava.

OPPOSITE With blocky instruments in their hands and mushroom hats on their heads, Garrett and Steve are ready to rock out!

178 A MINECRAFT MOVIE: FROM BLOCK TO BIG SCREEN

"We also did a saxophone that they play, which was quite a lot of fun. We ended up making it with a proper reed in it so that you could actually play about six different notes on it."

That attention to detail is all in a day's work, according to painter Gaëtan Leclercq. "Because I played *Minecraft* and chatted with Jack Black online, I knew he was really happy with the square saxophone," says Leclercq. "Of course, he was really impressed by how it looked and how it felt, and I asked him, 'Did you play it?' And he said, 'No,' that he hadn't tried it. But we made a working saxophone. Not the best sound, but when you're making something like that, that's one of a kind, you put in that extra effort and attention to detail.

"I think that's why I like to work in props, that we always try to go a little bit further, and to make things more real than they need to be for whatever scene they're in. But he told me that he was really happy with it. It's nice to get that bit of appreciation for your work."

The piglins got in on the musical action, too, according to Walker. "There were a few designs that went straight to the workshop, the ukelele being my favorite. That gets played in the piglin band, in one of my favorite scenes. Our prop maker Lisa Dunn just made that without a design page. It's got really beautiful square detailing all through it and was tuned and playable!"

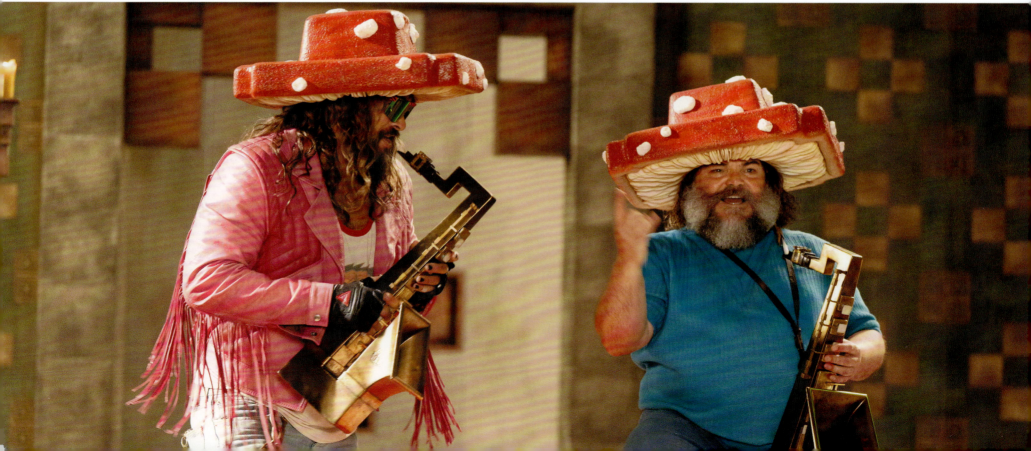

> "Jack brought the music, 100 percent."

Rock Formations

ABOVE Friends at last! Garrett rocks out on his keytar as Steve sings a triumphant song about their epic adventure.

Music plays a large part in *A Minecraft Movie*. And how could it not, with Tenacious D frontman Jack Black in the cast? "Jack brought the music, 100 percent," says VP of *Minecraft* franchise development, Kayleen Walters. "At one point, we looked around and asked, 'Did this become a musical?' It was just fun to see what he'd riff and create, and how it would fit in. It definitely brought joy to the movie itself. This is what he brings, that ability to weave the music into the story, since it's just natural to him. The flexible attitude that everybody had. The energy and passion he brought went into the movie, too."

And no one appreciated that energy and passion more than his fellow cast members. "Jack's a treasure," says Danielle Brooks. "They say be wary of meeting people you admire, but I'm so glad that he proved that statement to be wrong. He was the most generous actor—he goes on my list of generous actors, since I've worked with some very beautiful actors—but he's definitely on my top five for me, of generous actors. I knew how much I loved Jack Black as an actor, but I didn't realize just how much of an influence he'd been on me until I was in his presence. Then it was like, oh my gosh, that's who I stole that from! That's who I got that from. It truly was trippy for me, because I found myself slipping into his style, which works for this

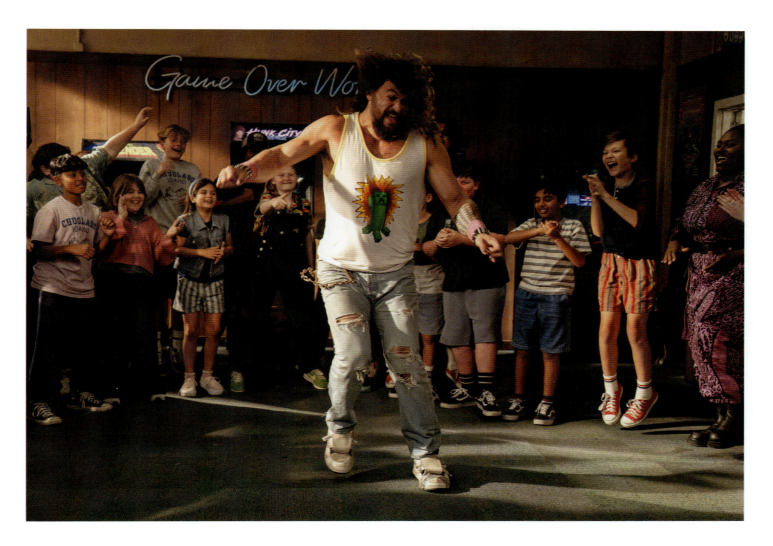

film, but I was just in awe of how much of an influence he's been on me as an artist, but also how much I haven't been able to tap into that onscreen yet, because of the roles I'd had previously. But now, playing Dawn, I'm excited because I actually get to tap into that part! Which was just so much fun. So much fun. Jack is something special. Truly, truly.

"On the set, we had lots of music, lots of singing. I didn't want to leave this project without adding to the musicality of it, what was being created—I don't know if I'm even making sense. I just wanted to make sure that I left a little spark of myself when it came to the music. So I requested that I get a song and ended up co-writing a song with Chris Galletta called 'Llama Drive My Zoo.' It's this really wacky, fun song, kind of a jingle for her zoo on wheels. She has a llama, two goats, some chickens, rabbits . . . I truly had to be in the car with these animals. Probably the hardest part of the job was having a llama's butt right in the back of the vehicle with me."

Those original songs featuring Jack Black and Danielle Brooks are just one part of the musical tapestry of *A Minecraft Movie*, which features a score by award-winning composer Mark Mothersbaugh, who has nearly three hundred productions to his credit on projects ranging from music videos showcasing his New Wave band Devo to the *What We Do in the Shadows* television series. Needless to say, he was at the top of Jared Hess's wish list for *Minecraft*. "Mark Mothersbaugh and his whole team are just fantastic. We're looking for ways to integrate some of the iconic *Minecraft* music into the film."

Honoring a classic score while enhancing and upscaling it for the big screen was a challenge, but one familiar to Mothersbaugh, whose experience with video game music dates back to the beginning of home console games. "I wrote music for Atari games back

ABOVE Celebration time! Garrett and his new friends party down at Game Over World.

4. PUTTING IT ALL TOGETHER 181

ABOVE A triumphant Steve serenades Natalie and her friends at Game Over World.

in the '80s where you had one sample that was like a half a second at the longest and you had to use that for your whole drum kit," Mothersbaugh recalls. "It would be tuned on a keyboard—*bop, bop, beep-beep-beep*! That's what you had for a drum kit, that one sound. Now it's totally different, with orchestral themes for video games."

It wasn't hard to convince the versatile composer to join the production team. Mothersbaugh had a great working relationship with many New Zealand–based filmmakers including Jemaine Clement and Taika Waititi, and the prospect of spending several weeks there recording while collaborating with Jared Hess was an easy sell for Mothersbaugh. "Jared Hess is such a gifted storyteller. *Napoleon Dynamite* and *Nacho Libre*, those are the films that made me want to work with him. That guy's a real artist. I don't know how many films I've done, probably seventy, and there aren't always artists involved. A lot of times it's technicians, and people who started their careers doing TV commercials and the studios hired them to do films because the studios knew they could tell them what to do. And then there are people who are really artists, and Jared falls into that category. I like that about him. He was very easy to work with. He had to reshape the film a couple of times to get the film exactly where he wanted it, from the beginning, so some parts of the film we had to score a few times, but in the end, it all came out really great.

"And I'm glad I got to work in New Zealand on the score. I'd never scored a film there before. It's kind of a nice energy there. The people, the place. It's calm. It doesn't have the same political divide we have in the U.S. It was nice to get away from all of that in the U.S. to record there for a few weeks. Plus, our band was great! The New Zealand Symphony Orchestra played the music, and they did a beautiful job."

Mothersbaugh took a deep dive into the game's score to get a feel for its music and to determine the qualities that had to come through when he adapted it for the big screen. "Musically, I tried to honor a lot of the music that's in *Minecraft* and paid a lot of attention to it," says Mothersbaugh. "My engineer who works with me here in-house, here in [our production company] Mutato Muzika, his son is a total crazy *Minecraft* fan, and he came in and showed me who the characters were and how the game worked. It's interesting to see how engaged the kids are with this. And it spans a lot of different age groups.

"I listened to the music and used that as a starting basis for how I thought about the music for the film. There are a few places in the film where I literally recreated the same music and went for the same sound quality as the game and then gave it a chance to build and build and build until we had that *Minecraft* sound surrounded by an eighty-piece orchestra and a choir. When you're going to different locations, you get reminders of where you started off. My goal with the music was to try to build a bridge between the two worlds. *Minecraft* was fun because I got to do some of that. It has a little bit of a *The Lord of the Rings* thing going on throughout the entire score. Because of the look of the way the animation translated to the screen.

"The music kind of stays out of the way of the game, doesn't it? When you're playing the game, you're busy creating new stuff, so you don't want the music to get in the way."

Music has been an integral part of all of Jared Hess's films, and he works closely with his team to ensure that every scene pairs the right music with the right moment. In addition to the new songs featuring Jack Black and Danielle Brooks, the director worked closely with music supervisor Karyn Rachtman to assemble the perfect soundtrack for *A Minecraft Movie*, an album's worth of tunes featuring classic rock that would have been blasting from Steve's and

182 A MINECRAFT MOVIE: FROM BLOCK TO BIG SCREEN

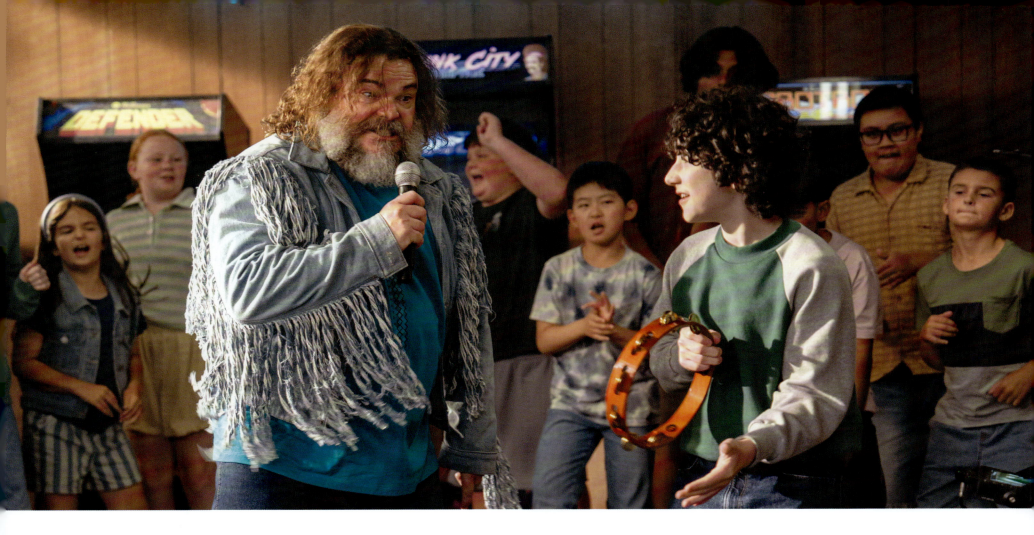

Garrett's stereo systems to brand-new songs by some of today's top artists.

"We had so many conversations about the music," says Hess. "If you try to put something in a soundtrack from right now, by the time the movie comes out, audiences feel that it's an old, played-out song. I think there's something fun about chasing original stuff that you introduce throughout the movie. Garrett's character is stuck in the late '80s and is definitely into classic rock. The characters, the tone, the energy, that's what we're chasing. More than anything, studios and filmmakers want to be fresh and new, but there's also the power of nostalgia in a song that was big twenty, thirty, forty years ago, so it's a matter of finding what works."

Mark Mothersbaugh wasn't directly involved with putting together that perfect *Minecraft* mixtape, but he was happy to leave that in the capable hands of his director. "Jared was responsible for the soundtrack, all the songs," he says. "Karyn Rachtman, who I worked with all the way back on *Rugrats*, a million years ago, who now lives in New Zealand, she was in charge of that. When Jared started out on this, it was kind of a Steppenwolf-heavy soundtrack, with different songs from the '70s and '80s in there as placeholders, but I think the final soundtrack will have a lot of contemporary artists on it. Not my territory.

"I would have written some songs for them if they'd asked, though. Actually, there's a Devo song called 'Blockhead' that I kind of said, 'Hey, why don't you use that?' And they said thanks, okay, forget it," Mothersbaugh laughs. "Oh well.

"On a film like this, my job is to support the animation and the storyline, to keep things moving. Because there's live action in it, it's an interesting hybrid. When you do a full animated piece, it becomes even more important because all those people playing instruments, they're breathing, and you sense that, and that transfers over to the animation and makes it feel more alive. This film, that was already there, with real people in it. It was very interesting to get to score this. I had a good time. I hope the kids and adults who play *Minecraft* find this amusing and fun, and a nice tribute to a really great game."

ABOVE Steve on vocals and Henry on tambourine make a dynamic duo!

Finishing Touches

Ian Lemmon was among the very first people hired to develop the philosophy and the visual identity of *A Minecraft Movie*, and nearly three years after he joined the production, he and his team are among the very last crew members left, refining, polishing, and finalizing everything from the opening titles to the end credits. Much like Henry and his friends, Lemmon can only look back in wonder at the journey that took him from the real world to the Overworld and back again.

"At the outset, we set up a virtual art department for this film, and sometimes that's part of VFX, sometimes it's part of the physical art department. It's a hub, a group of people that sit between art department, VFX, camera, storyboards, and it's a place where all the in-progress set designs and character designs and everything can come together, into a central place," says Lemmon. "We use a product called Unreal Engine, which is a video game engine, and we use that to stage shots and look at cameras and staging. There's a certain aspect of shot-finding that happens there, and that's where we negotiate how much of the set we build, how much gets extended, working out the look of that extension. That lives in that virtual art department.

"We make sure that in terms of lighting and green screens, we're shooting in a way that's going to produce the most successful shot. Usually, my biggest thing is to try to make the world feel big and rich, and to embrace the spectacle, but at all costs, make it feel realistic. Don't give people any reason to turn off their suspension of disbelief. And *Minecraft* has been a little bit different from that, as there's a willingness to sacrifice realism to better honor the game, to better honor the experience. Almost to create that kind of *Wizard of Oz* experience. When you go from Idaho to *Minecraft*, it feels like a Technicolor transition, where you've gone from a place that's a bit of a bummer to someplace that's visually very exciting. And that has a different set of requirements. I guess that the abstract nature of the source material and the number of different directions that you can go, then reconciling that to make your choices. Are they the right choices? If not, how do we arrive at a place where we reach a consensus with our creative partners and move forward."

And those creative partners could populate an entire village. "On the Warner Bros. side, the film production side, we've got about fifteen people in the office here. And we've got three companies doing most of the work, Wētā, Sony Pictures Imageworks, and Digital Domain. And each of those companies is doing somewhere between 200 and 600 shots. Within those companies, each probably has around 250 people working on the film," says Lemmon. "Some for only a few months, some for over a year. Probably around a thousand people working on VFX on this film. On set, we'll have another twenty people doing witness cameras, data gathering, scanning of the sets, our digital art department . . . it's a big department, and this is a big film. Something like 80 percent of the film has visual effects in it.

"It's really exciting to see all the pieces coming together. I hope that the experience for fans is that their experience that they've had playing the game is reflected in the picture. And that newcomers enjoy it and just have a fun ride."

RIGHT (Concept art) The limitless possibilities of *Minecraft* will let anyone make their mark on the world — even on a canvas made of solid rock!

OPPOSITE (Concept art) Peace returns to the mines — for now.

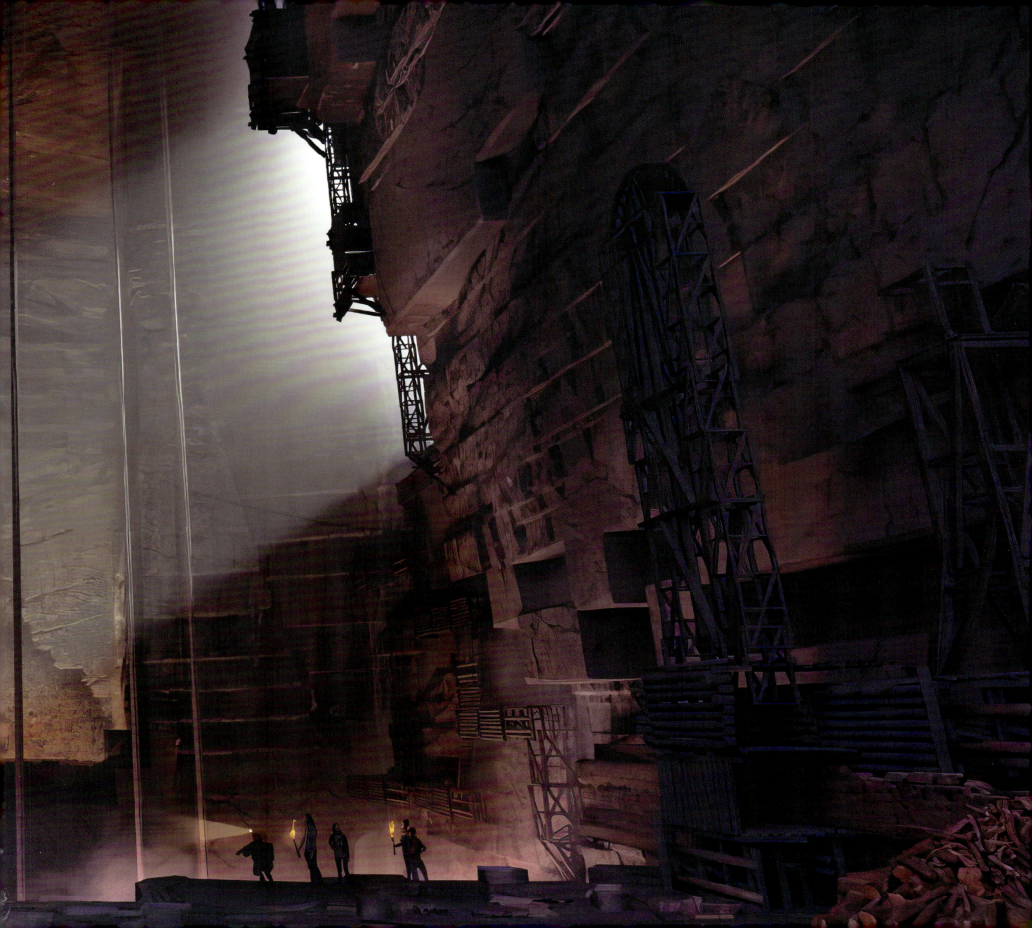

ENDGAME

Minecraft's journey from computer monitor to the silver screen has been a long one, filled with danger and unexpected challenges, occasional frustration, but, ultimately, a lot of fun and laughs along the way. Seasoned veterans shared their knowledge with complete newbs, top performers leveled up, and everyone pulled together to accomplish extraordinary feats that no one person could have accomplished on their own. In that regard, *A Minecraft Movie* truly captures the spirit of the game itself.

But, as director Jared Hess observes, each player connects to the game in their own way and embarks upon their own unique journey through the Overworld. "You definitely want to deliver on what everybody loves about the game, but those things are always personal, and specific, so you have to do what you love about it," says Hess. "You're always going to get it wrong if you try to guess what everyone else wants, so you just have to chase what you love about it, and what you connect with personally, and that's what we tried to do with this movie.

"We want to celebrate the fun of the game, and honor it. For me it goes back to when my kids were playing it with their friends. It's such an absurd game in the funnest, most chaotic way possible. So my experience with it is that, in the absurd, ridiculousness of the world, and celebrating that side of it. Finding your inner, creative nerd superpower within that world is so charming and so fun. And somebody else's experience with it might be speedrunning through it and going and killing the Ender Dragon, and that's a different thing. And that approach has just as much value, but for this particular thing, the movie was all about celebrating the absurdity and the creativity, as well as the adventure. There's so much adventure.

"Any movie, any project I've worked on—I really want to celebrate the experience and the fun in a new way with these characters. It's always character-based for me. From the beginning, it was about finding the right balance and fun with these characters, who go on this

ABOVE (Concept art) The Overworld is safe once more, and it's a perfect day for sightseeing by minecart.

OPPOSITE (Concept art) Malgosha and her army have been defeated, and peace has returned to Midport Village.

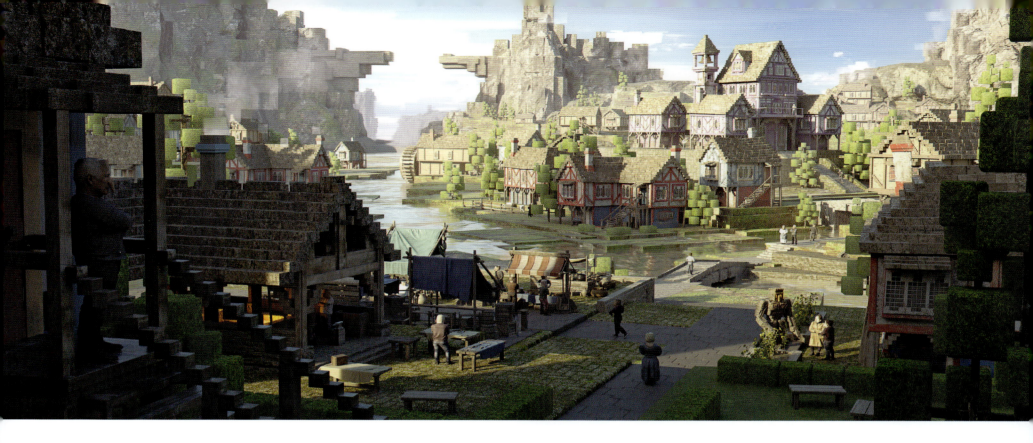

adventure together. So many people from all different walks of life play this game and find community going on these creative adventures together, and I just hope the spirit of the game comes through in the film."

The creative spirit was present in every aspect of A Minecraft Movie, from the top down, according to Warner Bros. executive producer Cate Adams. "What is it that's so resonant about Minecraft? Freedom, and control, but also the ability to do something for a random reason. I feel like children kind of lose that randomness as they grow up. The idea of 'I'm just gonna do this, I'm just gonna do it, I don't care.' Kids really love randomness.

"And that's what makes the game so much fun for kids. They just want to build a house and blow it up! Build another house. And it's in a place where no one's going to tell them not to do it. And because there's no story, you can play the way you want to play. Which is a unique thing. It's a really creative outlet, since there's no set story, and there is no winning in Creative mode. It's like life. You figure it out. I've got to do this thing, so I can feed myself. I've got to sleep, because if I don't sleep, this thing happens. We all go crazy. Much like the real world.

"I think what's great about Minecraft in general is that ability to try things and not be afraid of failure, and to keep going. And to realize that, at a certain point, you realize that YOU can have an effect, and if that message can come through too, yes, it's hard in the real world. Yes, there are rules and systems and it's annoying, but you can have an impact with what you do. And being creative is important. I hope that's what people take away from the movie. Or that they just have a good time. It's okay to just have a good time, too."

And if the filmmakers have done their job, it will be a good time for the entire family, from experienced crafters to those adults who are just along for the ride. "Parents will watch this with their kids and they can relate to something that their kids are so passionate about," says Kayleen Walters, VP of Minecraft franchise development. "Maybe the parents aren't able to sit down and spend the time playing the game with them, but ninety minutes in a theater where you get to go into the Minecraft world and see what it is in a way that's relatable to you, too? I think that creates a stronger bond, and helps parents know a little bit more about what's so special about Minecraft that their kids will play it for hours and hours. It's an easier entry point into Minecraft. Of course, they'll want to bond with their kids and not just drop them off. This is an opportunity to see what this game means to someone who's so special to them."

And that will be true for everyone in the audience, if Danielle Brooks has anything to say about it. "Thinking about representation, it's super important to have myself and Emma in this movie, because there are a lot of female gamers. I remember going to Target and seeing this little Black girl who was about ten years old and seeing her in the store dressed in Minecraft pajamas, where her parents had let her go to the store in her PJ's," says Brooks. "And I had to just stop and say, hey, and I know she didn't know me, because the work that I've done up to now hasn't really been kid-appropriate. But I had to say hi and ask her if she was a fan of Minecraft, and I told her I was going to be in the film, and that gave me so much pride, because I knew that in a few months, she'd see the film, and she'd feel seen, and that just really warmed my heart. It's going to mean a lot to a lot of girls out there.

"I understand why people love the game, even though I'm not a gamer. Because I'm creative, I'm an actor. I understand going into different worlds, into different time periods. Just getting to walk different paths of life, that excites me. And I think that's what gamers love about it. They get to create their own world. I can definitely connect to someone who enjoys playing—but if you were to actually ask me to play, it would be atrocious," she laughs.

"But being on the set, entering this world . . . it was mind-blowing. Everything from bread being square, carrots being square, trees being square . . . chickens being square. It made me excited, because I come from the theater world, where you just get a black box and you go out there! I was very impressed by the art department. And I think the audience and the gamers are really going to take to it. And I know that the people who play the game have such an ownership, that they feel such an ownership of these worlds, but they'll feel like they're taken care of. That's my hope, anyway, that they feel like we did them justice. That we did the *Minecraft* world justice.

"I feel like what we do, as an art form, can be so helpful for people's mental state. And I hope that people can find a little bit of escapism in it, where they can just let whatever problems they have go, and that they can escape with us and go on this crazy ride. And hopefully, just maybe, they will discover something about themselves that will kind of make life easier. Make you smile, or make you feel like you can keep going. That's what I hope people take from it."

Is it wishful thinking to hope that *Minecraft* can bring people together, and to make the world a better place? Maybe, but for a game that encourages players to dream big, there are no limits. "Mojang and Microsoft from very early on, they always said to me that when people play *Minecraft*, then they feel better about the world that they live in. And I understood that," says Legendary Pictures producer Cale Boyter, who was one of the very first people who believed in the cinematic potential of *Minecraft*. "My kids still play, and they all play together. And they all do different things as they play, and there's really only one game where that happens.

"The common denominator there is it brings people of different ages together, the virtue of creating and defending, then learning to play together. Sometimes the way they fight with each other online is the way they fight with their friends or siblings. It's bizarre and can be aggravating. But it's the one game you're okay with your kids playing. Finding that way to make the real world seem better, that's the bedrock of what we're doing.

"I'd love for people to see the movie and think it's a fun time, then ask their kids, that's what you've been doing this whole time? And then maybe take a trip to the Overworld together. I don't know if we get there, but if we do this right, it becomes a great ambassador for the brand and the game. And we evolve the game as we evolve the next movie, and we help each other. That's what I'd like to see."

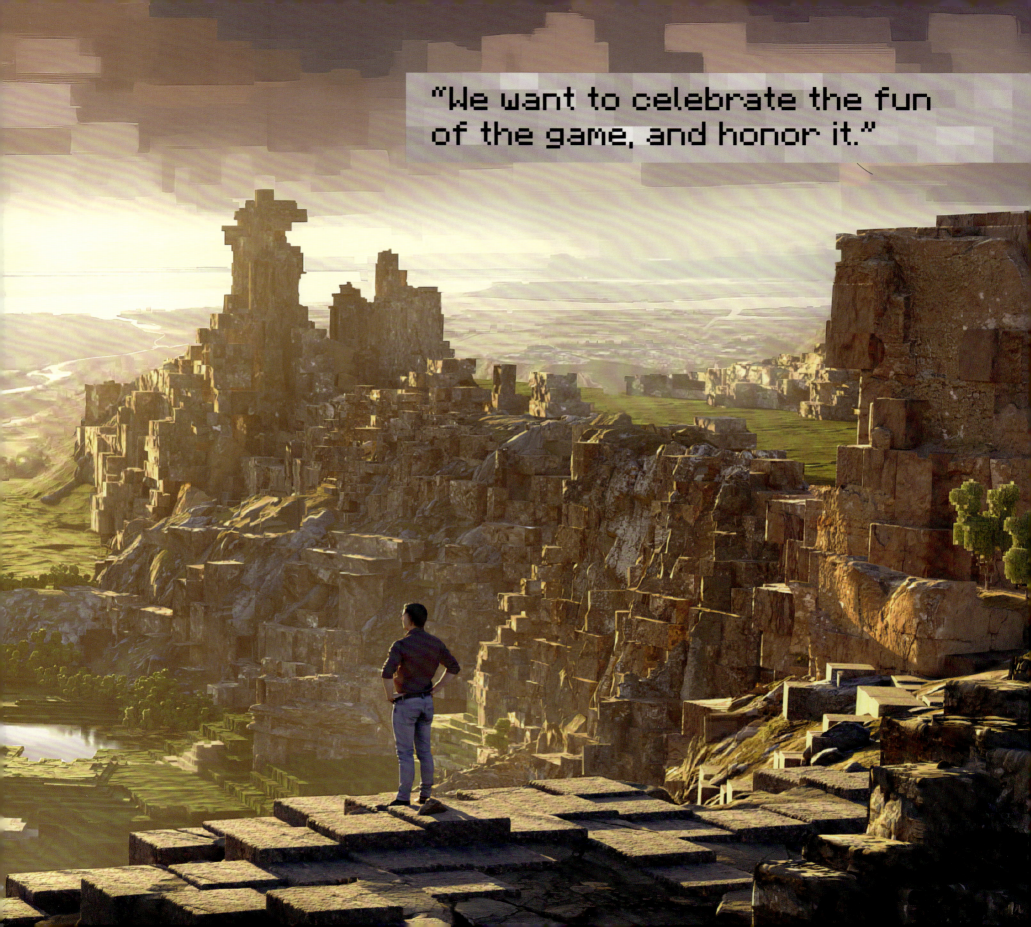

PO Box 3088
San Rafael, CA 94912
www.insighteditions.com
Find us on Facebook: www.facebook.com/InsightEditions
Follow us on Instagram: @insighteditions

Minecraft © 2025 Mojang AB. All Rights Reserved.
Minecraft, the *Minecraft* logo and the Mojang Studios logo are trademarks of the Microsoft group of companies.

A Minecraft Movie © 2025 Legendary and Warner Bros. Entertainment Inc. All Rights Reserved.

© 2025 Legendary Comics and Microsoft Corporation

All rights reserved. Published by Insight Editions, San Rafael, California, in 2025. No part of this book may be reproduced in any form without written permission from the publisher.

Library of Congress Cataloging-in-Publication Data available.

ISBN: 979-8-88663-942-1

Publisher: Raoul Goff
VP, Co-Publisher: Vanessa Lopez
Publishing Director: Mike Degler
VP, Creative: Chrissy Kwasnik
VP, Manufacturing: Alix Nicholaeff
VP, Managing Editorial Director: Katie Killebrew
Art Director: Catherine San Juan
Designer: Amazing15
Executive Editor: Jennifer Sims
Editor: Sadie Lowry
Editorial Assistant: Alecsander Zapata
Managing Editor: Nora Milman
Senior Production Manager: Greg Steffen
Strategic Production Planner: Lina s Palma-Temena

Insight Editions, in association with Roots of Peace, will plant two trees for each tree used in the manufacturing of this book. Roots of Peace is an internationally renowned humanitarian organization dedicated to eradicating land mines worldwide and converting war-torn lands into productive farms and wildlife habitats. Roots of Peace will plant two million fruit and nut trees in Afghanistan and provide farmers there with the skills and support necessary for sustainable land use.

Manufactured in Turkey by Insight Editions
10 9 8 7 6 5 4 3 2 1

Dedication: To Robin, for his encouragement, expertise, and patience when explaining everything about *Minecraft* to his father.

About the Author

Andrew Farago is the Curator of San Francisco's Cartoon Art Museum and the author of *Batman: The Definitive History of the Dark Knight in Comics, Film, and Beyond*, *The Complete Peanuts Family Album*, and the Harvey Award–winning *Teenage Mutant Ninja Turtles: The Ultimate Visual History*. He lives in California with his wife, cartoonist Shaenon K. Garrity, and their son, Robin.

Special Thanks

Cale Boyter, Mary Parent, Katie MacKay, Jill Benscoter, Jennifer Mizener, Nick Gligor, WB Photo Lab Team, Kilou Picard, Dan Lemmon, Legendary Marketing, Romy Schneider and Legendary Legal Team, Robert Napton, Torfi Frans Ólafsson, Alex Wiltshire, Sherin Kwan, Lauren Marklund, Audrey Searcy, and the rest of the amazing teams at Legendary Pictures, Mojang, and Warner Bros. who made this book possible.

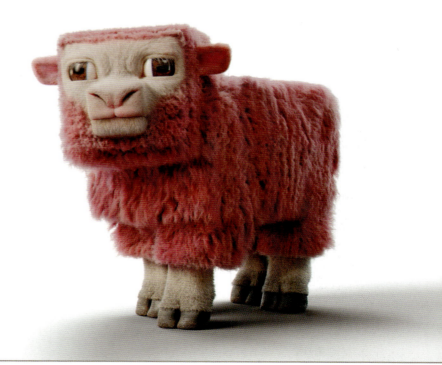